The Big Book of Color in Design

edited by

David E .Carter

The Big Book of Color in Design

First published in 2003 by HDI,
an imprint of HarperCollins Publishers
10 East 53rd Street
New York, NY 10022-5299

ISBN: 0-06-053612-8

Distributed in the U.S. and throughout the rest of the world by
HarperCollins International
10 East 53rd Street
New York, NY 10022-5299
Fax: (212) 207-7654

Printed in Hong Kong by Everbest Printing Company through Four
Colour Imports, Louisville, Kentucky.

To paraphrase an old TV commercial, this is TWO, TWO, TWO books in one.

First of all, this is a great design resource book. There are hundreds upon hundreds of design ideas within these pages. For those who do what I call "solitary brainstorming," this is another excellent source of design ideas.

But this book is much more. The focus of the book is how color is used to create moods and images. The index shows more than thirty different descriptors: classy, corporate, cool, etc. And within each of those sections, you will find interesting and, often, innovative use of colors in design.

And when you see a particular color or combination of colors that you like, you will find that each image shown in this book has the CMYK formula on how to create that exact color.

All in all, I think this book is one that creative people will find very useful.

For every book that I produce, that is my basic goal.

Table of Contents

classy .. 7
fresh .. 28
exciting .. 38
fun ... 56
rich .. 84
masculine ... 94
feminine ... 108
corporate .. 118
regal ... 132
hot ... 134
healthy .. 144
durable .. 152
tasty ... 164
soothing .. 186
powerful .. 194
sexy .. 214
carefree ... 220
cool .. 234
trustworthy .. 242
relaxing ... 256
cheerful ... 266
natural ... 280
soft ... 298
futuristic .. 302
vintage .. 312
genuine .. 326
ecological ... 336
patriotic ... 344
reflective .. 350
geographic .. 356
technological ... 362
friendly .. 376

Index ... 384

• Black is always classy (ask any woman about the "little black dress") • Black and gold are even classier • Grey is classy (it's a variation of black) • So is silver (it's related to gold) • Deep blue is also very classy (maybe because it's a variation of black)

• Green is the color of gardens and grass and springtime • Yellow is the morning light • Yellow is fresh flowers in springtime • Sky blue is the promise of a new day • Pink is a newborn baby, fresh as can be • Black and white is fresh morning e-mail

• Red is fireworks • Red is a new Corvette • Yellow is icing on a birthday cake • Green is a ticket to the World Series • Black is the small box that holds a diamond ring • Blue is exciting, especially if you're a Duke fan • Tea leaf green, at the Boston Tea Party •

• Yellow is balloons • Yellow is picking daisies on a spring day • Orange is several different colors in a box of crayons, especially fun if you have the 64 box • Carolina blue is fun, especially at the Dean Dome •

• Brown is hardwood floors and chestnuts • Rich is a black sports car • With red accents in the interior • A white Rolls Royce is very rich • Gold is rich, especially when it wraps around a Liz Taylor diamond • Pearl-colored pearls are very rich •

• Black tuxedo is masculine •Camel cashmere is also masculine (not to mention rich) • Navy blue (just like sailors wear) is very masculine • Black bathroom fixtures are masculine • Dark green is masculine (and if it's the color of money, it's also rich) •

• Baby girls wear pink • So do grown-up girls • Yellow ribbons in her hair. • Cream-colored sweaters are feminine too • Lacy black stockings • Earth tone sweaters, ditto • Tan (as in sun tan) is very feminine •

corporate

• Blue, as in IBM blue • Navy blue with pinstripes • Gray flannel suits are corporate, as in the movie "The Man in the Gray Flannel Suit" • Multiple neon colors at Times Square in New York City •

regal

• Centuries ago, in many societies, only royalty could wear purple • Purple is still a color associated with royalty • Gold, of course is royal, as in golden crowns • Mother of pearl, a cream-colored elegance • Multiple gemstone colors, as in the crown jewels •

hot

• Orange is hot (at 2,700°F, molten steel is orange) • The sunset is orange, or maybe yellow, or a variation of red • Red is spicy sauce • Red is the 4th of July • Red is hot summer days • Orange is a hot time at a Tennessee football game •

healthy

• Pink cheeks, rosy pink cheeks • Red lips • Green vegetables • Orange-colored vitamin pills • Healthy is a black Volvo, because it's a very safe car • Red wine makes you live longer they say (white wine isn't as healthy—nor as pretty) •

durable

• Gray is steel, which seems to last forever • Brownish gray is the color of tree trunks, trees which have been around longer than we have • Black is steel-belted radial tires, which last forever or 40,000 miles, whichever comes first •

tasty

• Yellow is the taste of honey • Red is a fresh apple, just off the tree • Green is veggies, like beans on the vine • Green (in many shades) is a watermelon • Pink is the inside of the watermelon • Black and white Oreo • Honey and chestnut colors, beautiful and tasty •

soothing

• Brown is morning coffee, easing the start of a new day • Green aloe lotion is soothing, especially after a (fresh) pink sunburn • Light green is the color of an income tax refund check, which is much more soothing than owing the IRS money •

powerful

• Black is powerful; imagine a black business suit • Green is money, which translates into power • Blue is powerful, as in New York Yankees pinstripe blue • Gold is powerful, like the gold at Ft. Knox • Yellow is powerful, as in Caterpillar dozers •

sexy

• Black, as in the little black dress • Purple, as in lacy lingerie • Red, as in wet, red lips • Yellow can be very sexy, even a plain yellow shirt • White, pure simple white, can also be very sexy • Actually, any color can be sexy, given the right place and time... •

carefree

• Black & white saddle oxfords • With pink shoelaces • Yellow ties • Gray sweatshirts • Pink bubble gum • Blue skies • Yellow sunshine • Green oceans • Brown tree trunks, while walking casually in the woods • Green grass, as in center field • White popcorn •

cool

• Ice blue is cool • Light green is cool; just like the Kool cigarette package (although smoking is definitely not "cool") • White snow is cool, or to be more precise, cold • Snow White is cool, if you like fairy tales • Sky blue is cool on a Chicago windy day •

trustworthy

• Khaki is the Boy Scout uniform; a Scout is trustworthy • Green is trustworthy; our currency says "In God We Trust" • Blue is a policeman's uniform • Brown is a plain brown envelope, which is how confidential materials are mailed •

relaxing

• Black is the midnight sky • Pink is the morning sky, just before sunrise • Relaxing is a powder blue, knitted afghan • Fresh white, wool sweat socks are relaxing • Green is the placid emerald ocean • Blue is the sky on a cloudless day •

some others...

• Plaid skirts • Argyle socks • Blue Monday • Brown nose • Green grocers • Jet Blue • Black Friday • Pink flamingos • Curious yellow • Statutory grape • Envy green • Blue-nosed censors • Yellow bellies • White Christmas • Green party • Purple monsters •

design firm
Tangram Strategic Design
Novara (Italy)
client
Borsani Comunicazione

C - 0
M - 100
Y - 100
K - 0

C - 0
M - 0
Y - 0
K - 100

C - 14
M - 43
Y - 81
K - 10

C - 9
M - 69
Y - 92
K - 12

C - 73
M - 57
Y - 47
K - 25

C - 0
M - 0
Y - 0
K - 100

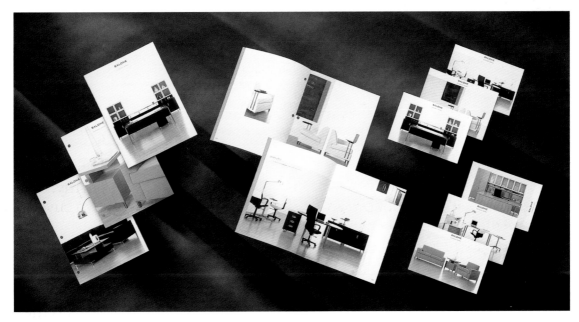

design firm
5D Studio
Malibu, California
client
Tuohy

C - 0
M - 0
Y - 0
K - 100

C - 0
M - 11
Y - 44
K - 30

design firm
The Wecker Group
Monterey, California

(Borsani) } **Comunicazione**

Agenzia di comunicazione d'impresa

(Servizi) (Clienti) (Eventi) (Contattaci) (Virtual press office)

Appuntamenti

Innovazione organizzativa e tecnologia negli Enti Locali
09/10/2002.
Convegno organizzato dal mensile Pubblica.
Milano, Hotel Executive.
Per informazioni: Edipi Conference - Moira Bellocchio - tel. 0267100340, fax 0267100448, e-mail: mbellocchio@edipi.it, http://www.edipi.com/conference

L'Economia Digitale nel Settore dei Servizi Finanziari 16/10/2002.
La manifestazione è organizzata da Assintel e dalla Federazione per l'Economia Digitale in collaborazione con la Camera di Commercio di Milano.
Milano, Palazzo Castiglioni, Corso Venezia 49.

design firm
Tangram Strategic Design
Novara (Italy)
client
Borsani Comunicazione

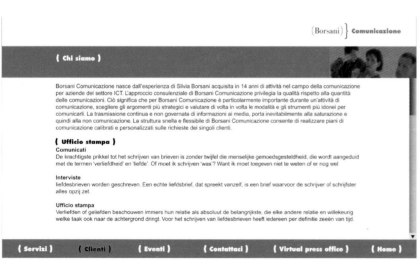

C - 0	C - 0	C - 0
M - 100	M - 100	M - 0
Y - 100	Y - 100	Y - 0
K - 0	K - 10	K - 100

classy

RIVERMARK

of Santa Clara

©2001 RIVERMARK PARTNERS, LLC

C - 28	C - 14	C - 76
M - 89	M - 55	M - 42
Y - 83	Y - 68	Y - 0
K - 4	K - 1	K - 0

design firm
Gauger + Santz
San Francisco, California
client
Rivermark

C - 92	C - 57	C - 47
M - 84	M - 27	M - 42
Y - 65	Y - 6	Y - 70
K - 51	K - 0	K - 8

design firm
Rule29
Elgin, Illinois
client
Rule29

Creative Matter | *volume 1*

RULE29

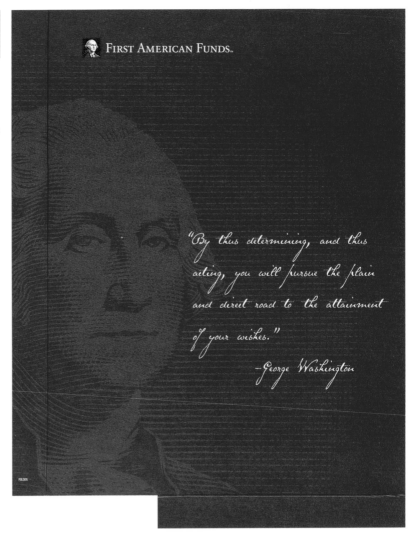

C - 35 C - 38
M - 98 M - 99
Y - 56 Y - 72
K - 13 K - 20

design firm
U.S. Bancorp Asset Management
Minneapolis, Minnesota

 FIRST AMERICAN FUNDS.

"By thus determining, and thus acting, you will pursue the plain and direct road to the attainment of your wishes."

—George Washington

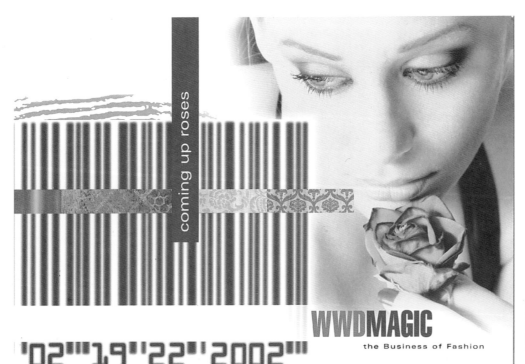

coming up roses

the Business of Fashion

'02"'19"'22"'2002"'

design firm
Marketing Design Group
San Diego, California
client
Magic International

C - 27 C - 1 C - 14
M - 89 M - 51 M - 46
Y - 56 Y - 75 Y - 26
K - 2 K - 0 K - 0

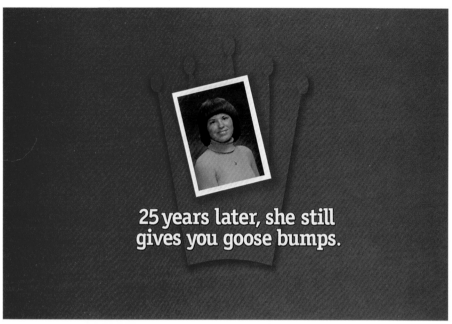

25 years later, she still gives you goose bumps.

C - 28 C - 42
M - 97 M - 38
Y - 79 Y - 32
K - 11 K - 0

design firm
SevenTwenty Group
Indianapolis, Indiana
client
Indiana Basketball Hall of Fame

Keeneland July

EATONSALES

Setting the standard

2001's leading consignor of group/graded stakes winning graduates offers 35 yearlings at Keeneland July. Representing breeding altering, established sires and the most promising new sires.

EATONSALES
Reiley McDonald • Tom VanMeter
4454 Mt. Horeb Pike • Lexington, Kentucky 40511
Tel. (859) 233-4021 • Fax (859) 231-5036
email: eaton@mis.net • website: www.eatonsales.com
photo by Katey Barrett

C - 14 C - 89
M - 98 M - 88
Y - 92 Y - 87
K - 24 K - 84

design firm
Saybrook Advertising
Lexington, Kentucky
client
Eaton Sales

REYNOLDS
VINEYARDS

As Distinctive As The Land It Comes From.

design firm
Trinchero Family Vineyards
St. Helena, California
client
Trinchero Family Estates

C - 64 C - 40
M - 88 M - 60
Y - 91 Y - 60
K - 25 K - 0

NEW JERSEY
JEWISH
FILM FESTIVAL

design firm
Creative, Ink.
Short Hills, New Jersey
client
JCC MetroWest

C - 87 C - 70
M - 88 M - 66
Y - 84 Y - 61
K - 80 K - 36

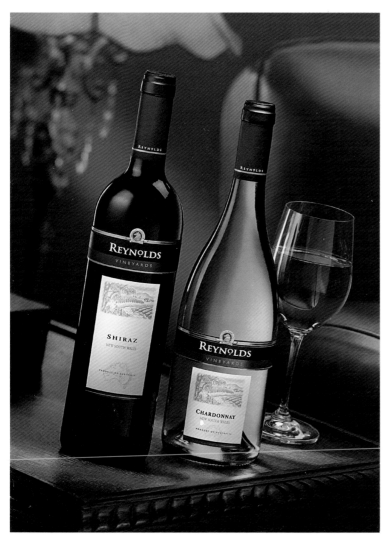

C - 86 C - 19 C - 51
M - 68 M - 33 M - 53
Y - 20 Y - 58 Y - 91
K - 18 K - 0 K - 15

design firm
Trinchero Family Vineyards
St. Helena, California
client
Trinchero Family Estates

C - 39
M - 46
Y - 72
K - 0

design firm
Design Objectives Pte Ltd
Singapore (Singapore)
client
Straits Advisors Pte Ltd

DESIGNING THE STORES YOU LOVE TO SHOP™

www.jga.com

RETAIL FOCUS

NEWS & VIEWS FROM **JGA, INC.**

RESTORE THE EXPERIENCE

Relate. Create. Elate. Understand your consumer. Develop an energizing environment. Provide a place where they love to shop.

In today's world, consumer interest passes quickly. Retail concepts have a shorter life span. Retailers need to be more responsive, especially those in trend businesses that must reinvent themselves much more frequently. Restore the shopping experience to form a dynamic bond between buyer and seller and as the consumer pie is reallocated, innovative retailers grab a bigger bite of sales.

C - 40	C - 0
M - 24	M - 61
Y - 99	Y - 97
K - 0	K - 0

design firm
JGA, Inc.
Southfield, Michigan
client
JGA, Inc.

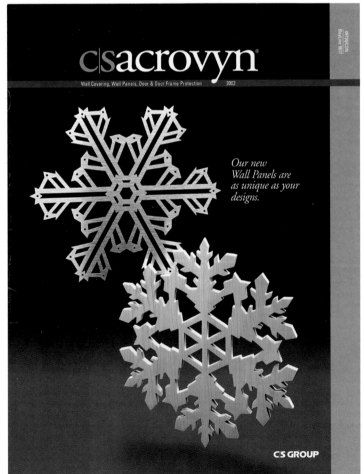

c|sacrovyn®

Wall Covering, Wall Panels, Door & Door Frame Protection 2002

*Our new
Wall Panels are
as unique as your
designs.*

C|S GROUP

design firm
Brian J. Ganton & Associates
Cedar Grove, New Jersey
client
Construction Specialties, Inc.

C - 21	C - 88	C - 5
M - 65	M - 86	M - 49
Y - 80	Y - 88	Y - 80
K - 1	K - 77	K - 0

14

C - 12	C - 0
M - 91	M - 11
Y - 86	Y - 92
K - 2	K - 0

design firm
Nassar Design
Brokline, Massachusetts
client
Louise Wegmann

Collège Louise Wegmann
مدرسة لويز فكمان

design firm
viadesign
San Diego, California
client
Polycom

C - 6	C - 69
M - 66	M - 76
Y - 99	Y - 42
K - 0	K - 1

POLYCOM® 2001 Annual Report

Be there.

C - 0 C - 62
M - 0 M - 51
Y - 0 Y - 49
K - 100 K - 63

design firm
Paradowski Graphic Design
St. Louis, Missouri
client
Paradowski Graphic Design

investment
indepth

SIRACH

design firm
Phinney/Bischoff Design House
Seattle, Washington
client
Sirach Capital Management

C - 17 C - 0 C - 0
M - 15 M - 61 M - 83
Y - 49 Y - 79 Y - 62
K - 0 K - 0 K - 0

SIX SIGMA
CANADA INC

C - 44	C - 0
M - 47	M - 0
Y - 74	Y - 0
K - 7	K - 100

design firm
Hardball Sports
Jacksonville, Florida
client
Six Sigma Canada

design firm
Barbour Design Inc.
New York, New York
client
The ESPY Awards

C - 87	C - 85	C - 58	C - 54
M - 50	M - 77	M - 93	M - 44
Y - 73	Y - 45	Y - 93	Y - 42
K - 7	K - 6	K - 9	K - 0

THE ESPY AWARDS
IN SUPPORT OF THE V FOUNDATION FOR CANCER RESEARCH

"DON'T GIVE UP...DON'T EVER GIVE UP."
JIM VALVANO, 3.3.93

C - 11 C - 71
M - 100 M - 73
Y - 71 Y - 49
K - 16 K - 44

design firm
Dever Designs
Laurel, Maryland
client
James Madison Council

C - 70 C - 0
M - 100 M - 0
Y - 0 Y - 0
K - 15 K - 100

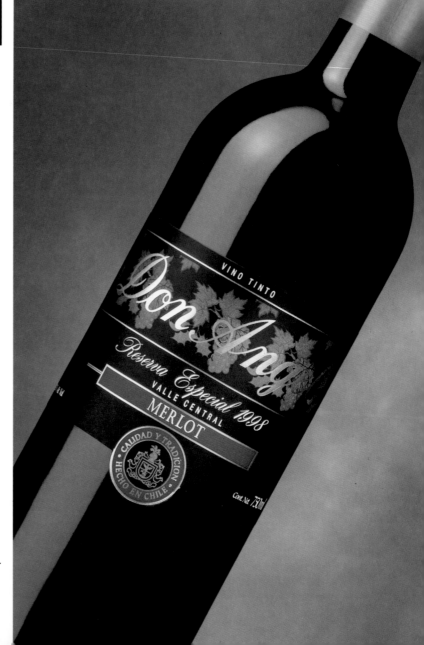

design firm
Praxis Diseñadores, S.C.
México City (Mexico)
client
Valle Redondo

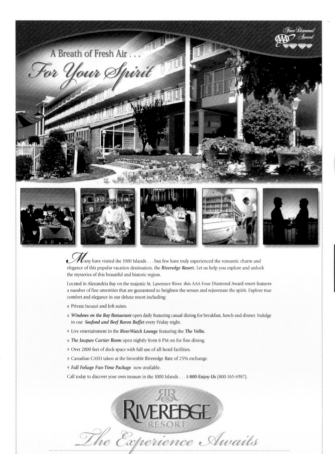

A Breath of Fresh Air . . .
For Your Spirit

*M*any have visited the 1000 Islands . . . but few have truly experienced the romantic charm and elegance of this popular vacation destination, the *Riveredge Resort*. Let us help you explore and unlock the mysteries of this beautiful and historic region.

Located in Alexandria Bay on the majestic St. Lawrence River, this AAA Four Diamond Award resort features a number of fine amenities that are guaranteed to heighten the senses and rejuvenate the spirit. Explore true comfort and elegance in our deluxe resort including:

◆ Private Jacuzzi and loft suites.

◆ *Windows on the Bay Restaurant* open daily featuring casual dining for breakfast, lunch and dinner. Indulge in our *Seafood and Beef Baron Buffet* every Friday night.

◆ Live entertainment in the *RiverWatch Lounge* featuring the *The Volks.*

◆ *The Jacques Cartier Room* open nightly from 6 PM on for fine dining.

◆ Over 2000 feet of dock space with full use of all hotel facilities.

◆ Canadian CASH taken at the favorable Riveredge Rate of 25% exchange.

◆ *Fall Foliage Fun-Time Package* now available.

Call today to discover your own treasure in the 1000 Islands . . . 1-800-Enjoy-Us (800-365-6987).

The Experience Awaits

17 Holland Street ◆ Alexandria Bay, New York 13607 ◆ 1-315-482-9917 ◆ Fax: 1-315-482-5010 ◆ www.riveredge.com ◆ e-mail: enjoyus@riveredge.com

design firm
McElveney & Palozzi Design Group
Rochester, New York
client
Riveredge Resort

C - 0	C - 0
M - 100	M - 23
Y - 65	Y - 100
K - 47	K - 27

C - 85	C - 75
M - 14	M - 60
Y - 29	Y - 49
K - 7	K - 51

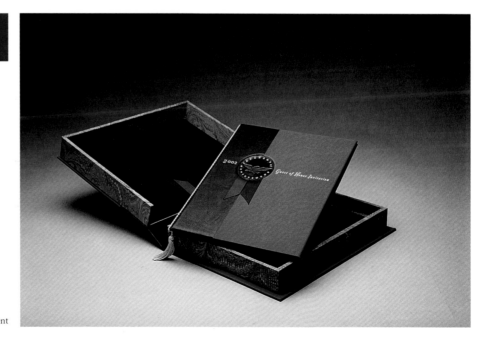

design firm
Dever Designs
Laurel, Maryland
client
Academy of Achievement

Creative Matter | *volume 2*

ANNUAL REPORTS

design firm
Rule29
Elgin, Illinois

client
Rule29

C - 92	C - 57	C - 0
M - 84	M - 27	M - 67
Y - 65	Y - 6	Y - 80
K - 51	K - 0	K - 0

C - 18	C - 91
M - 99	M - 86
Y - 99	Y - 90
K - 24	K - 74

design firm
Mike Salisbury L.L.C.
Venice, California

client
Polygram Record Group

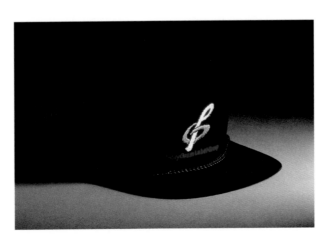

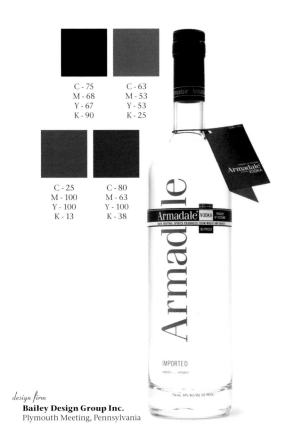

C - 75
M - 68
Y - 67
K - 90

C - 63
M - 53
Y - 53
K - 25

C - 25
M - 100
Y - 100
K - 13

C - 80
M - 63
Y - 100
K - 38

design firm
Bailey Design Group Inc.
Plymouth Meeting, Pennsylvania

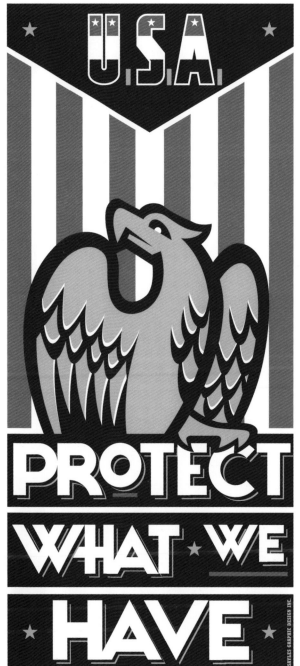

design firm
Sayles Graphic Design
Des Moines, Iowa
client
"Art Fights Back"

C - 100
M - 77
Y - 18
K - 15

C - 0
M - 89
Y - 93
K - 0

C - 0
M - 50
Y - 90
K - 0

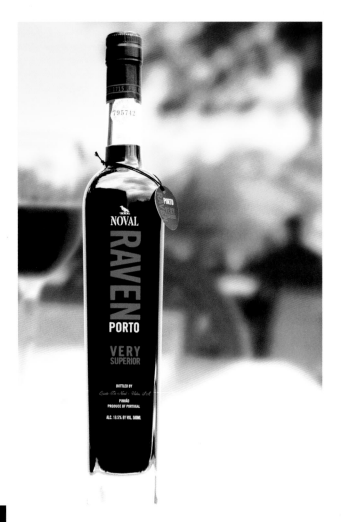

design firm
Bailey Design Group Inc.
Plymouth Meeting, Pennsylvania

C - 6 C - 0
M - 90 M - 0
Y - 100 Y - 0
K - 1 K - 100

C - 13 C - 0
M - 25 M - 0
Y - 56 Y - 0
K - 0 K - 100

design firm
Lewis Moberly
London (England)
client
Fina Flichman S.A.

FINCA FLICHMAN
WINERY

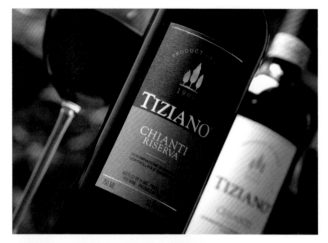

design firm
Bailey Design Group Inc.
Plymouth Meeting, Pennsylvania

C - 50
M - 100
Y - 39
K - 29

C - 55
M - 42
Y - 39
K - 6

C - 58
M - 51
Y - 37
K - 9

C - 72
M - 65
Y - 63
K - 65

design firm
Klündt Hosmer Design
Spokane, Washington
client
Linesoft

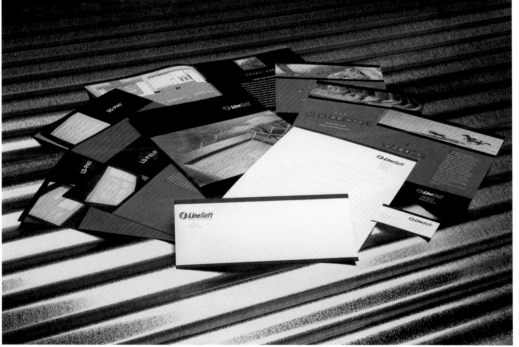

C - 47
M - 32
Y - 67
K - 47

C - 74
M - 49
Y - 12
K - 29

C - 13
M - 26
Y - 80
K - 6

C - 22
M - 82
Y - 90
K - 35

23

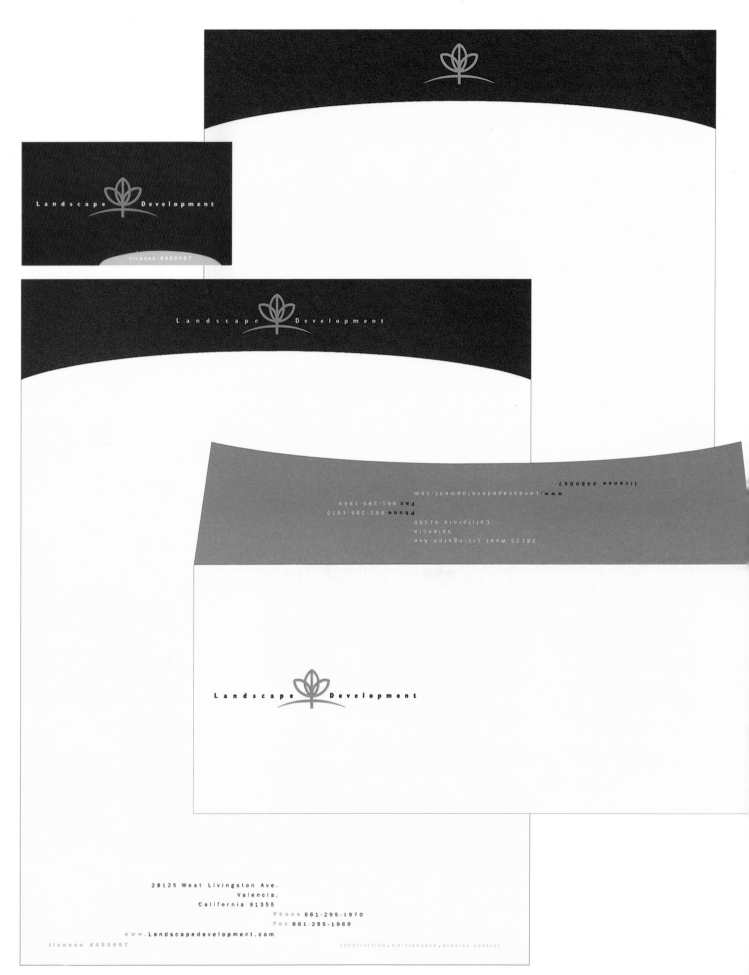

Landscape Development

license #450067

Landscape Development

28125 West Livingston Ave.
Valencia,
California 91355
Phone 661-295-1970
Fax 661-295-1969
www.Landscapedevelopment.com
license #450067

Landscape Development

28125 West Livingston Ave.
Valencia,
California 91355
Phone 661-295-1970
Fax 661-295-1969
www.Landscapedevelopment.com
license #450067 construction.maintenance.erosion control

24

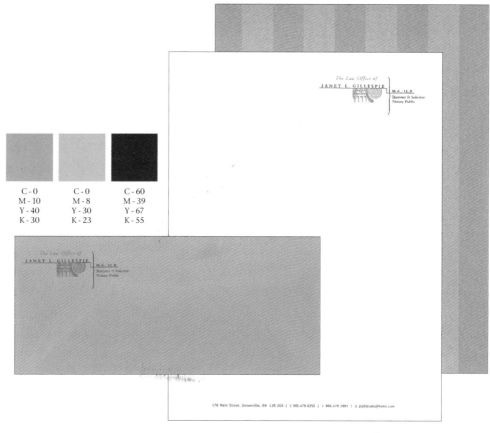

(opposite) design firm
Erbe Design
South Pasadena, California
client
Landscape Development

C - 63	C - 33	C - 1
M - 50	M - 26	M - 46
Y - 55	Y - 82	Y - 89
K - 73	K - 16	K - 0

C - 0	C - 0	C - 60
M - 10	M - 8	M - 39
Y - 40	Y - 30	Y - 67
K - 30	K - 23	K - 55

design firm
The Riordon Design Group Inc
Oakville, Ontario
(Canada)
client
Janet Gillespie Law Office

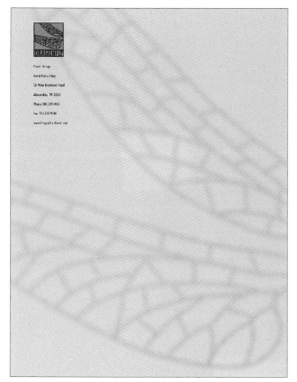

design firm
Gibson Creative
Washington, D.C.
client
Dragonfly

C - 27	C - 20
M - 19	M - 70
Y - 40	Y - 100
K - 15	K - 400

C - 0 C - 0
M - 30 M - 0
Y - 50 Y - 0
K - 10 K - 100

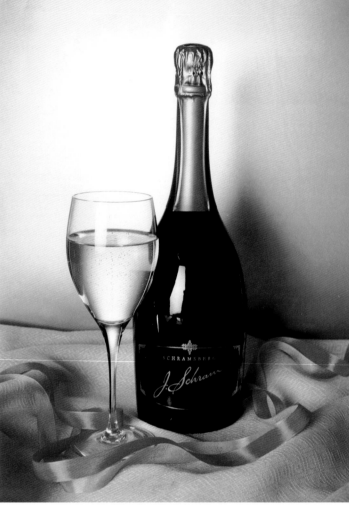

design firm
Ortega Design
St. Helena, California
client
Foppiano Vineyards

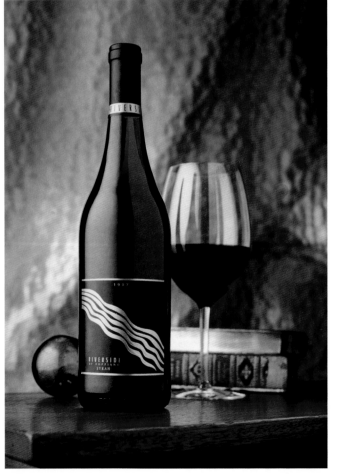

design firm
Ortega Design
St. Helena, California
client
Schramsberg Champagne Winery

C - 0 C - 0
M - 25 M - 0
Y - 30 Y - 0
K - 10 K - 100

The Signature of Quality® Awards

1999

Johnson & Johnson
The Signature of Quality

C - 0	C - 0
M - 100	M - 0
Y - 100	Y - 0
K - 0	K - 100

design firm
Checkman Design
New York, New York
client
Johnson & Johnson

C - 93
M - 33
Y - 85
K - 23

C - 65
M - 1
Y - 95
K - 0

design firm
Becker Design
Milwaukee, Wisconsin
client
Jarmuz

C - 30
M - 9
Y - 56
K - 0

C - 24
M - 10
Y - 3
K - 0

C - 19
M - 31
Y - 5
K - 0

C - 29
M - 27
Y - 55
K - 1

C - 20
M - 37
Y - 34
K - 0

design firm
Louis & Partners Design
Bath, Ohio
client
Souper Salad

C - 33	C - 62	C - 0	C - 31	C - 1
M - 86	M - 18	M - 27	M - 31	M - 82
Y - 23	Y - 35	Y - 93	Y - 90	Y - 72
K - 17	K - 11	K - 0	K - 20	K - 0

design firm
Compass Design
Minneapolis, Minnesota

C - 37	C - 7
M - 65	M - 14
Y - 54	Y - 80
K - 51	K - 1

design firm
Klündt Hosmer Design
Spokane, Washington
client
Maryhill Winery

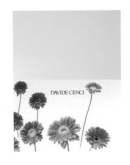

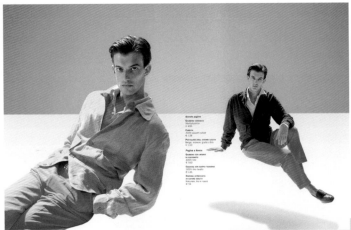

design firm
Tangram Strategic Design
Novara (Italy)
client
Davide Cenci

C - 5
M - 81
Y - 90
K - 1

C - 0
M - 21
Y - 84
K - 1

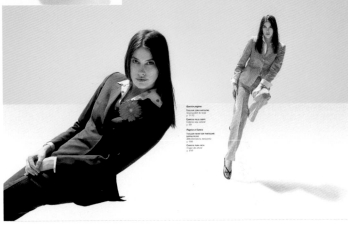

design firm
**Hornall Anderson
Design Works**
Seattle, Washington

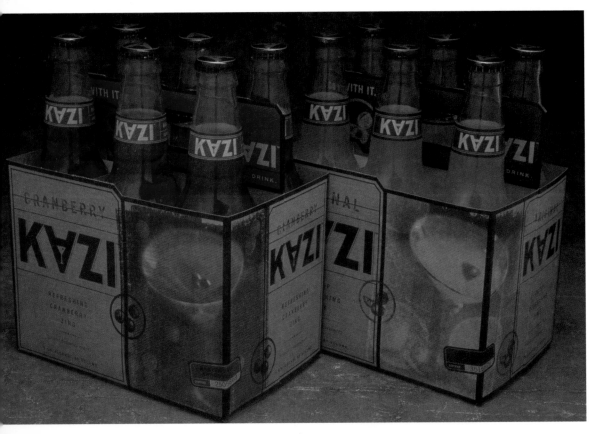

C - 25
M - 47
Y - 63
K - 15

C - 4
M - 87
Y - 69
K - 30

C - 25
M - 27
Y - 75
K - 63

design firm
**Hornall Anderson
Design Works**
Seattle, Washington

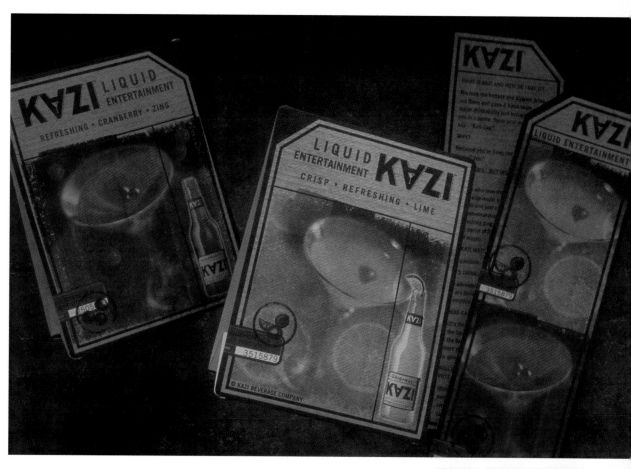

C - 25	C - 4	C - 25
M - 47	M - 87	M - 27
Y - 63	Y - 69	Y - 75
K - 15	K - 30	K - 63

C - 100	C - 0	C - 0	C - 30
M - 94	M - 30	M - 84	M - 95
Y - 34	Y - 87	Y - 70	Y - 63
K - 27	K - 0	K - 0	K - 22

design firm
Pearlfisher
London (England)

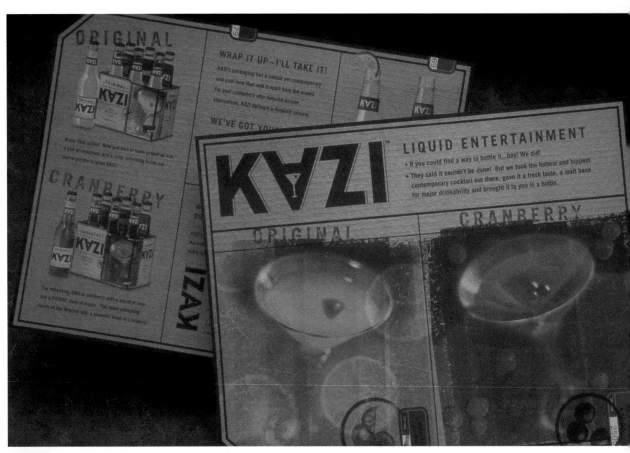

design firm
Hornall Anderson Design Works
Seattle, Washington

C - 25
M - 47
Y - 63
K - 15

C - 4
M - 87
Y - 69
K - 30

C - 25
M - 27
Y - 75
K - 63

design firm
Pearlfisher
London (England)

C - 18
M - 79
Y - 7
K - 0

C - 63
M - 7
Y - 99
K - 0

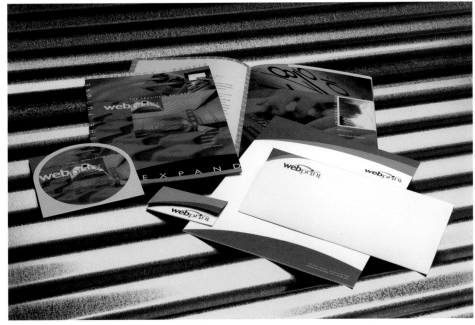

C - 17	C - 62	C - 12	C - 58
M - 12	M - 82	M - 91	M - 18
Y - 97	Y - 20	Y - 86	Y - 94
K - 3	K - 22	K - 2	K - 11

design firm
Klündt Hosmer Design
Spokane, Washington
client
Webprint

design firm
Hornall Anderson Design Works
Seattle, Washington

C - 25	C - 4	C - 25
M - 47	M - 87	M - 27
Y - 63	Y - 69	Y - 75
K - 15	K - 30	K - 63

C - 81　　C - 21
M - 58　　M - 3
Y - 0　　　Y - 1
K - 0　　　K - 0

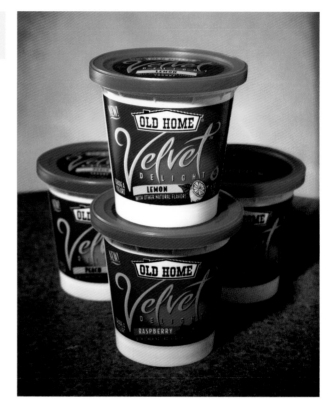

design firm
Compass Design
Minneapolis, Minnesota

C - 13　　C - 73　　C - 0
M - 88　　M - 52　　M - 0
Y - 63　　Y - 0　　Y - 98
K - 5　　　K - 0　　K - 0

design firm
Cassata & Associates
Schaumbug, Illinois
client
Wm Wrigley Jr. Company

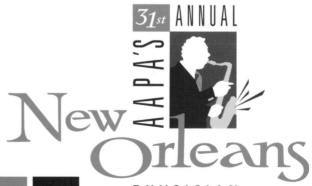

design firm
Dever Designs
Laurel, Maryland
client
American Academy
of Physician Assistants

C - 10　　C - 75　　C - 90
M - 100　M - 0　　M - 100
Y - 10　　Y - 80　　Y - 0
K - 15　　K - 0　　K - 0

31st ANNUAL

AAPA'S

New Orleans

PHYSICIAN
ASSISTANT
CONFERENCE

May 22-27, 2003

34

fresh

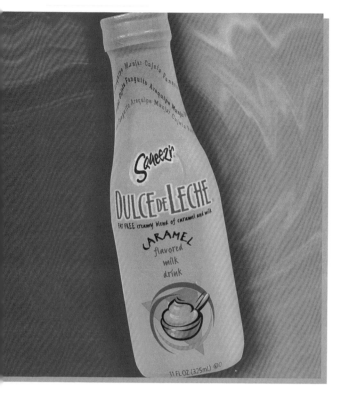

C - 49	C - 16	C - 5	C - 72
M - 98	M - 58	M - 100	M - 51
Y - 2	Y - 92	Y - 96	Y - 13
K - 0	K - 0	K - 18	K - 14

design firm
s²design Group
New York, New York

client
Brooklyn Bottling

Jamie Stedman-Novo Tel 646 486 7470

design firm
Compass Design
Minneapolis, Minnesota

C - 78	C - 87	C - 16
M - 48	M - 47	M - 43
Y - 0	Y - 11	Y - 61
K - 0	K - 12	K - 6

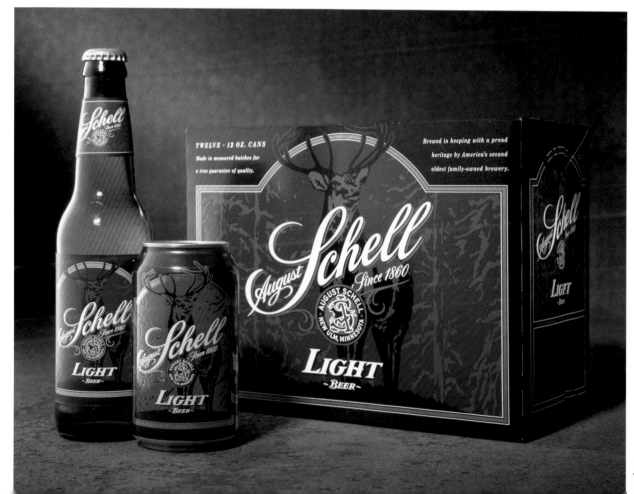

35

C - 16	C - 0	C - 100	C - 61
M - 100	M - 0	M - 71	M - 95
Y - 85	Y - 100	Y - 0	Y - 76
K - 0	K - 0	K - 0	K - 56

design firm
Bailey Design Group Inc.
Plymouth Meeting, Pennsylvania

C - 62	C - 62	C - 13
M - 82	M - 31	M - 70
Y - 20	Y - 0	Y - 99
K - 22	K - 0	K - 3

design firm
Compass Design
Minneapolis, Minnesota

C - 82	C - 0	C - 5
M - 0	M - 13	M - 100
Y - 82	Y - 91	Y - 98
K - 20	K - 0	K - 24

design firm
McElveney & Palozzi Design Group
Rochester, New York
client
Sun Orchard Brand

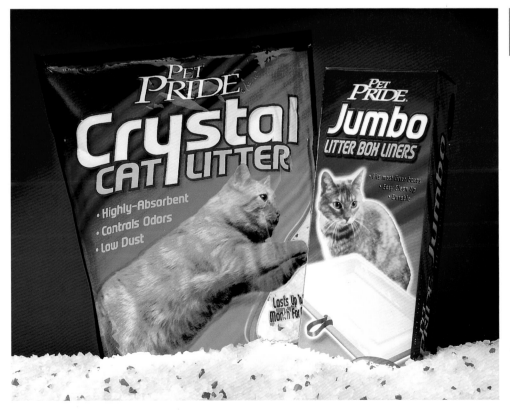

C - 75	C - 20	C - 96
M - 1	M - 0	M - 58
Y - 99	Y - 91	Y - 1
K - 0	K - 0	K - 0

design firm
Interbrand Hulefeld
Cincinnati, Ohio
client
Kroger Company

37

C - 0 M - 100 Y - 100 K - 0	C - 80 M - 0 Y - 100 K - 0	C - 100 M - 50 Y - 0 K - 0

C - 0 M - 50 Y - 100 K - 0	C - 0 M - 10 Y - 100 K - 0	C - 39 M - 80 Y - 0 K - 0

SAN FRANCISCO MUSEUM OF MODERN ART

SAN FRANCISCO MUSEUM OF MODERN ART

design firm
Michael Osborne Design
San Francisco, California
client
San Francisco Museum of Modern Art

design firm
Sayles Graphic Design
Des Moines, Iowa
client
"Art Fights Back"

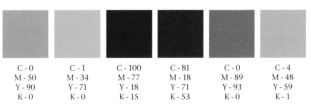

C - 0 M - 50 Y - 90 K - 0	C - 1 M - 34 Y - 71 K - 0	C - 100 M - 77 Y - 18 K - 15	C - 81 M - 18 Y - 71 K - 53	C - 0 M - 89 Y - 93 K - 0	C - 4 M - 48 Y - 59 K - 1

P. O. Box 495
Monterey, CA 93942

831.373.3000
Fax 831.620.1845

www.ComputerRepairExpress.com

C - 1
M - 96
Y - 89
K - 0

C - 69
M - 91
Y - 2
K - 0

C - 2
M - 13
Y - 92
K - 0

P. O. Box 495
Monterey, CA 93942

831.373.3000
Fax 831.620.1845

MICHAEL ANTONCICH

www.ComputerRepairExpress.com

design firm
The Wecker Group
Monterey, California
client
Computer Repair Express

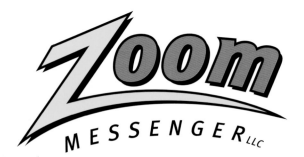

Get it there.

P.O. Box 1834 Milwaukee, Wisconsin 53201 Phone 414 289 9999 Fax 414 289 8388

Get it there.

Zoom Messenger, LLC
P.O. Box 1834
Milwaukee, WI 53201

C - 2 C - 3
M - 91 M - 1
Y - 76 Y - 91
K - 0 K - 0

design firm
Becker Design
Milwaukee, Wisconsin
client
Zoom Messenger

exciting

"and I, if I be lifted up from the earth will draw all men to myself." John 12:32

JESUS lifted high

This year Cook Communications Ministries, will host three worship together/children's worship & discipleship conferences in Canada. Each conference is two conferences (Worship Together & Children's Worship and Discipleship) simultaneously at the same venue. There will be several general sessions that the delegates from both conferences will attend together for times of refreshing and inspiration. The registration fee for one conference will allow delegates to chose workshops from either conference.

For Example: You are attending the Vancouver conference. You are a CE Director, and your plan is to focus most of your time at the Children's Worship & Discipleship conference. As you look through the workshop listings, you would also like to hear Mike Pilavachi & Matt Redman's workshop on "The Heart of Worship" as found at the Worship Together conference. Or perhaps you're a worship pastor attending the conference and you want to hear Bob Hartman's workshop on "The Art of Storytelling" as found at the Children's Worship & Discipleship conference. We have good news! You will be able to attend these sessions at no extra cost. It truly is two conferences in one!

This year, Alpha Canada will be joining us and running workshops for those interested in learning more about Alpha.

WORSHIP TOGETHER

Conference Sponsor, Publisher of:
Cook
COMMUNICATIONS MINISTRIES
Cook Communications Ministries > Box 98, 55 Woodslee Avenue > Paris, ON N3L 3E5

JESUS lifted high

WORSHIP TOGETHER

Great Ideas For Worship >
Worship for Small Groups · Personal Worship · Creative Expression in Worship · Senior Pastor as Head Worship Leader · The Pastors Point of View · Out of the Abundance · Ways to Get Inspired for Song Writing · Worship Leader or Lead Worshiper? Looking at the Holy Spirit as the Ultimate Worship Leader and What This Means for Us · Finding God in the Desert · Worship & Evangelism · Worship & the Fatherhood of God · Commanded Blessing, Worship, Healing & Reconciliation · Songwriting a "Practical" Focus · Songwriting Panel · Creative Worship Concepts · Actor's Improvisation · Script Writing · Basics in Acting · Hands-on Directing

PA & Sound · Be equipped, informed & resourced >
Basic Sound Systems · Successful Soundchecks · Overcoming Acoustic Problems · Recording Techniques · Mixing Skills

Developing the Heart of a Worship Leader >
The Father Heart of God · Intimacy with the Father · Developing the Heart of a Worship Leader

Revival Generation · Aimed specifically, but not exclusively, at people involved in youth worship
How to be a Worship Leader Without Being a Donkey · Writing Songs for a New Generation · The Heart of Worship · Worship & Evangelism · Worship & Contemporary Culture · The Modern Worship Band · Walking on the Wild Side · Leading Worship on a Band · Rearranging songs in Modern Music Styles · Computer-Based Recording

Releasing the Prophetic in Worship
Worship & Intercession · Prophecy · the Biblical Pattern · Spiritual Songs · How to Prophecy in Song · The Heart of the Musical Prophet · Spontaneity & Creativity in Worship

Leading in Worship · Foundational skills for the worship leader
The Senior Pastor as Head Worship Leader · How to Excel as a Worship Leader · Breaking Out of the 'Verse-Chorus' Rut · Rhythm of the Saints · Worship Group Skills · Worship Group Leadership · Come & Learn New Songs · Transitioning from Traditional to Contemporary Worship · The Arts in Worship · Drama in Worship · Rehearsing the Band · Surviving the Worship Wars

Musical Skills
Keyboards Masterclass · Vocals Masterclass · Acoustic Guitar Master Class

Sharpen your skills by joining us for 8 General Sessions and go home even further equipped having chosen from over 40 Seminars, Panels, and Workshops.

WORKSHOPS

CHILDREN'S WORSHIP & DISCIPLESHIP

Communications
· Drama for Kids · Surviving an All-Age Service · Writing for Children · Incorporating Stories, Songs & Prayers in an All-Age Service · Puppets in the Classroom · Puppet Manipulation · Illusions You Can Make & Use · Children & Creativity · The Theology of Storytelling · The Art of Storytelling

Children and Worship
· Worship for 21st Century Kids · Writing Songs for Children · Discipling Through Dance · Children Serving Others · What is God Doing with Kids · Preschool Worship · Working with a Children's Worship Band · The Purpose of Flags · Flag Ideas You Can Use

Foundations
· Generation X's Children · Brain Growth · Church in a Postmodern World · A Safe Place

Discipleship
· Shepherding Children · Linking Church & Home · The Spiritual Journey of a Child · Prayer with Children · Prayer Ideas

Special Interest/Misc.
· Big Ideas for Small Churches · Children & the Holy Spirit *and more*

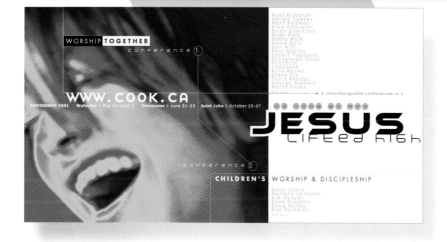

WORSHIP TOGETHER
conference 1

WWW.COOK.CA
CONFERENCES 2001 Waterloo > May 31-June 2 Vancouver > June 21-23 Saint John > October 25-27

Noel Richards
Gerald Coates
Matt Redman
Mike Pilavachi
Brian Doerksen
Andy Park
Bobby Mark
David Ruis
Dan Wilt
Paul Oakley
Stuart Townend
Stoneleigh Band
Phatfish
Capstone
Russ Rosen
Steve Fry
Tricia Rhodes
George Baldwin
Marty Parks

· 2 interchangeable conferences in 1

JESUS lifted high

conference 2
CHILDREN'S WORSHIP & DISCIPLESHIP

Dean Stone
Marlene Le Fever
Kim Mester
Dave Roberts
Doug Horley
Bob Hartman

design firm
The Riordon Design Group Inc.
Oakville, Ontario
(Canada)

C - 0	C - 0	C - 90	C - 0	C - 0
M - 100	M - 60	M - 100	M - 100	M - 15
Y - 20	Y - 80	Y - 0	Y - 100	Y - 100
K - 0	K - 0	K - 0	K - 0	K - 10

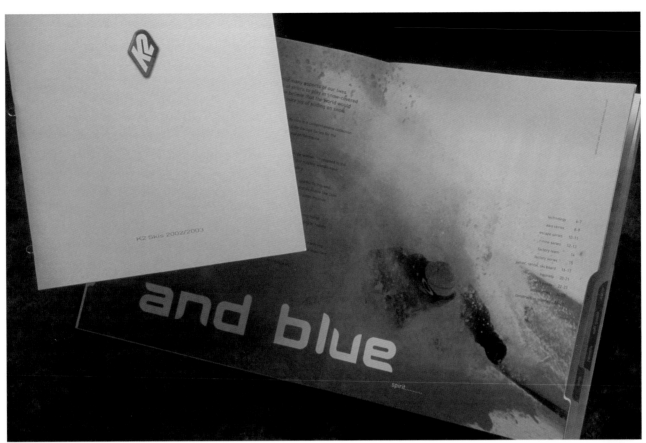

design firm
Hornall Anderson Design Works
Seattle, Washington

C - 12 C - 45
M - 72 M - 49
Y - 59 Y - 45
K - 37 K - 35

IVARA
WORK SMART

C - 55 C - 14
M - 19 M - 0
Y - 0 Y - 50
K - 46 K - 30

design firm
The Riordon Group Inc.
Oakville, Ontario
(Canada)

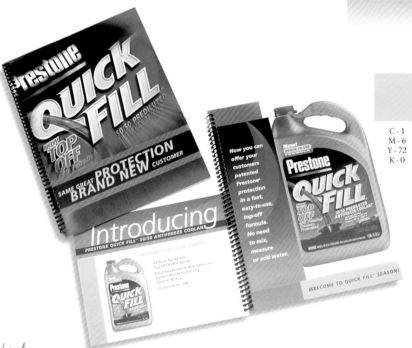

design firm
Tom Fowler, Inc.
Norwalk, Connecticut

client
Honeywell Consumer Products

C - 1	C - 0	C - 86	C - 33
M - 6	M - 83	M - 58	M - 44
Y - 72	Y - 99	Y - 0	Y - 74
K - 0	K - 0	K - 0	K - 8

design firm
DGWB
Santa Ana, California

client
South Coast Plaza

C - 53	C - 63
M - 84	M - 52
Y - 0	Y - 51
K - 0	K - 100

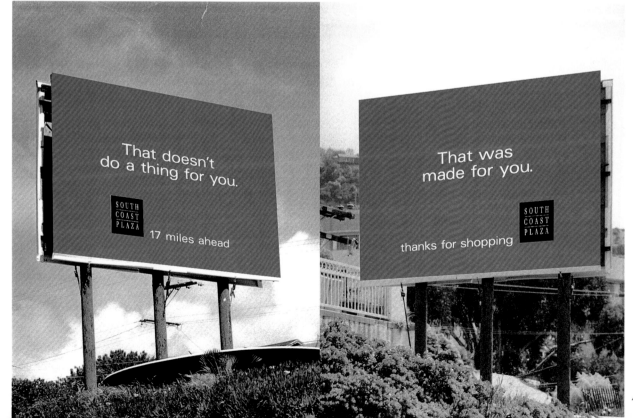

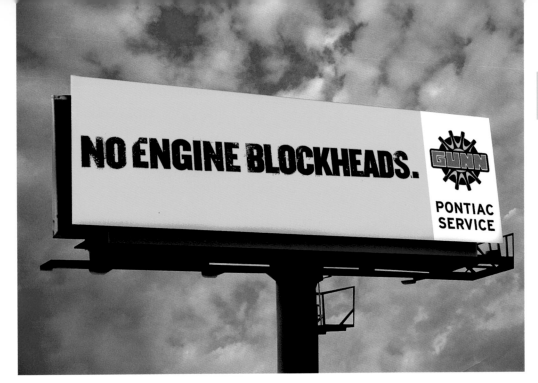

C - 0
M - 27
Y - 96
K - 0

C - 0
M - 99
Y - 82
K - 12

C - 0
M - 0
Y - 0
K - 100

design firm
Toolbox Studios, Inc.
San Antonio, Texas
client
Gunn Automotive

C - 53
M - 85
Y - 16
K - 0

C - 0
M - 25
Y - 94
K - 0

C - 48
M - 7
Y - 89
K - 0

C - 0
M - 66
Y - 99
K - 0

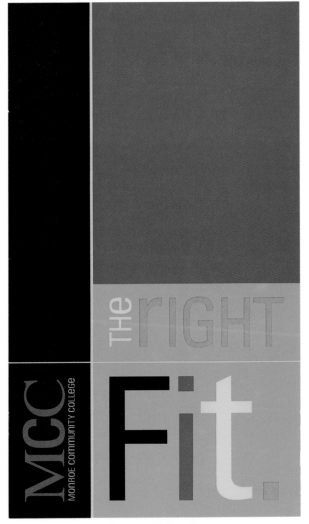

design firm
Buck & Pulleyn
Pittsford, New York
client
MCC

44

C - 69
M - 65
Y - 0
K - 31

C - 0
M - 79
Y - 94
K - 0

C - 0
M - 31
Y - 94
K - 0

design firm
Greteman Group
Wichita, Kansas

design firm
Funk/Levis & Associates
Eugene, Oregon
client
Sony

C - 18
M - 12
Y - 89
K - 3

C - 79
M - 83
Y - 1
K - 0

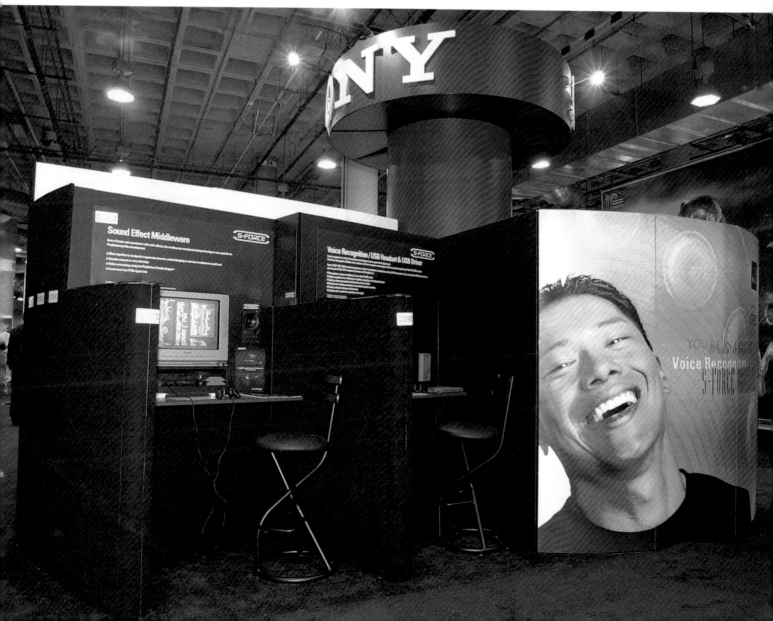

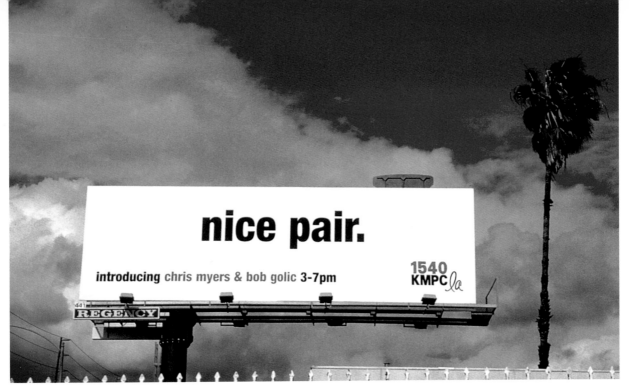

nice pair.

introducing chris myers & bob golic 3-7pm

1540 KMPC *la*

design firm
Campbell-Ewald Advertising
Warren, Michigan
client
KMPC Sporting News

C - 25	C - 0
M - 76	M - 0
Y - 50	Y - 0
K - 4	K - 100

C - 98	C - 8	C - 0
M - 69	M - 98	M - 25
Y - 0	Y - 92	Y - 68
K - 3	K - 1	K - 23

MAKING *History*
ONE PERSON
AT A TIME

design firm
Dotzler Creative Arts
Omaha, Nebraska

C - 0	C - 0
M - 99	M - 0
Y - 95	Y - 0
K - 11	K - 100

red**graf!x**
design&illustration studio

design firm
Redgrafix Design & Illustration Studio
New Berlin, Wisconsin
client
Redgrafix Design & Illustration Studio

ADVERTISING FEDERATION

C - 26
M - 99
Y - 73
K - 20

design firm
Mark Oliver, Inc.
Solvang, California
client
Santa Barbara Ad Federation

C - 25	C - 0	C - 90	C - 0
M - 0	M - 100	M - 65	M - 35
Y - 95	Y - 100	Y - 0	Y - 100
K - 27	K - 22	K - 15	K - 0

design firm
McElveney & Palozzi Design Group
Rochester, New York
client
Empire Forster

design firm
Kontrapunkt
Ljubljana (Slovenia)
client
Ministry for European Integration, Croatia

C - 12	C - 62
M - 91	M - 51
Y - 86	Y - 49
K - 2	K - 63

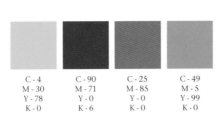

C - 4 C - 90 C - 25 C - 49
M - 30 M - 71 M - 85 M - 5
Y - 78 Y - 0 Y - 0 Y - 99
K - 0 K - 6 K - 0 K - 0

design firm
ProWolfe Partners
St. Louis, Missouri
client
Tripos

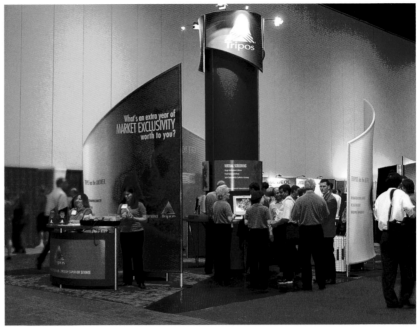

C - 45 C - 5
M - 25 M - 15
Y - 57 Y - 68
K - 0 K - 0

design firm
McClain Finlon Advertising
Denver, Colorado
client
Mutual UFO Network Museum

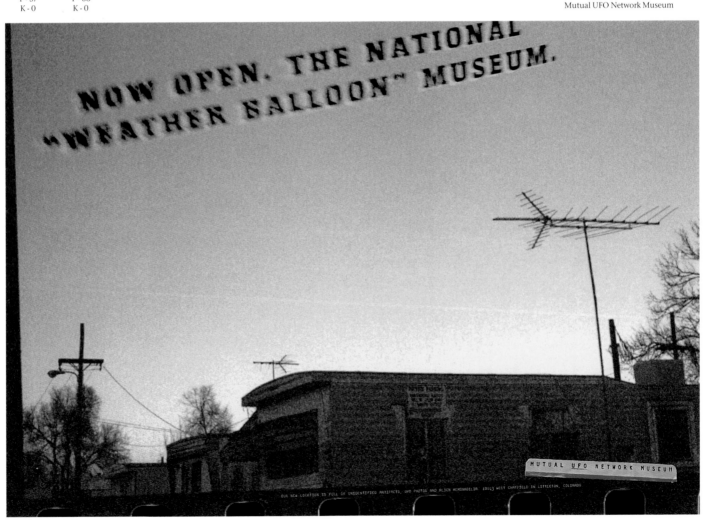

C - 4
M - 41
Y - 96
K - 0

C - 82
M - 92
Y - 6
K - 1

C - 6
M - 100
Y - 99
K - 1

C - 74
M - 29
Y - 100
K - 15

design firm
Bailey Design Group Inc.
Plymouth Meeting, Pennsylvania

C - 0
M - 39
Y - 93
K - 0

C - 0
M - 96
Y - 80
K - 1

C - 66
M - 58
Y - 5
K - 0

C - 47
M - 30
Y - 92
K - 0

design firm
Lawrence & Ponder Ideaworks
Newport Beach, California
client
Lawrence & Ponder Ideaworks

design firm
Belyea
Seattle, Washington
client
ColorGraphics

C - 27	C - 44	C - 71	C - 0	C - 100
M - 81	M - 17	M - 20	M - 13	M - 80
Y - 55	Y - 65	Y - 13	Y - 64	Y - 0
K - 4	K - 2	K - 0	K - 0	K - 12

C - 0	C - 75	C - 3
M - 100	M - 75	M - 20
Y - 100	Y - 0	Y - 54
K - 0	K - 0	K - 0

design firm
Tom Ventress Design
Nashville, Tennessee
client
Synergy Business Environments

COVANCE™

design firm
Addison
San Francisco, California
client
Covance

C - 91	C - 1
M - 9	M - 93
Y - 11	Y - 65
K - 0	K - 0

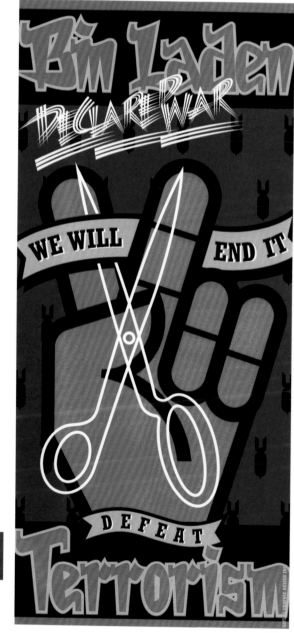

design firm
Sayles Graphic Design
Des Moines, Iowa
client
"Art Fights Back"

C - 0	C - 0	C - 61
M - 89	M - 50	M - 31
Y - 93	Y - 90	Y - 83
K - 0	K - 0	K - 54

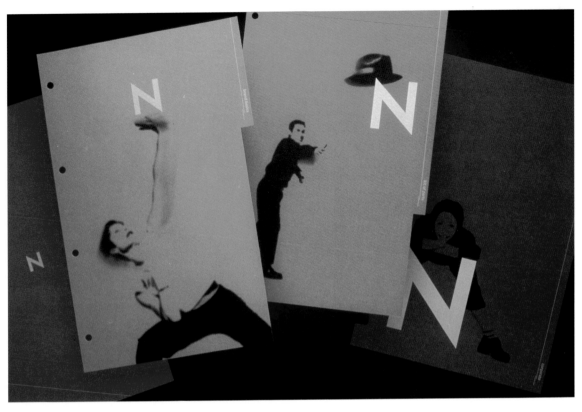

C - 0
M - 90
Y - 73
K - 0

C - 0
M - 68
Y - 78
K - 0

C - 15
M - 69
Y - 52
K - 55

design firm
**Hornall Anderson
Design Works**
Seattle, Washington

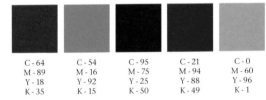

C - 64
M - 89
Y - 18
K - 35

C - 54
M - 16
Y - 92
K - 15

C - 95
M - 75
Y - 25
K - 50

C - 21
M - 94
Y - 88
K - 49

C - 0
M - 60
Y - 96
K - 1

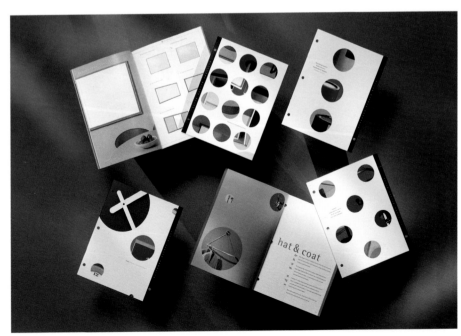

design firm
5D Studio
Malibu, California

client
Peter Pepper Products

C - 0
M - 57
Y - 87
K - 0

C - 0
M - 0
Y - 100
K - 0

design firm
Greteman Group
Wichita, Kansas

C - 27
M - 0
Y - 63
K - 0

C - 80
M - 67
Y - 67
K - 50

C - 3
M - 0
Y - 49
K - 0

C - 0
M - 49
Y - 80
K - 0

design firm
Louis & Partners Design
Bath, Ohio
client
Sound Addict

design firm
Klündt Hosmer Design
Spokane, Washington
client
Webprint

C - 35
M - 100
Y - 0
K - 0

C - 55
M - 0
Y - 100
K - 0

C - 0
M - 0
Y - 0
K - 100

C - 13　C - 33　C - 97
M - 72　M - 85　M - 100
Y - 88　Y - 37　Y - 22
K - 3　　K - 55　K - 7

design firm
Mobium Creative Group
Chicago, Illinois

client
Neovation

design firm
Pinkhaus
Miami, Florida

client
Wolfsonian Institute

C - 40　　C - 0
M - 2　　M - 0
Y - 93　　Y - 0
K - 1　　K - 100

exciting

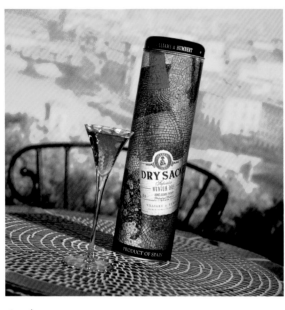

C - 78	C - 0	C - 13	C - 95	C - 1
M - 30	M - 75	M - 100	M - 81	M - 11
Y - 100	Y - 99	Y - 100	Y - 49	Y - 98
K - 19	K - 0	K - 7	K - 21	K - 0

design firm
Bailey Design Group Inc.
Plymouth Meeting, Pennsylvania

C - 54	C - 10
M - 72	M - 10
Y - 0	Y - 10
K - 0	K - 1

design firm
Dentz & Cristina
New York, New York
client
Paco Rabanne

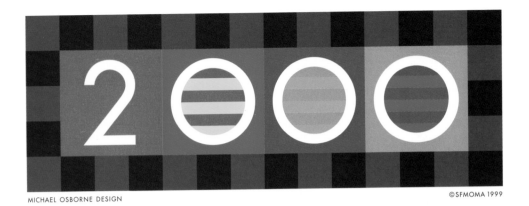

MICHAEL OSBORNE DESIGN

©SFMOMA 1999

SAN FRANCISCO MUSEUM OF MODERN ART

design firm
Michael Osborne Design
San Francisco, California
client
San Francisco Museum of Modern Art

C - 0	C - 100	C - 70	C - 0	C - 39
M - 100	M - 10	M - 70	M - 65	M - 5
Y - 100	Y - 0	Y - 0	Y - 87	Y - 100
K - 0	K - 0	K - 0	K - 0	K - 0

C - 5	C - 1	C - 68
M - 91	M - 47	M - 13
Y - 93	Y - 69	Y - 6
K - 0	K - 0	K - 1

design firm
Becker Design
Milwaukee, Wisconsin
client
GraphicSource

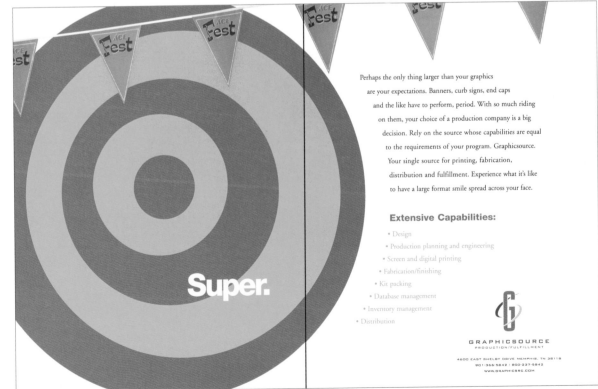

Perhaps the only thing larger than your graphics
are your expectations. Banners, curb signs, end caps
and the like have to perform, period. With so much riding
on them, your choice of a production company is a big
decision. Rely on the source whose capabilities are equal
to the requirements of your program. Graphicsource.
Your single source for printing, fabrication,
distribution and fulfillment. Experience what it's like
to have a large format smile spread across your face.

Extensive Capabilities:

• Design
• Production planning and engineering
• Screen and digital printing
• Fabrication/finishing
• Kit packing
• Database management
• Inventory management
• Distribution

Super.

GRAPHICSOURCE
PRODUCTION/FULFILLMENT

4600 EAST SHELBY DRIVE MEMPHIS, TN 38118
901-366-5842 | 800-237-5842
WWW.GRAPHICSRC.COM

C - 0
M - 40
Y - 90
K - 0

C - 100
M - 50
Y - 0
K - 0

C - 30
M - 70
Y - 0
K - 10

C - 30
M - 0
Y - 100
K - 0

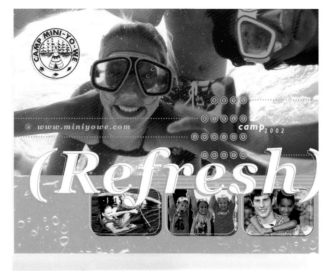

design firm
The Riordon Design Group Inc.
Oakville, Ontario
(Canada)

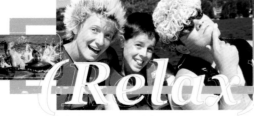

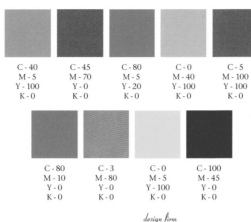

C - 40
M - 5
Y - 100
K - 0

C - 45
M - 70
Y - 0
K - 0

C - 80
M - 5
Y - 20
K - 0

C - 0
M - 40
Y - 100
K - 0

C - 5
M - 100
Y - 100
K - 0

C - 80
M - 10
Y - 0
K - 0

C - 3
M - 80
Y - 0
K - 0

C - 0
M - 5
Y - 100
K - 0

C - 100
M - 45
Y - 0
K - 0

design firm
Michael Osborne Design
San Francisco, California

LOVE 37 USA

sing to me...

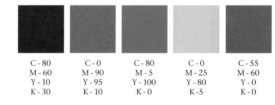

C - 80
M - 60
Y - 10
K - 30

C - 0
M - 90
Y - 95
K - 10

C - 80
M - 5
Y - 100
K - 0

C - 0
M - 25
Y - 80
K - 5

C - 55
M - 60
Y - 0
K - 0

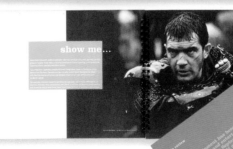

show me...

The late Kurt Cobain
of the group Nirvana
threw down the gauntlet
for a whole generation
when he said:
"Here we are now,
entertain us."

Corus Entertainment has
accepted that challenge.
Through its versatile and
inventive programming and
content, Corus has established
a connection to its audiences,
capturing their hearts, minds
and imaginations.

enter

design firm
The Riordon Design Group Inc.
Oakville, Ontario
(Canada)
client
Corus Entertainment

58

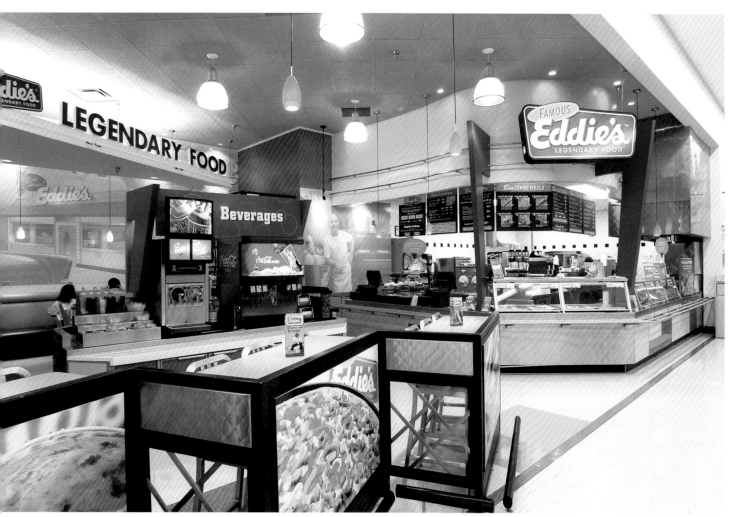

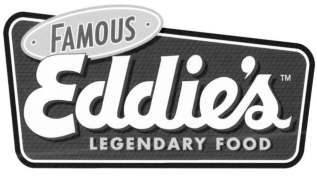

C - 0	C - 0	C - 100	C - 47
M - 100	M - 9	M - 56	M - 95
Y - 91	Y - 94	Y - 0	Y - 93
K - 0	K - 0	K - 34	K - 22

design firm
Louis & Partners Design
Bath, Ohio

client
Famous Eddie's

MONTEREY
SPORTS CENTER

C - 50	C - 0	C - 100	C - 100
M - 100	M - 100	M - 0	M - 50
Y - 0	Y - 50	Y - 100	Y - 0
K - 0	K - 0	K - 0	K - 0

design firm
The Wecker Group
Monterey, California
client
Monterey Sports Center

C - 1	C - 15	C - 66
M - 96	M - 12	M - 80
Y - 89	Y - 9	Y - 0
K - 0	K - 0	K - 0

C - 50	C - 0	C - 60
M - 0	M - 30	M - 4
Y - 0	Y - 100	Y - 80
K - 0	K - 0	K - 0

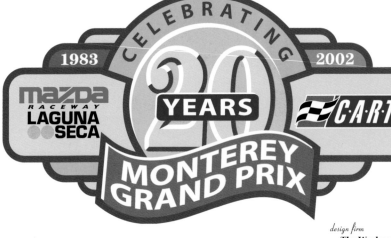

design firm
The Wecker Group
Monterey, California

design firm
Stan Gellman Graphic Design
St. Louis, Missouri

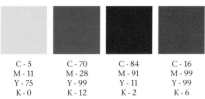

C - 5	C - 70	C - 84	C - 16
M - 11	M - 28	M - 91	M - 99
Y - 75	Y - 99	Y - 11	Y - 99
K - 0	K - 12	K - 2	K - 6

JIM PINCKNEY

137 Littlefield Road
Monterey, CA
93940
Tel 831-375-1964
Fax 831-375-1676
Email jim@jimpinckney.com
jimpinckney.com

design firm
The Wecker Group
Monterey, California
client
Pinckney Photography

C - 100
M - 100
Y - 100
K - 0

C - 33
M - 24
Y - 15
K - 0

C - 0
M - 100
Y - 100
K - 0

C - 0
M - 0
Y - 100
K - 0

C - 50
M - 0
Y - 100
K - 0

C - 75
M - 0
Y - 0
K - 0

C - 100
M - 20
Y - 0
K - 0

C - 35
M - 90
Y - 0
K - 0

C - 65
M - 80
Y - 0
K - 0

JIM PINCKNEY

137 Littlefield Road
Monterey, CA
93940

JIM PINCKNEY

137 Littlefield Road
Monterey, CA
93940
Tel 831-375-1964
Fax 831-375-1676
Email jim@jimpinckney.com
jimpinckney.com

C - 7
M - 19
Y - 0
K - 50

C - 18
M - 61
Y - 81
K - 0

C - 43
M - 0
Y - 30
K - 27

Woof!

design firm
After Hours Creative
Phoenix, Arizona

62

World Wide Packets®
ACCESS BRILLIANCE

design firm
Klündt Hosmer Design
Spokane, Washington
client
WorldWide Packets

C - 100	C - 30
M - 50	M - 45
Y - 5	Y - 80
K - 15	K - 30

EXPRESS
Theatre
n o r t h w e s t

design firm
Klündt Hosmer Design
Spokane, Washington
client
Express Theatre

C - 100	C - 15	C - 4
M - 5	M - 75	M - 22
Y - 20	Y - 100	Y - 30
K - 45	K - 0	K - 0

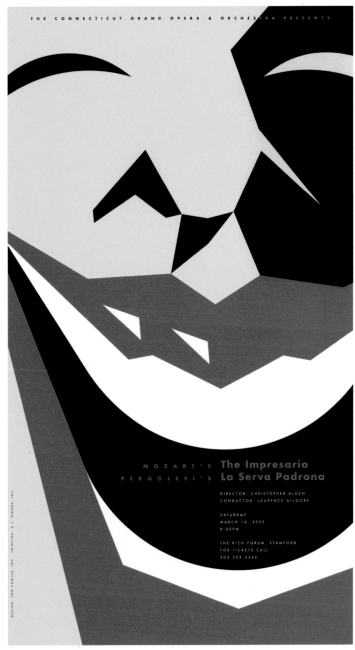

THE CONNECTICUT GRAND OPERA & ORCHESTRA PRESENTS

MOZART'S **The Impresario**
PERGOLESI'S **La Serva Padrona**

DIRECTOR: CHRISTOPHER ALDEN
CONDUCTOR: LAURENCE GILGORE

SATURDAY
MARCH 16, 2002
8:00PM

THE RICH FORUM, STAMFORD
FOR TICKETS CALL
203.325.4466

DESIGN: TOM FOWLER, INC. PRINTING: H.S. WOODS, INC.

C - 11	C - 0	C - 0
M - 98	M - 20	M - 0
Y - 85	Y - 30	Y - 0
K - 2	K - 0	K - 100

design firm
Tom Fowler, Inc.
Norwalk, Connecticut
client
Connecticut Grand Opera & Orchestra

design firm
Wallace Church, Inc.
New York, New York
client
Kodak

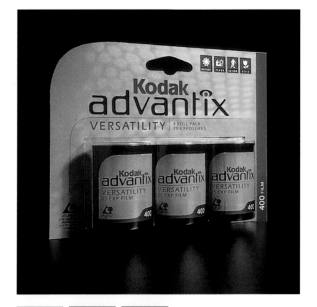

C - 0	C - 87	C - 26
M - 50	M - 47	M - 87
Y - 85	Y - 11	Y - 79
K - 0	K - 12	K - 21

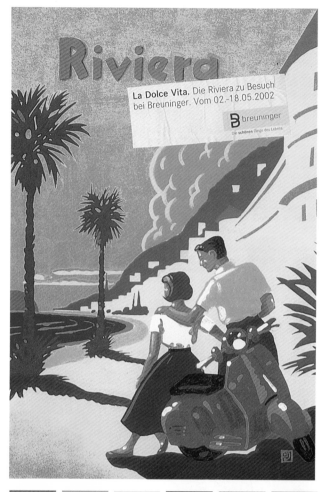

C - 9 M - 87 Y - 99 K - 0	C - 7 M - 45 Y - 99 K - 0	C - 2 M - 7 Y - 56 K - 0	C - 75 M - 34 Y - 99 K - 0	C - 61 M - 16 Y - 28 K - 0	C - 97 M - 52 Y - 2 K - 0

design firm
Heye
Unerhaching/Muchich (Germany)
client
Breuninger

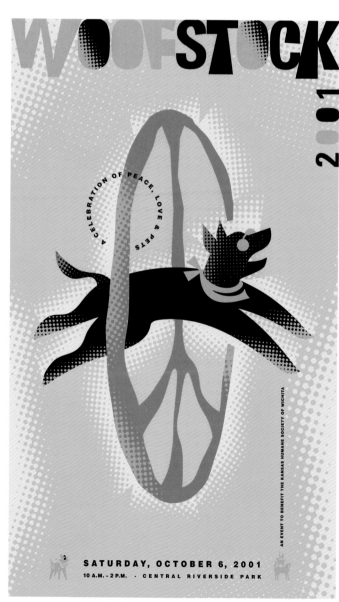

design firm
Greteman Group
Wichita, Kansas

C - 56 M - 51 Y - 0 K - 0	C - 0 M - 56 Y - 87 K - 0	C - 0 M - 30 Y - 94 K - 0	C - 2 M - 10 Y - 38 K - 0	C - 0 M - 0 Y - 0 K - 100

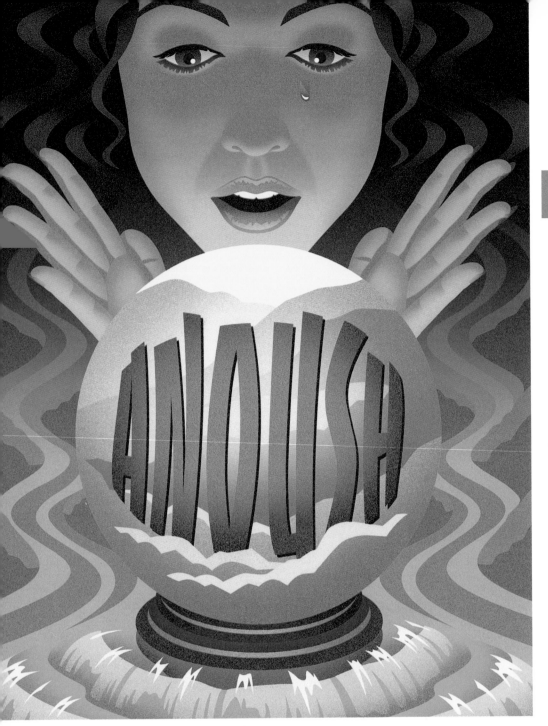

C - 60
M - 4
Y - 22
K - 0

C - 89
M - 18
Y - 76
K - 0

C - 36
M - 54
Y - 69
K - 0

C - 1
M - 0
Y - 43
K - 0

C - 25
M - 54
Y - 69
K - 0

design firm
Fusion/Design Communications
Madison Heights, Michigan
client
Michigan Opera Theatre

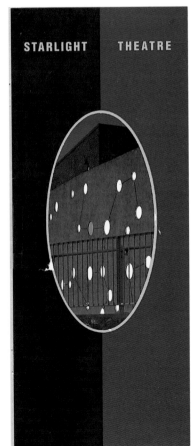

design firm
Conflux Design
Rockford, Illinois
client
Rock Valley College
Starlight Theatre

C - 84
M - 93
Y - 0
K - 0

C - 1
M - 19
Y - 96
K - 1

C - 75
M - 72
Y - 72
K - 57

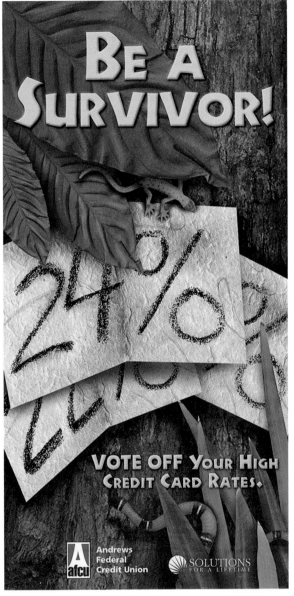

C - 73	C - 18	C - 42	C - 6
M - 37	M - 19	M - 62	M - 85
Y - 91	Y - 56	Y - 86	Y - 85
K - 0	K - 0	K - 15	K - 6

design firm
Rottman Creative Group, LLC
La Plata, Maryland
client
Andrews Federal Credit Union

C - 5	C - 85	C - 91	C - 6	C - 30	C - 0
M - 4	M - 11	M - 79	M - 6	M - 8	M - 96
Y - 30	Y - 32	Y - 1	Y - 97	Y - 96	Y - 88
K - 0	K - 0	K - 13	K - 0	K - 0	K - 6

design firm
AMP
Costa Mesa, California
client
Adjobs.com

C - 0
M - 9
Y - 86
K - 0

C - 24
M - 96
Y - 79
K - 9

C - 73
M - 16
Y - 21
K - 0

design firm
Marshall Fenn Communications
Toronto (Canada)
client
Casino Rama

C - 95
M - 99
Y - 20
K - 13

C - 17
M - 98
Y - 11
K - 0

C - 12
M - 51
Y - 21
K - 0

design firm
Pensaré Design Group, Ltd.
Washington, D.C.
client
National Cherry Blossom Festival

C - 0　　　C - 0　　　C - 0
M - 0　　　M - 0　　　M - 0
Y - 0　　　Y - 0　　　Y - 0
K - 0　　　K - 0　　　K - 100

design firm
Interbrand Hulefeld
Cincinnati, Ohio
client
Kroger Company

C - 91　　　C - 75
M - 2　　　M - 8
Y - 9　　　Y - 81
K - 0　　　K - 0

C - 18　　　C - 99
M - 99　　　M - 80
Y - 0　　　Y - 4
K - 0　　　K - 2

design firm
**Disneyland Creative
Print Services**
Anaheim, California
client
Brand Management

C - 38 C - 97
M - 99 M - 71
Y - 95 Y - 2
K - 0 K - 3

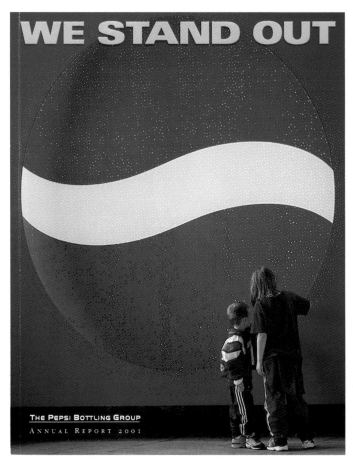

design firm
Champ Cohen Design
Del Mar, California
client
Abbott Animal Health

design firm
Davidoff Associates Inc.
New York, New York
client
The Pepsi Bottling Group, Inc.

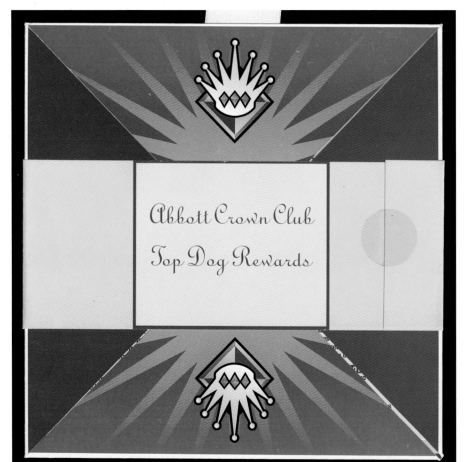

C - 0 C - 0 C - 80 C - 0
M - 99 M - 73 M - 96 M - 19
Y - 89 Y - 95 Y - 0 Y - 75
K - 9 K - 0 K - 0 K - 0

design firm
Bridge Creative Inc.
Kennebunk, Maine

client
Stu Small

C - 0 M - 98 Y - 97 K - 1	C - 35 M - 56 Y - 8 K - 0

C - 92 M - 68 Y - 10 K - 6	C - 8 M - 35 Y - 63 K - 0	C - 0 M - 11 Y - 98 K - 0

C - 88 M - 84 Y - 0 K - 9	C - 76 M - 53 Y - 73 K - 22	C - 0 M - 22 Y - 95 K - 0

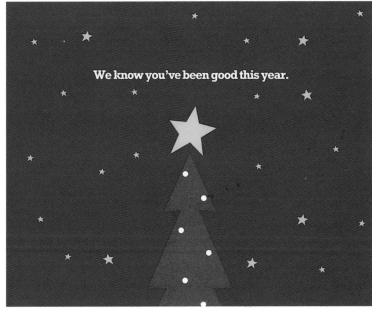

We know you've been good this year.

design firm
[i]e design, Los Angeles
Manhattan Beach, California

client
[i]e design, Los Angeles

design firm
Sterrett Dymond Stewart Advertising
Charlotte, North Carolina

client
Sterrett Dymond Stewart Advertising

C - 65 M - 51 Y - 10 K - 0	C - 33 M - 4 Y - 56 K - 0	C - 6 M - 67 Y - 80 K - 1

71

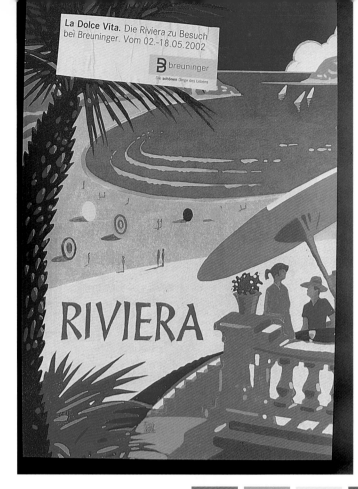

design firm
Heye
Unterhaching/Munich (Germany)
client
Breuninger

C - 9	C - 7	C - 2	C - 75	C - 61	C - 97
M - 87	M - 45	M - 7	M - 34	M - 16	M - 52
Y - 99	Y - 99	Y - 56	Y - 99	Y - 28	Y - 2
K - 0	K - 0	K - 0	K - 0	K - 0	K - 0

C - 0	C - 62
M - 57	M - 95
Y - 100	Y - 100
K - 0	K - 27

design firm
Interbrand Hulefeld
Cincinnati, Ohio
client
Procter & Gamble

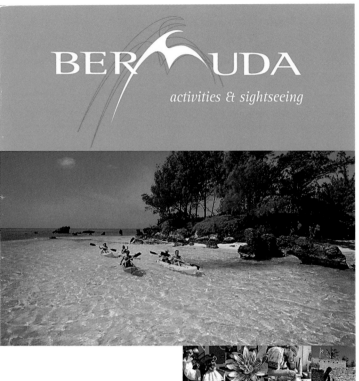

C - 46
M - 0
Y - 93
K - 0

C - 71
M - 55
Y - 0
K - 0

design firm
Advantage Ltd.
Hamilton (Bermuda)
client
Bermuda Tourism

INFORMATION & PRICE GUIDE

BERMUDA DEPARTMENT OF TOURISM

design firm
**Performance Graphics
of Lake Norman**
Cornelius, North Carolina
client
LimeAide
Refreshing Delivery

C - 0
M - 24
Y - 86
K - 0

C - 11
M - 98
Y - 85
K - 2

design firm
Dotzler Creative Arts
Omaha, Nebraska

| C - 1
M - 0
Y - 87
K - 0 | C - 61
M - 0
Y - 88
K - 0 | C - 0
M - 60
Y - 86
K - 0 | C - 100
M - 50
Y - 0
K - 16 | C - 3
M - 87
Y - 90
K - 5 |

design firm
Bailey Design Group Inc.
Plymouth Meeting, Pennsylvania

| C - 0
M - 100
Y - 89
K - 0 | C - 44
M - 0
Y - 100
K - 22 | C - 84
M - 16
Y - 26
K - 8 | C - 0
M - 0
Y - 85
K - 0 |

design firm
Bailey Design Group Inc.
Plymouth Meeting, Pennsylvania

| C - 4
M - 80
Y - 84
K - 1 | C - 0
M - 35
Y - 95
K - 1 | C - 100
M - 100
Y - 4
K - 6 | C - 53
M - 100
Y - 5
K - 2 | C - 100
M - 100
Y - 4
K - 6 |

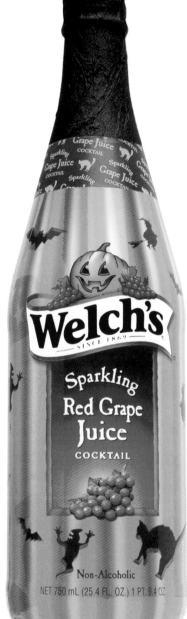

74

design firm
Sagmeister Inc.
New York, New York

C - 82 C - 2
M - 82 M - 64
Y - 85 Y - 95
K - 58 K - 0

C - 83 C - 40 C - 4 C - 22 C - 68 C - 0
M - 63 M - 89 M - 6 M - 100 M - 0 M - 90
Y - 0 Y - 0 Y - 99 Y - 41 Y - 100 Y - 100
K - 0 K - 0 K - 0 K - 3 K - 0 K - 0

design firm
McElveney & Palozzi Design Group
Rochester, New York
client
McElveney & Palozzi Design Group

C - 0 C - 3 C - 85 C - 4
M - 80 M - 14 M - 71 M - 0
Y - 100 Y - 99 Y - 0 Y - 50
K - 0 K - 0 K - 0 K - 0

design firm
McElveney & Palozzi Design Group
Rochester, New York
client
McElveney & Palozzi Design Group

C - 13	C - 4	C - 65	C - 71	C - 58
M - 100	M - 0	M - 83	M - 0	M - 0
Y - 12	Y - 88	Y - 0	Y - 100	Y - 1
K - 0	K - 0	K - 0	K - 0	K - 0

design firm
McElveney & Palozzi Design Group
Rochester, New York
client
McElveney & Palozzi Design Group

a very stylish girl®

C - 0
M - 14
Y - 0
K - 0

design firm
After Hours Creative
Phoenix, Arizona

design firm
Michael Osborne Design
San Francisco, California
client
Gymboree

C - 2	C - 2	C - 75	C - 40	C - 69	C - 6
M - 41	M - 10	M - 33	M - 91	M - 70	M - 6
Y - 92	Y - 93	Y - 9	Y - 20	Y - 29	Y - 56
K - 0	K - 0	K - 7	K - 12	K - 59	K - 1

SWIRLS
COFFEE SHOP

C - 34	C - 0
M - 0	M - 0
Y - 24	Y - 0
K - 9	K - 100

design firm
Greteman Group
Wichita, Kansas

C - 0	C - 39	C - 100	C - 70
M - 10	M - 5	M - 10	M - 70
Y - 100	Y - 100	Y - 0	Y - 0
K - 0	K - 0	K - 0	K - 0

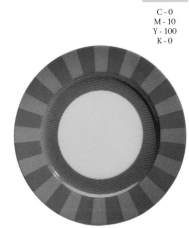

design firm
Michael Osborne Design
San Francisco, California
client
San Francisco Museum of Modern Art

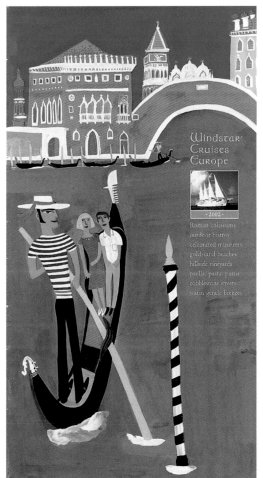

Windstar Cruises Europe

· 2002 ·

Roman coliseums
outdoor bistros
celebrated museums
gold-sand beaches
hillside vineyards
paella, pasta, pastis
cobblestone streets
warm gentle breezes

C - 0	C - 2	C - 80	C - 71
M - 93	M - 14	M - 60	M - 28
Y - 82	Y - 92	Y - 0	Y - 29
K - 3	K - 0	K - 0	K - 5

design firm
Besser Design Group
Santa Monica, California
client
Windstar Cruises

C - 0	C - 0	C - 56
M - 79	M - 31	M - 56
Y - 94	Y - 94	Y - 0
K - 0	K - 0	K - 0

design firm
Greteman Group
Wichita, Kansas

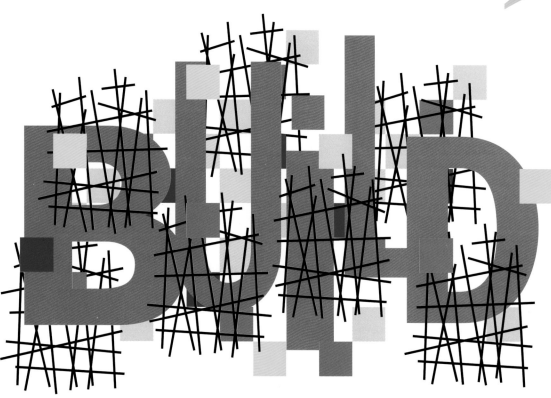

design firm
Bruce Yelaska Design
San Fransico, California
client
Saarman Construction

C - 5	C - 2	C - 86	C - 94
M - 91	M - 22	M - 22	M - 69
Y - 93	Y - 77	Y - 2	Y - 5
K - 0	K - 0	K - 0	K - 0

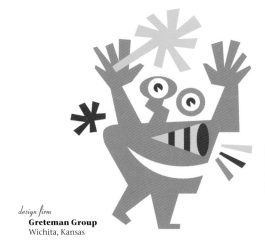

design firm
Greteman Group
Wichita, Kansas

C - 0	C - 78	C - 0
M - 80	M - 94	M - 15
Y - 100	Y - 0	Y - 100
K - 0	K - 0	K - 0

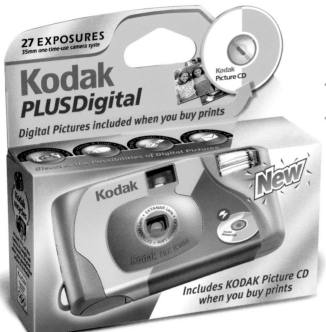

design firm
McElveney & Palozzi Design Group
Rochester, New York
client
Eastman Kodak Company

C - 0	C - 0	C - 85	C - 0
M - 100	M - 18	M - 47	M - 0
Y - 100	Y - 100	Y - 0	Y - 0
K - 0	K - 0	K - 0	K - 31

design firm
Becker Design
Milwaukee, Wisconsin
client
Beta Systems

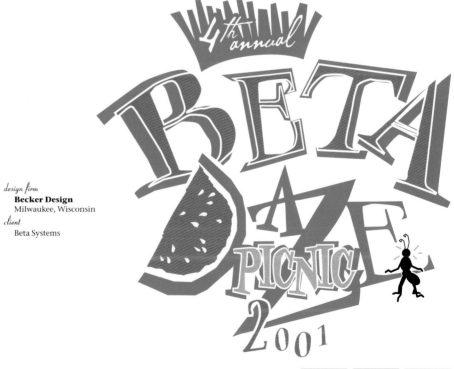

C - 84	C - 9	C - 9
M - 1	M - 93	M - 45
Y - 100	Y - 63	Y - 80
K - 0	K - 1	K - 1

Barbie Indoor Sleeping Bags 2002 Promotional Calendar

Doll Up Your Sales

with

Barbie™

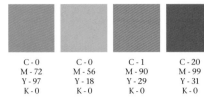

C - 0	C - 0	C - 1	C - 20
M - 72	M - 56	M - 90	M - 99
Y - 97	Y - 18	Y - 29	Y - 31
K - 0	K - 0	K - 0	K - 0

design firm
Launch Creative Marketing
Hillside, Illinois

client
Hedstrom Corporation

design firm
Disney Online
Los Angeles, California

client
The Walt Disney Company

C - 1	C - 2	C - 43
M - 96	M - 13	M - 30
Y - 89	Y - 92	Y - 41
K - 0	K - 0	K - 14

Disney Online

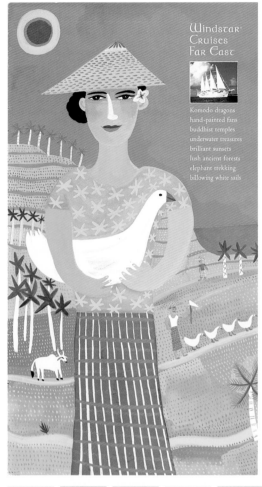

Windstar
Cruises
Far East

Komodo dragons
hand-painted fans
buddhist temples
underwater treasures
brilliant sunsets
lush ancient forests
elephant trekking
billowing white sails

C - 5	C - 13	C - 0	C - 9	C - 61
M - 49	M - 99	M - 78	M - 0	M - 11
Y - 14	Y - 50	Y - 84	Y - 93	Y - 85
K - 0	K - 0	K - 0	K - 0	K - 0

design firm
Besser Design Group
Santa Monica, California

client
Windstar Cruises

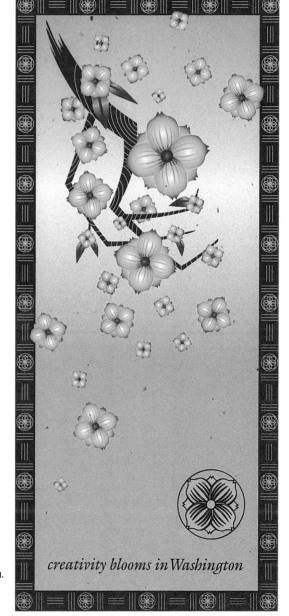

creativity blooms in Washington

design firm
Greenfield/Belser Ltd.
Washington, D.C.

client
Greenfield/Belser Ltd.

C - 46	C - 1	C - 0
M - 15	M - 33	M - 62
Y - 48	Y - 28	Y - 54
K - 0	K - 0	K - 0

C - 48
M - 14
Y - 97
K - 5

C - 7
M - 1
Y - 87
K - 0

C - 0
M - 0
Y - 0
K - 100

5207 Grant Avenue Cleveland, Ohio 44125

design firm
Design Room
Cleveland, Ohio
client
eguana.com

5207 Grant Avenue Cleveland, Ohio 44125
t 216 641-7148 f 216 641-7147 e info@eguana.com

C - 0
M - 100
Y - 100
K - 0

C - 2
M - 5
Y - 93
K - 0

C - 82
M - 24
Y - 96
K - 18

C - 50
M - 100
Y - 0
K - 40

design firm
Sunspots Creative, Inc.
Hoboken, New Jersey
client
Power Play Billiards

82

design firm
Oakley Design Studios
Portland, Oregon
client
Sokol Blosser Winery

C - 56	C - 0
M - 0	M - 0
Y - 27	Y - 0
K - 0	K - 100

C - 0	C - 90	C - 20	C - 10
M - 30	M - 0	M - 0	M - 70
Y - 100	Y - 0	Y - 80	Y - 20
K - 0	K - 10	K - 0	K - 20

design firm
Hughes Design
Norwalk, Connecticut
client
Mott's U.S.A.

design firm
Hornall Anderson Design Works
Seattle, Washington

C - 18	C - 13	C - 47	C - 51
M - 72	M - 85	M - 62	M - 50
Y - 75	Y - 64	Y - 33	Y - 62
K - 16	K - 12	K - 7	K - 61

C - 52	C - 59	C - 5
M - 70	M - 17	M - 1
Y - 65	Y - 0	Y - 35
K - 57	K - 0	K - 0

design firm
Pearlfisher
London (England)

design firm
The Wecker Group
Monterey, California
client
Scheid Vineyards

C - 75
M - 90
Y - 0
K - 0

C - 32
M - 43
Y - 76
K - 19

C - 51
M - 79
Y - 46
K - 30

C - 32
M - 83
Y - 61
K - 22

C - 55
M - 36
Y - 77
K - 14

C - 36
M - 35
Y - 65
K - 4

design firm
Michael Osborne Design
San Francisco, California
client
Canyon Road

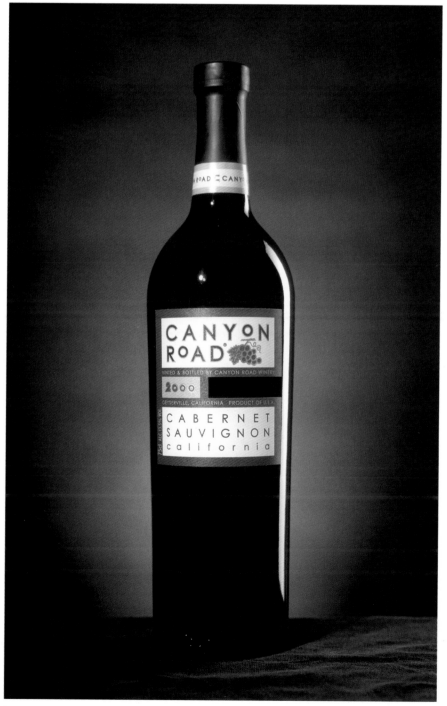

NORWEGIAN WOODS

design firm
Becker Design
Milwaukee, Wisconsin
client
Beta Systems

C - 32	C - 0
M - 83	M - 0
Y - 76	Y - 0
K - 23	K - 100

C - 0	C - 40	C - 22
M - 60	M - 60	M - 46
Y - 79	Y - 57	Y - 59
K - 0	K - 80	K - 2

design firm
Hornall Anderson Design Works
Seattle, Washington

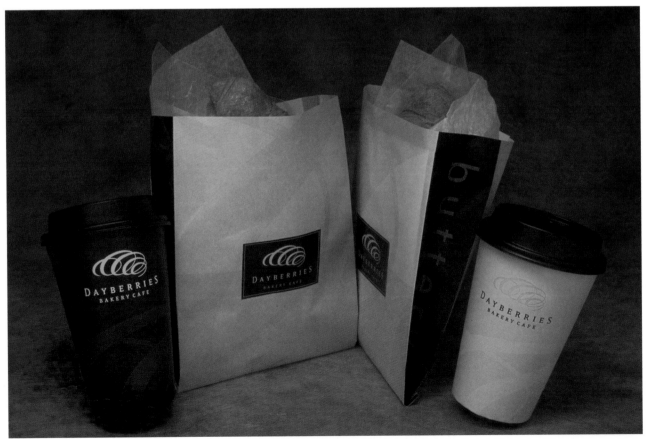

C - 100 C - 24 C - 19 C - 0
M - 77 M - 84 M - 97 M - 72
Y - 18 Y - 99 Y - 96 Y - 90
K - 15 K - 19 K - 8 K - 0

design firm
Sayles Graphic Design
Des Moines, Iowa
client
"Art Fights Back"

C - 23 C - 36 C - 7 C - 6
M - 51 M - 47 M - 80 M - 71
Y - 67 Y - 58 Y - 70 Y - 72
K - 71 K - 57 K - 52 K - 6

design firm
**Hornall Anderson
Design Works**
Seattle, Washington

design firm
Bacardi USA
New York, New York
client
Ciclón

C - 69
M - 63
Y - 36
K - 13

C - 0
M - 34
Y - 99
K - 0

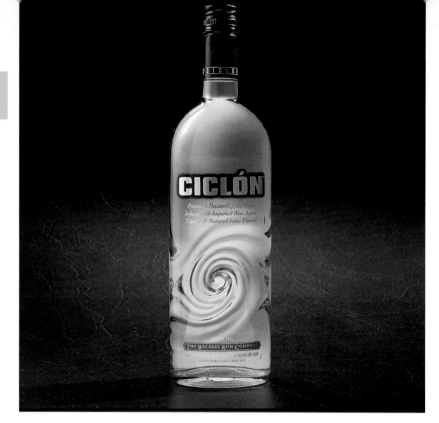

C - 1
M - 6
Y - 72
K - 0

C - 12
M - 91
Y - 86
K - 2

C - 34
M - 70
Y - 54
K - 52

design firm
Compass Design
Minneapolis,
Minnesota

C - 26
M - 87
Y - 79
K - 21

C - 0
M - 51
Y - 95
K - 0

design firm
Compass Design
Minneapolis, Minnesota

C - 0
M - 24
Y - 86
K - 0

C - 26
M - 87
Y - 79
K - 21

C - 54
M - 43
Y - 42
K - 31

design firm
Compass Design
Minneapolis, Minnesota

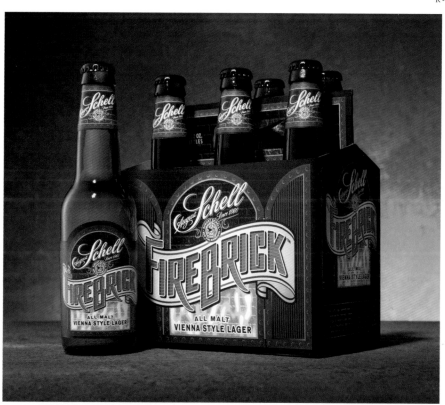

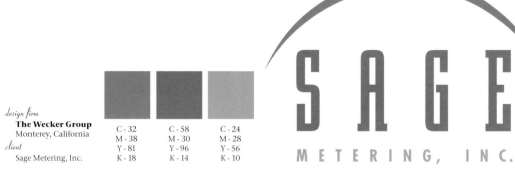

design firm
The Wecker Group
Monterey, California
client
Sage Metering, Inc.

C - 32
M - 38
Y - 81
K - 18

C - 58
M - 30
Y - 96
K - 14

C - 24
M - 28
Y - 56
K - 10

C - 25
M - 57
Y - 83
K - 25

C - 7
M - 96
Y - 97
K - 1

C - 1
M - 6
Y - 72
K - 0

C - 12
M - 91
Y - 86
K - 2

C - 13
M - 72
Y - 88
K - 3

C - 0
M - 50
Y - 85
K - 0

design firm
Compass Design
Minneapolis, Minnesota

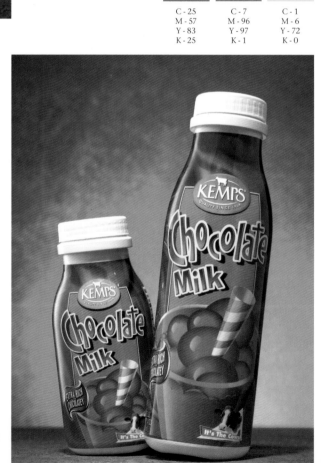

design firm
Compass Design
Minneapolis, Minnesota

design firm
Shields Design
Fresno, California
client
maltwhiskey.com

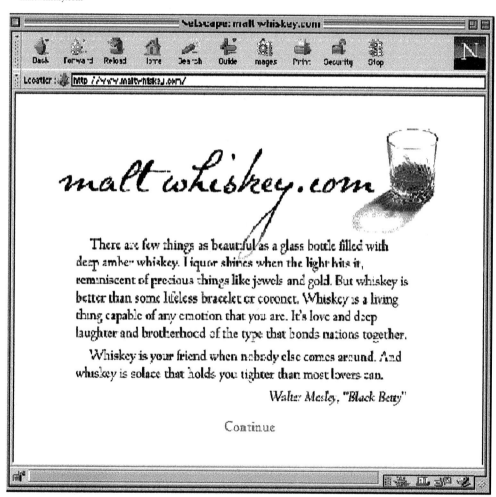

C - 10 C - 0
M - 50 M - 0
Y - 60 Y - 0
K - 10 K - 100

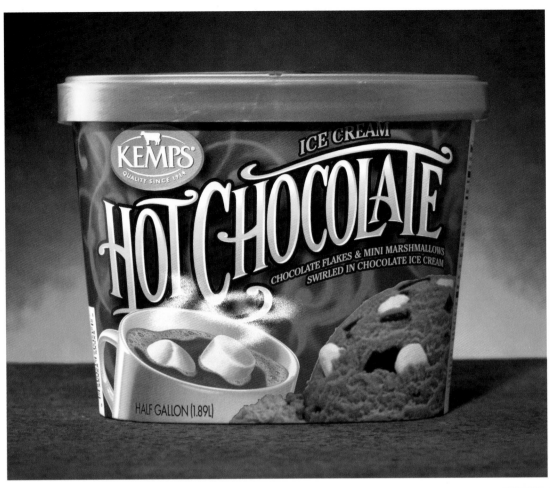

design firm
Compass Design
Minneapolis, Minnesota

C - 1	C - 4	C - 27	C - 41
M - 6	M - 58	M - 82	M - 67
Y - 67	Y - 65	Y - 75	Y - 62
K - 0	K - 1	K - 37	K - 69

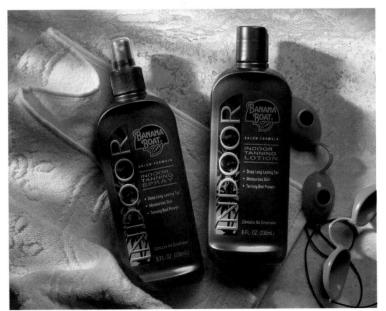

C - 38	C - 26	C - 13
M - 73	M - 36	M - 78
Y - 58	Y - 60	Y - 97
K - 64	K - 12	K - 4

design firm
Tom Fowler, Inc.
Norwalk, Connecticut
client
Playtex Products, Inc.

design firm
Ortega Design Studio
St. Helena, California
client
Simi Winery

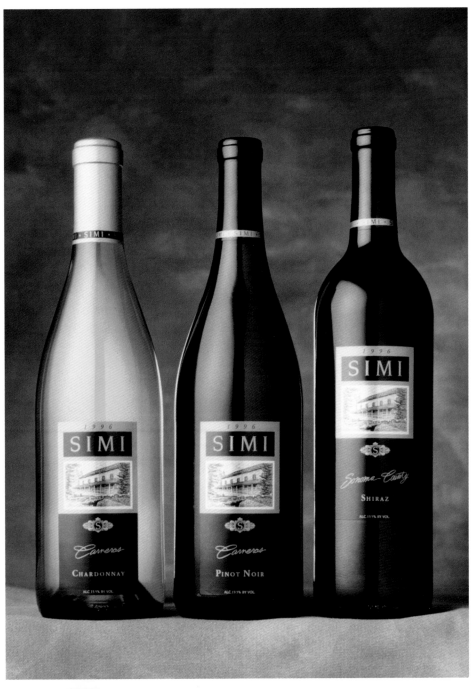

C - 15 C - 0
M - 30 M - 0
Y - 70 Y - 0
K - 0 K - 100

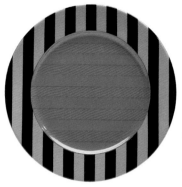

C - 75	C - 0	C - 70	C - 100
M - 60	M - 0	M - 70	M - 10
Y - 70	Y - 0	Y - 0	Y - 0
K - 14	K - 100	K - 0	K - 0

design firm
Michael Osborne Design
San Francisco, California
client
San Francisco Museum of Modern Art

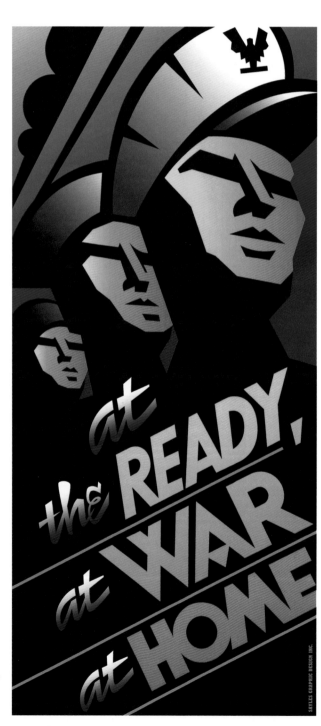

SAYLES GRAPHIC DESIGN INC.

design firm
Sayles Graphic Design
Des Moines, Iowa
client
"Art Fights Back"

C - 75	C - 0	C - 74	C - 0
M - 28	M - 50	M - 92	M - 72
Y - 3	Y - 90	Y - 15	Y - 90
K - 2	K - 0	K - 4	K - 0

94

C - 60	C - 18
M - 45	M - 12
Y - 18	Y - 10
K - 5	K - 1

design firm
The Wecker Group
Monterey, California
client
Hammer Golf

HAMMER GOLF
PERFORMANCE & FITNESS

HAMMER GOLF
PERFORMANCE & FITNESS

Andrea Hammer MS, PT, CSCS
Physical Therapist
Certified Strength &
Conditioning Specialist

891 E. Hamilton Ave.
Campbell, CA 95008
Tel (408) 558-9518
Fax (408) 558-9528
www.hammergolf.net
andrea@hammergolf.net

Combining Biomechanical Analysis with Manual Therapy, Strength Training and Conditioning

Combining Biomechanical
Analysis with Manual
Therapy, Strength Training
and Conditioning

891 E. HAMILTON AVE.
CAMPBELL, CA 95008
TEL (408) 558-9518
FAX (408) 558-9528
www.hammergolf.net

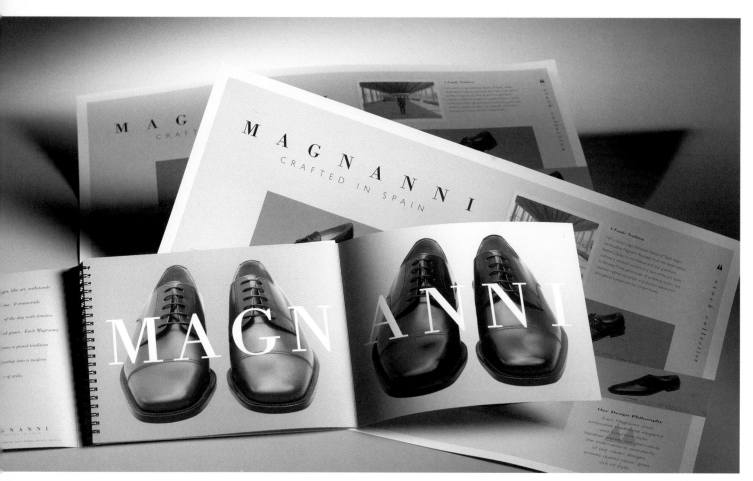

design firm
Louis & Partners Design
Bath, Ohio

client
Magnanni

C - 10	C - 12	C - 39	C - 15
M - 10	M - 21	M - 20	M - 14
Y - 13	Y - 20	Y - 16	Y - 29
K - 0	K - 5	K - 0	K - 0

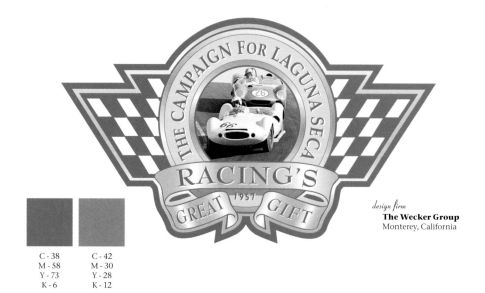

design firm
The Wecker Group
Monterey, California

C - 38	C - 42
M - 58	M - 30
Y - 73	Y - 28
K - 6	K - 12

design firm
Klündt Hosmer Design
Spokane, Washington
client
GoBookMax

C - 53	C - 29	C - 68	C - 0
M - 40	M - 87	M - 28	M - 58
Y - 43	Y - 94	Y - 34	Y - 80
K - 11	K - 29	K - 8	K - 0

C - 28	C - 66
M - 60	M - 86
Y - 74	Y - 83
K - 0	K - 51

design firm
After Hours Creative
Phoenix, Arizona

Marlon Shirley
lost leg at the age of 5
paralympic sprinter 2000
world-record holder

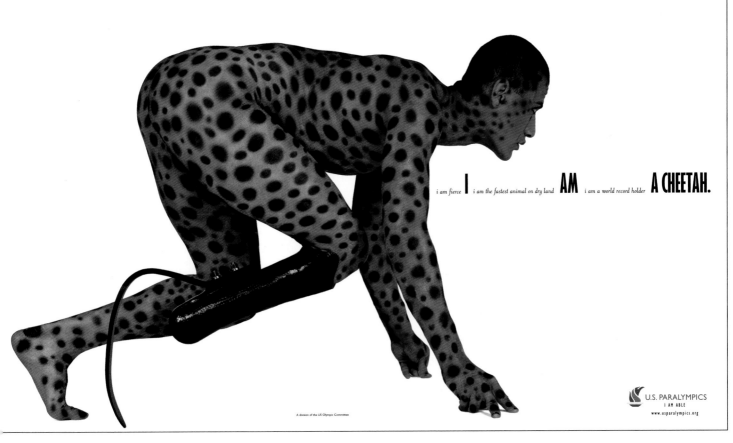

i am fierce **I** *i am the fastest animal on dry land* **AM** *i am a world record holder* **A CHEETAH.**

A division of the US Olympic Committee

U.S. PARALYMPICS
I AM ABLE
www.usparalympics.org

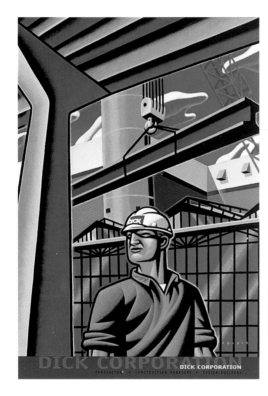

design firm
Bradley Brown Design Group
Carnegie, Pennsylvania
client
Dick Corporation

C - 76	C - 44	C - 65	C - 2	C - 1	C - 57	C - 0
M - 62	M - 27	M - 38	M - 79	M - 27	M - 77	M - 0
Y - 12	Y - 11	Y - 89	Y - 87	Y - 81	Y - 64	Y - 0
K - 9	K - 0	K - 1	K - 0	K - 0	K - 34	K - 100

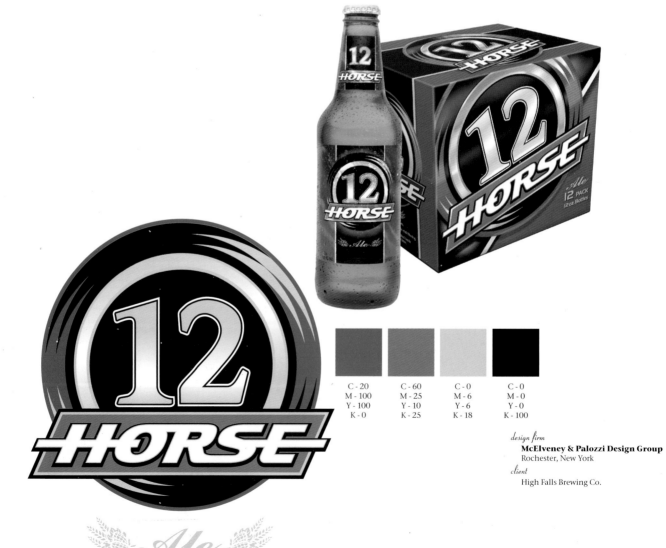

C - 20	C - 60	C - 0	C - 0
M - 100	M - 25	M - 6	M - 0
Y - 100	Y - 10	Y - 6	Y - 0
K - 0	K - 25	K - 18	K - 100

design firm
McElveney & Palozzi Design Group
Rochester, New York
client
High Falls Brewing Co.

C - 37 C - 16 C - 0
M - 20 M - 87 M - 24
Y - 22 Y - 96 Y - 86
K - 11 K - 24 K - 0

design firm
Tom Fowler, Inc.
Norwalk, Connecticut
client
Honeywell Consumer Products

design firm
Greteman Group
Wichita, Kansas

C - 100 C - 67 C - 0 C - 0
M - 75 M - 32 M - 30 M - 99
Y - 0 Y - 6 Y - 93 Y - 91
K - 39 K - 0 K - 0 K - 0

AS CLOSE TO BALLET

AS YOU CAN GET AND STILL

RETAIN YOUR DIGNITY.

APRIL 22-28

GREATER GREENSBORO CHRYSLER CLASSIC

GGCC.COM

STALK FAMOUS PEOPLE

WITHOUT RISKING

A RESTRAINING ORDER.

APRIL 22-28

GREATER GREENSBORO CHRYSLER CLASSIC

GGCC.COM

design firm
Bouvier Kelly
Greensboro, North Carolina
client
Greater Greensboro Chrysler Classic

C - 6	C - 84	C - 21
M - 11	M - 86	M - 45
Y - 64	Y - 44	Y - 65
K - 0	K - 16	K - 0

C - 21	C - 0	C - 44	C - 42
M - 23	M - 51	M - 49	M - 51
Y - 76	Y - 82	Y - 55	Y - 57
K - 48	K - 0	K - 39	K - 81

design firm
Hornall Anderson
Design Works
Seattle, Washington

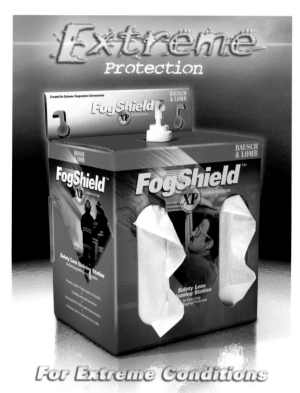

C - 100	C - 100	C - 0	C - 0
M - 9	M - 96	M - 68	M - 0
Y - 0	Y - 0	Y - 99	Y - 95
K - 16	K - 50	K - 0	K - 0

design firm
McElveney & Palozzi Design Group
Rochester, New York
client
Bausch & Lomb

design firm
Goldforest
Miami, Florida
client
Continuum Sales & Marketing

C - 2	C - 74	C - 87
M - 55	M - 41	M - 25
Y - 99	Y - 50	Y - 48
K - 0	K - 68	K - 33

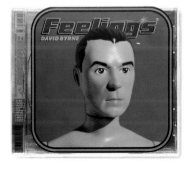

design firm
Sagmeister Inc.
New York, New York

C - 91	C - 24
M - 59	M - 60
Y - 12	Y - 51
K - 7	K - 2

C - 20
M - 100
Y - 100
K - 2

C - 100
M - 70
Y - 0
K - 0

C - 8
M - 35
Y - 60
K - 240

C - 0
M - 0
Y - 0
K - 100

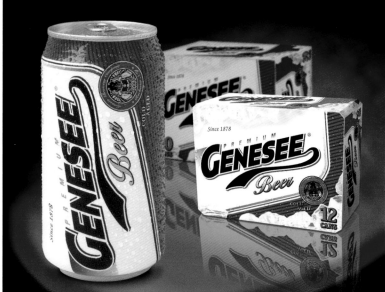

design firm
McElveney & Palozzi Design Group
Rochester, New York
client
High Falls Brewing Co.

C - 12
M - 91
Y - 86
K - 2

C - 0
M - 11
Y - 92
K - 0

C - 36
M - 99
Y - 99
K - 26

C - 0
M - 0
Y - 0
K - 100

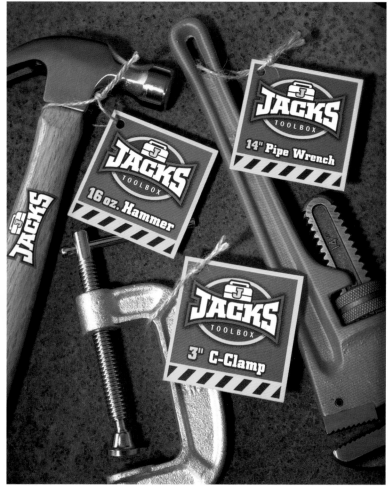

IF YOU DON'T KNOW JACKS
YOU DON'T KNOW TOOLS!

design firm
Compass Design
Minneapolis, Minnesota
client
Jack Toolbox Company

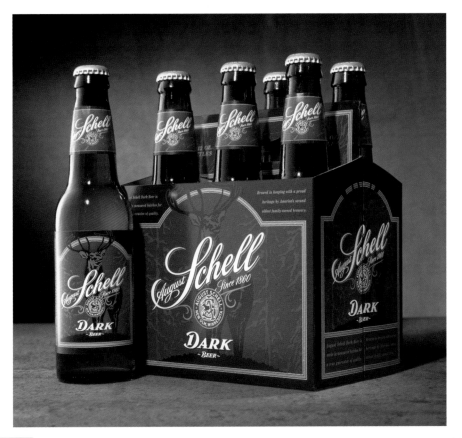

C - 44	C - 62	C - 15
M - 61	M - 51	M - 44
Y - 60	Y - 49	Y - 81
K - 61	K - 63	K - 9

design firm
Compass Design
Minneapolis, Minnesota
client
August Schell Brewing Co.

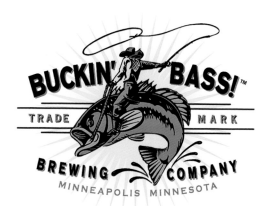

C - 53	C - 25	C - 0	C - 30
M - 40	M - 89	M - 12	M - 72
Y - 89	Y - 99	Y - 70	Y - 90
K - 0	K - 18	K - 0	K - 18

design firm
Compass Design
Minneapolis, Minnesota
client
Buckin' Bass Brewing Co.

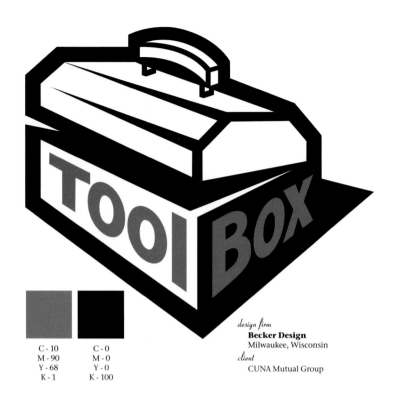

design firm
Becker Design
Milwaukee, Wisconsin
client
CUNA Mutual Group

C - 10	C - 0
M - 90	M - 0
Y - 68	Y - 0
K - 1	K - 100

design firm
Pat Taylor Inc.
Washington, D.C.
client
Palis Gen. Contracting

C - 0
M - 0
Y - 0
K - 100

design firm
The Wecker Group
Monterey, California
client
Myrick Photographic

C - 0	C - 0	C - 10
M - 100	M - 0	M - 20
Y - 80	Y - 100	Y - 0
K - 0	K - 0	K - 60

Cameras, films & quality photofinishing

design firm
The Wecker Group
Monterey, California
client
Blue Fin Cafe & Billiards

C - 0	C - 81
M - 0	M - 6
Y - 0	Y - 5
K - 100	K - 0

design firm
Compass Design
Minneapolis, Minnesota
client
August Schell Brewing Co.

C - 50	C - 34	C - 23
M - 98	M - 64	M - 26
Y - 87	Y - 91	Y - 56
K - 25	K - 0	K - 0

design firm
Michael Osborne Design
San Francisco, California
client
San Francisco Museum of Modern Art

C - 0	C - 0	C - 70	C - 0
M - 100	M - 65	M - 70	M - 0
Y - 100	Y - 87	Y - 0	Y - 0
K - 0	K - 0	K - 0	K - 100

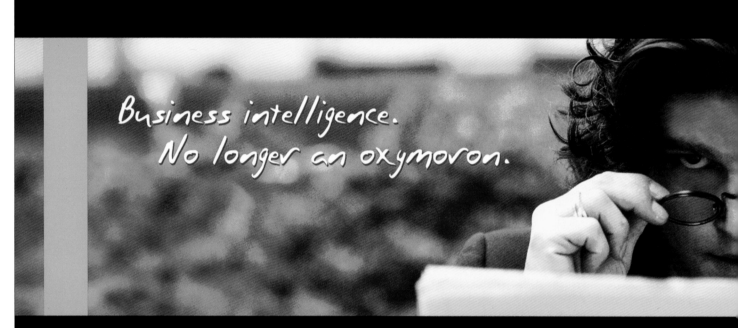

Business intelligence.
No longer an oxymoron.

New rules. New solutions.

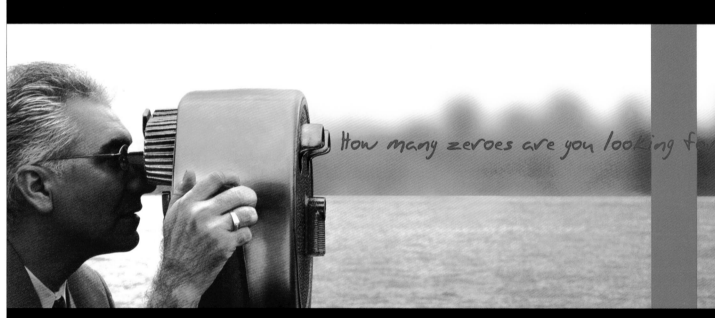

How many zeroes are you looking for?

New rules. New solutions.

design firm
Amber Design Associates
Hackettstown, New Jersey
client
Microsoft

C - 35	C - 4	C - 83	C - 10	C - 0
M - 6	M - 59	M - 14	M - 38	M - 0
Y - 93	Y - 88	Y - 3	Y - 88	Y - 0
K - 1	K - 1	K - 1	K - 15	K - 100

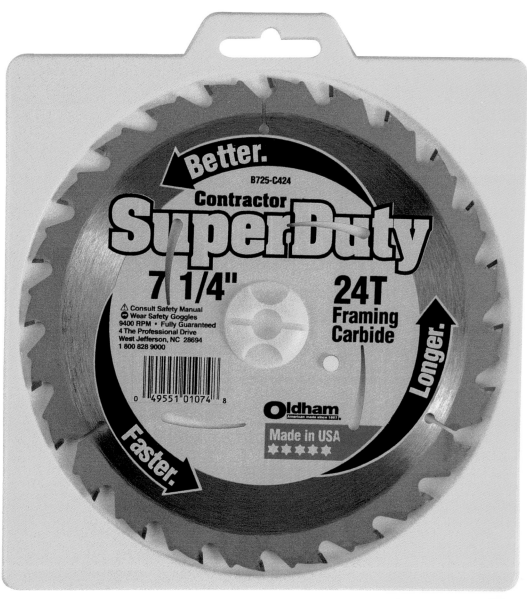

design firm
Ball Advertising & Design
Statesville, North Carolina
client
Oldham

C - 0	C - 20	C - 0
M - 10	M - 0	M - 0
Y - 90	Y - 0	Y - 0
K - 0	K - 20	K - 100

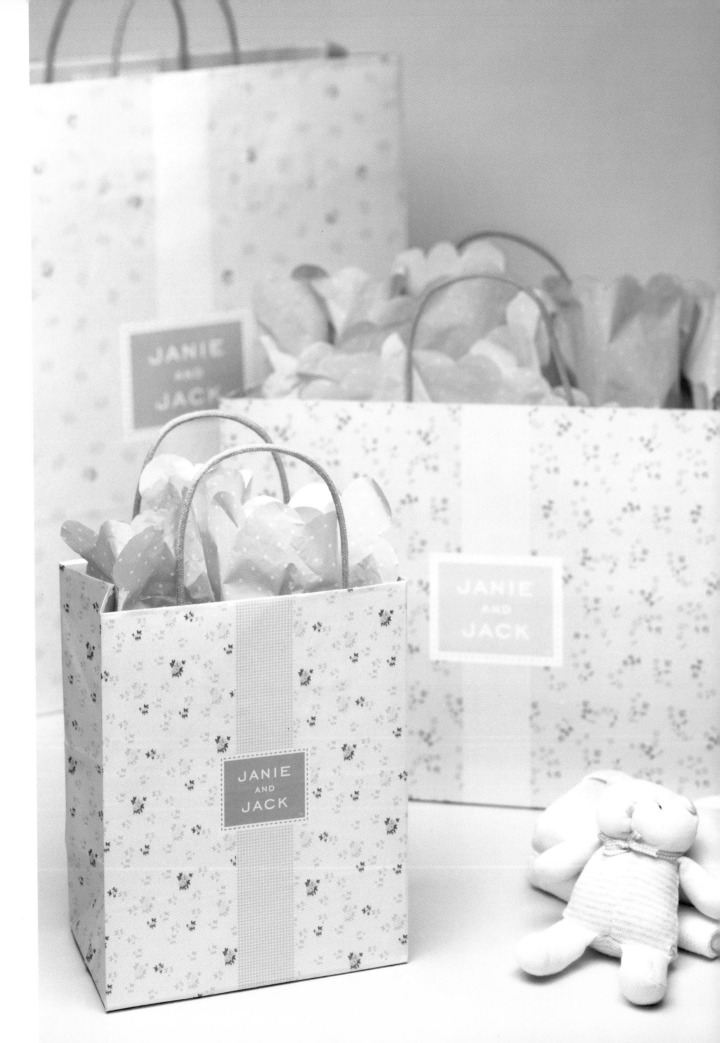

PLASTIC SURGERY

ROBERT L. COOPER M.D.

C - 45	C - 0	C - 0
M - 42	M - 34	M - 8
Y - 3	Y - 50	Y - 32
K - 0	K - 0	K - 0

design firm
Klündt Hosmer Design
Spokane, Washington
client
Robert L. Cooper, M.D.

design firm
After Hours Creative
Phoenix, Arizona

C - 13	C - 22	C - 65
M - 72	M - 59	M - 51
Y - 27	Y - 31	Y - 84
K - 3	K - 5	K - 19

C - 3	C - 22
M - 12	M - 23
Y - 40	Y - 4
K - 0	K - 0

C - 0	C - 16
M - 22	M - 4
Y - 11	Y - 26
K - 0	K - 0

C - 28	C - 29
M - 16	M - 1
Y - 4	Y - 17
K - 1	K - 0

(opposite) design firm
Michael Osborne Design
San Francisco, California
client
Janie and Jack

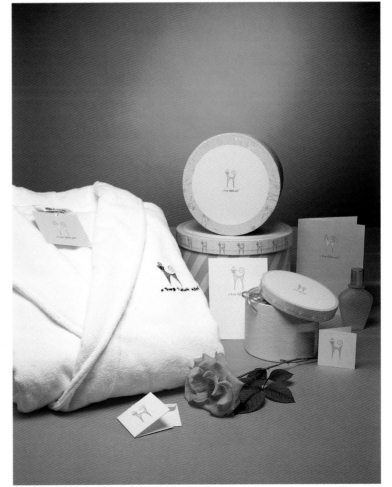

feminine

109

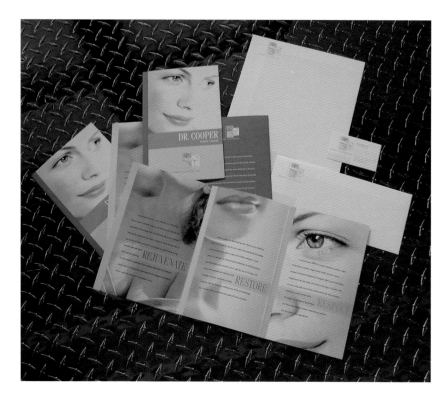

design firm
Klündt Hosmer Design
Spokane, Washington
client
Robert L.Cooper, M.D.

C - 57	C - 25	C - 50	C - 25
M - 53	M - 53	M - 17	M - 35
Y - 20	Y - 32	Y - 40	Y - 40
K - 30	K - 10	K - 5	K - 4

design firm
The Wecker Group
Monterey, California
client
Chateau Valeria

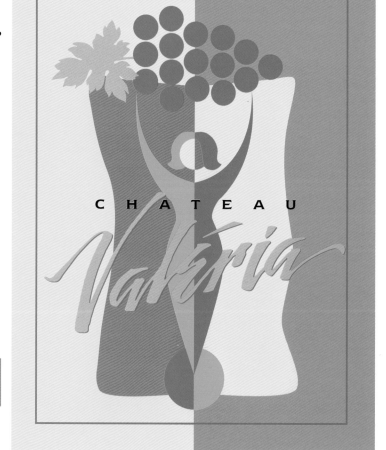

C - 0	C - 10	C - 60	C - 60	C - 46	C - 0
M - 14	M - 30	M - 60	M - 0	M - 20	M - 90
Y - 39	Y - 100	Y - 0	Y - 30	Y - 0	Y - 100
K - 0	K - 0	K - 0	K - 0	K - 13	K - 0

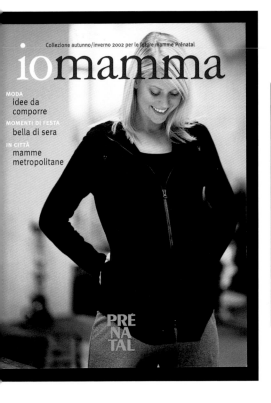

C - 21	C - 7	C - 96	C - 41
M - 99	M - 47	M - 73	M - 29
Y - 100	Y - 85	Y - 33	Y - 87
K - 5	K - 3	K - 33	K - 1

design firm
Tangram Strategic Design
Novara (Italy)
client
Prénatal

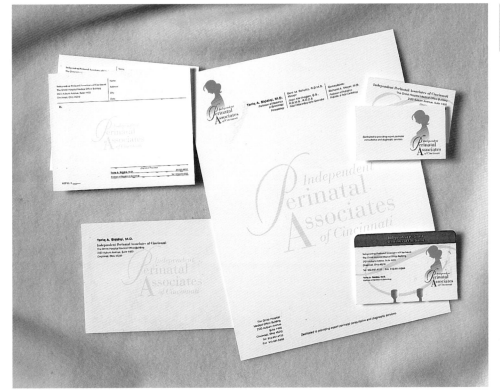

C - 18	C - 12	C - 84
M - 45	M - 96	M - 26
Y - 17	Y - 28	Y - 90
K - 0	K - 2	K - 32

design firm
Interbrand Hulefeld
Cincinnati, Ohio
client
Independent Perinatal Associates of Cincinnati

C - 1 C - 14
M - 42 M - 0
Y - 52 Y - 12
K - 0 K - 0

our love

design firm
After Hours Creative
Phoenix, Arizona

WEĪSHÄÄR
S U E W E I S H A A R . D D S

C - 50 C - 10
M - 35 M - 60
Y - 0 Y - 80
K - 0 K - 0

design firm
Klündt Hosmer Design
Spokane, Washington
client
Sue Weishaar, D.D.S.

push, push

design firm
After Hours Creative
Phoenix, Arizona

C - 35 C - 0
M - 35 M - 0
Y - 0 Y - 30
K - 0 K - 0

113

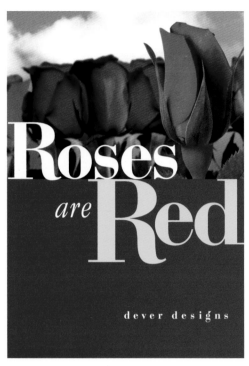

Roses are Red

dever designs

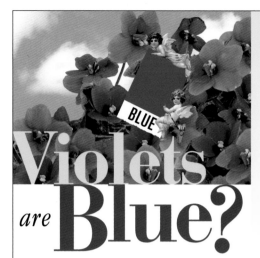

BLUE

Violets are Blue?

Clichéd poetry and color correc-
tions aside, Dever Designs would
love to work with you. We're in the
business of creating fresh commu-
nication graphics, the kind your
competitors will lust after. So as
you plan your next project call on
us so we can lovingly create for you.

Conference Kits

Magazines

Corporate Identity

Annual Reports

Books

Consultation

dever designs
The point where art and communication meet

301-776-2812

VIOLET
RED

C - 76	C - 96	C - 2	C - 2
M - 83	M - 60	M - 96	M - 5
Y - 3	Y - 2	Y - 85	Y - 93
K - 1	K - 1	K - 0	K - 0

design firm
Dever Designs
Laurel, Maryland
client
Dever Designs

C - 0	C - 100
M - 30	M - 100
Y - 10	Y - 0
K - 0	K - 10

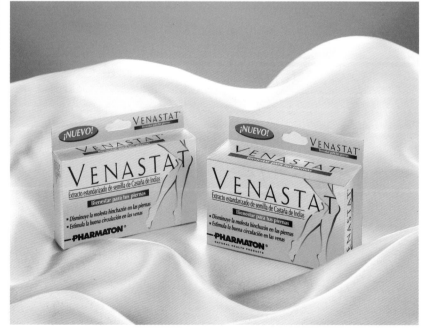

design firm
Praxis Diseñadores, S.C.
México City (Mexico)
client
Laboratorios Promeco

C - 100
M - 60
Y - 0
K - 6

C - 100
M - 0
Y - 30
K - 6

C - 100
M - 0
Y - 70
K - 15

C - 94
M - 94
Y - 0
K - 0

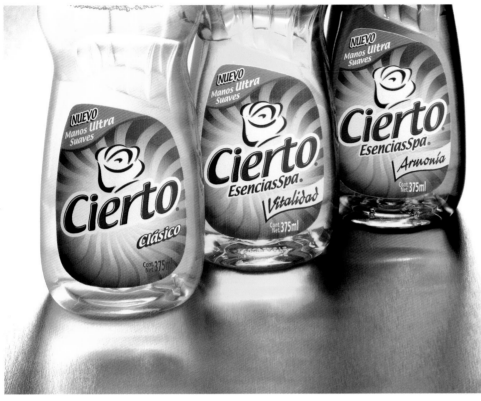

design firm
Praxis Diseñadores, S.C.
México City (Mexico)
client
Procter & Gamble Argentina

C - 0
M - 10
Y - 100
K - 0

C - 90
M - 90
Y - 0
K - 0

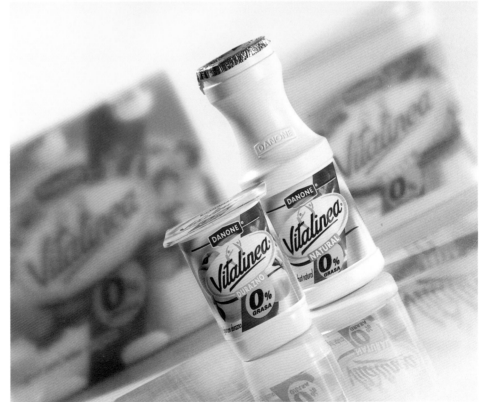

design firm
Praxis Diseñadores, S.C.
México City (Mexico)
client
Danone de México

115

C - 18 C - 17
M - 44 M - 95
Y - 26 Y - 84
K - 5 K - 6

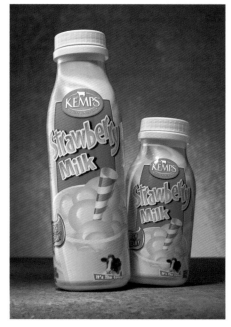

design firm
Compass Design
Minneapolis, Minnesota

C - 100 C - 26
M - 44 M - 19
Y - 48 Y - 11
K - 17 K - 0

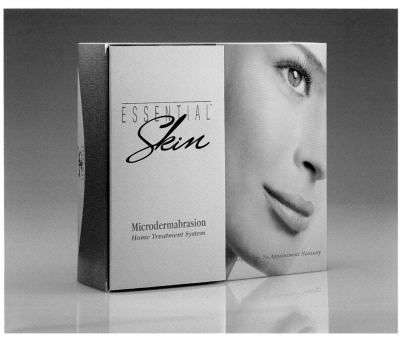

design firm
Allen Bell Solutions Inc.
Agoura Hills, California
client
Essential Skin Inc.

design firm
Mike Salisbury L.L.C.
Venice, California
client
 LFP

C - 0 C - 2 C - 91
M - 95 M - 68 M - 88
Y - 99 Y - 96 Y - 90
K - 0 K - 0 K - 74

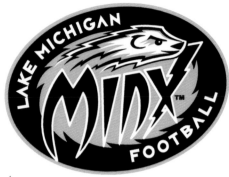

design firm
Compass Design
Minneapolis, Minnesota
client
Womens Professional Football League

 1 2 3 4 5
6 7 8 9 0

C - 0
M - 34
Y - 92
K - 0

C - 0
M - 0
Y - 0
K - 100

C - 1	C - 1	C - 44	C - 1	C - 45
M - 0	M - 56	M - 11	M - 64	M - 20
Y - 46	Y - 26	Y - 2	Y - 32	Y - 4
K - 51	K - 1	K - 30	K - 46	K - 60

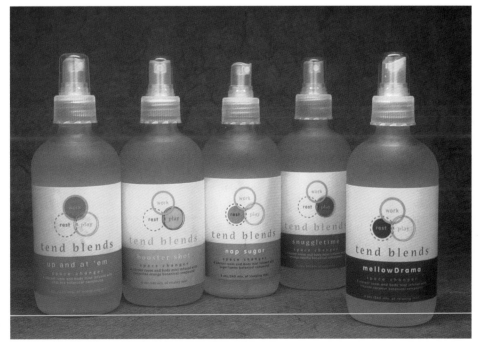

design firm
Hornall Anderson Design Works
Seattle, Washington

117

CRYSTAL CLEAR

YOU KNOW
your stuff.
WE HELP YOU
USE IT.

CRYSTAL CLEAR
The Accelerators

design firm
Becker Design
Milwaukee, Wisconsin
client
Crystal Clear

CRYSTAL CLEAR
Communications, Inc.

iness
lence.
ETHING
E WAY?

In today's business climate of rapid change, it is not unusual for top executives to feel that their organizations are not reaching their potential. This is especially the case when everything seems to have been done by the book: A strategic plan has been developed. Goals have been established. The company's mission has been communicated. Yet performance lags expectations and change is not occurring fast enough.

The temptation is often to fault the company's strategy and change direction again. Unfortunately, this typically results in even less clarity and obscures the real problem: behaviors and attitudes that block the transformation of a good company into a great one.

Crystal Clear helps leaders perform better and organizations attain greater success.

Transformation:
Action, not more information.

How do businesses reach the next level? Seldom by amassing more data. In fact, most companies are awash in information, from research reports to marketing studies to strategic plans. Rather, what they need is a means of utilizing the data they already have to implement meaningful change. Since 1986, Crystal Clear has fulfilled this role with numerous Fortune 1000 companies.

As consultants to key executives, Crystal Clear helps clients identify the factors that are inhibiting performance. Is the company's strategic direction thoroughly understood? Has there been "buy-in" at every level? Are there points of resistance? Have executives misidentified strengths as weaknesses and vice versa? Are the words and deeds of management consistent?

The process of asking tough questions discerns critical issues and provides an accurate assessment of a company's "business reality." Connecting this with the company's strategy, Crystal Clear works in partnership with executives to act as a catalyst for change.

Access your wisdom.

Unlike most consultants, Crystal Clear makes a bold assumption: you already have the answers you need to take your company to the next level. You may, however, be mired down and deterred from acting on what you know. Crystal Clear helps executives regain focus to improve company performance. Through our interaction, you'll heighten your awareness and be able to clarify your vision and goals.

Whether it's during your strategic planning process or implementing a plan that's already created, Crystal Clear brings an action orientation to the wisdom that is already in place. Consistent follow-through on the part of Crystal Clear, developed in long-term relationships with clients, helps companies stay on track and on strategy.

ASSUMPTION:

You know

what

needs to

get done.

People don't change.
But the way they do business can.

2

3

When to consult wit
Crystal Clear.

It's not a matter of business structure.
We've worked with:

> PUBLIC CORPORATIONS > PRIVATELY HELD CORPORATIONS
> FAMILY OWNED COMPANIES

Clarifying

DIRECTION

and improving

implementation

since

1986.

It's not a matter of the business field.
We've worked with firms in:

> RETAIL
> SERVICE
> MANUFACTURING
> MARKETING
> SALES
> DISTRIBUTION

It's not a matter of the current state.
We've worked with firms that are:

> GROWING
> SHRINKING
> PROFITABLE
> NOT PROFITABLE
> HIGHLY SUCCESSFUL
> DYSFUNCTIONAL

IT'S A MATTER OF THE **COMMITMENT** TO CHANGE.
AND WE ARE THE CATALYSTS.

C - 41
M - 27
Y - 96
K - 10

C - 95
M - 79
Y - 26
K - 14

6

HR VALUEGROUP

design firm
Becker Design
Milwaukee, Wisconsin
client
HR Value Group

C - 91	C - 44
M - 94	M - 25
Y - 31	Y - 96
K - 22	K - 9

design firm
**Stan Gellman
Graphic Design**
St. Louis, Missouri
client
FMC Technologies

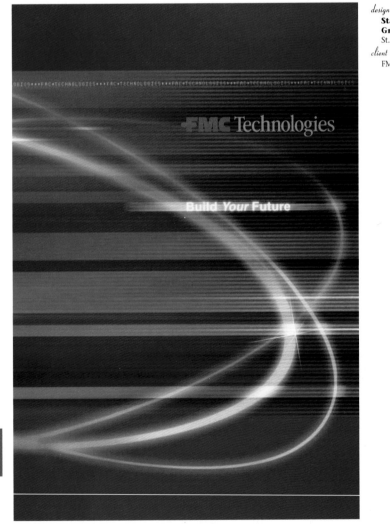

C - 99	C - 76	C - 12	C - 73
M - 75	M - 35	M - 100	M - 63
Y - 23	Y - 7	Y - 87	Y - 20
K - 7	K - 0	K - 2	K - 2

C - 12
M - 100
Y - 87
K - 2

C - 0
M - 0
Y - 0
K - 100

C - 23
M - 100
Y - 99
K - 16

design firm
Stan Gellman Graphic Design
St. Louis, Missouri
client
LaBarge Inc.

WE ARE **REALIZING VALUE** THROUG
THE **SUCCESSFUL** EXECUTION
OF OUR BUSINESS **STRATEGY**

2002 ANNUAL REPORT FOR THE FISCAL YEAR ENDED JUNE 30, 2002

Creating new answers.

2001 | ANNUAL REPORT

THE WHO IN HOW THINGS WORK™

design firm
Inc Design
New York, New York
client
Ashland

C - 31
M - 99
Y - 86
K - 0

C - 50
M - 10
Y - 72
K - 0

C - 40
M - 3
Y - 2
K - 0

BETHEL
CONSTRUCTION

C - 1	C - 0	C - 38
M - 96	M - 0	M - 27
Y - 89	Y - 0	Y - 25
K - 0	K - 100	K - 90

design firm
The Wecker Group
Monterey, California
client
Bethel Construction

design firm
Sagmeister Inc.
New York, New York

PAT METHENY
TRIO 99 → 00

C - 43	C - 64	C - 69
M - 38	M - 73	M - 61
Y - 18	Y - 1	Y - 28
K - 0	K - 1	K - 7

C - 76	C - 0	C - 46	C - 69
M - 23	M - 100	M - 38	M - 94
Y - 0	Y - 91	Y - 36	Y - 0
K - 9	K - 0	K - 4	K - 0

design firm
The Wecker Group
Monterey, California

GREEN JESPERSEN

Certified Public Accountants
A PROFESSIONAL CORPORATION

C - 27	C - 61	C - 35
M - 16	M - 46	M - 23
Y - 94	Y - 98	Y - 22
K - 3	K - 44	K - 6

design firm
The Wecker Group
Monterey, California
client
Green Jespersen

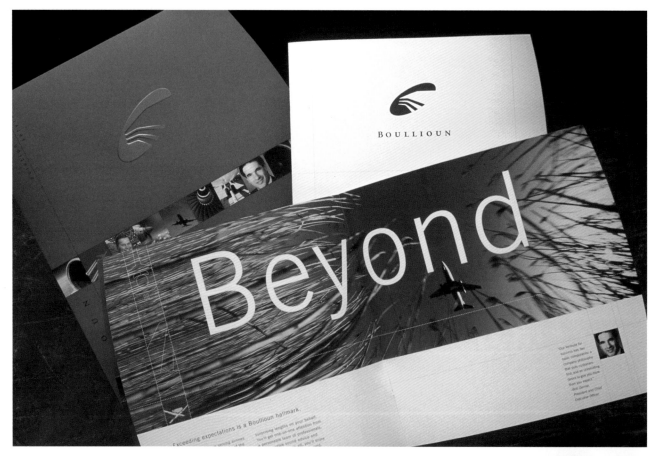

design firm
Hornall Anderson Design Works
Seattle, Washington

C - 70	C - 25
M - 56	M - 59
Y - 11	Y - 58
K - 7	K - 44

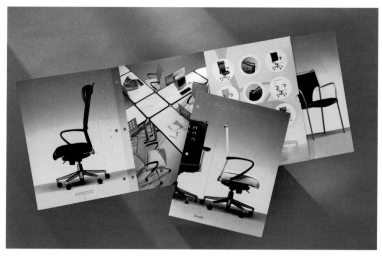

C - 13 C - 19 C - 49
M - 47 M - 63 M - 45
Y - 87 Y - 92 Y - 36
K - 4 K - 21 K - 24

design firm
5D Studio
Malibu, California
client
Arcadia

C - 22 C - 0 C - 31
M - 51 M - 5 M - 29
Y - 52 Y - 5 Y - 44
K - 40 K - 0 K - 29

design firm
Hornall Anderson Design Works
Seattle, Washington

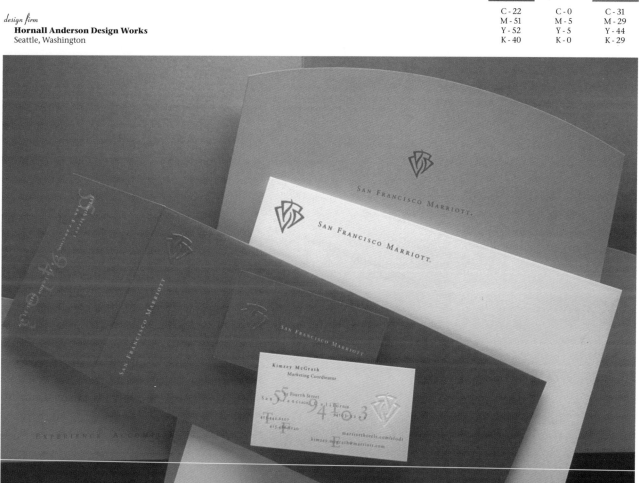

C - 89 C - 55
M - 57 M - 24
Y - 84 Y - 40
K - 26 K - 2

design firm
Greenfield/Belser Ltd.
Washington, D.C.
client
Weil Gotshal + Manges

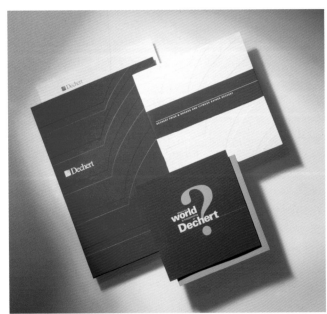

expand your reach

SHAPE AN INDUSTRY

cure the system

foster competition

CONNECT WITH OPPORTUNITY

energize wall street

protect the franchise

cover ground

manage crisis

reach out

Annual Report : 2001
WEIL, GOTSHAL & MANGES LLP

C - 50 C - 100 C - 93
M - 8 M - 84 M - 54
Y - 90 Y - 21 Y - 0
K - 2 K - 22 K - 0

design firm
Bailey Design Group Inc.
Plymouth Meeting, Pennsylvania

design firm
Bailey Design Group Inc.
Plymouth Meeting, Pennsylvania

C - 75	C - 0
M - 28	M - 23
Y - 0	Y - 68
K - 0	K - 0

TranSuite Company

A partnership of strength between two
important technology groups in
the marine logistics industry

design firm
Jiva Creative
Alameda, California
client
Embarcadero Systems Corp.

C - 59	C - 71	C - 11	C - 35
M - 51	M - 72	M - 71	M - 37
Y - 46	Y - 25	Y - 82	Y - 77
K - 9	K - 7	K - 0	K - 0

C - 100
M - 43
Y - 0
K - 0

C - 100
M - 94
Y - 0
K - 27

C - 47
M - 11
Y - 0
K - 0

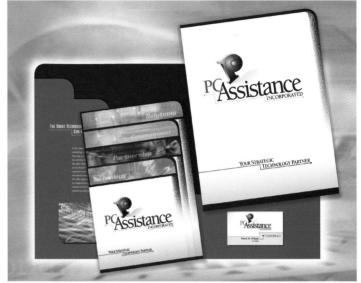

design firm
McElveney & Palozzi Design Group
Rochester, New York
client
PC Assistance, Inc.

AVERY
DENNISON

design firm
Addison
San Francisco, California
client
Avery Dennison

C - 0
M - 91
Y - 87
K - 0

C - 0
M - 0
Y - 0
K - 100

C - 88
M - 48
Y - 0
K - 2

C - 0
M - 0
Y - 0
K - 100

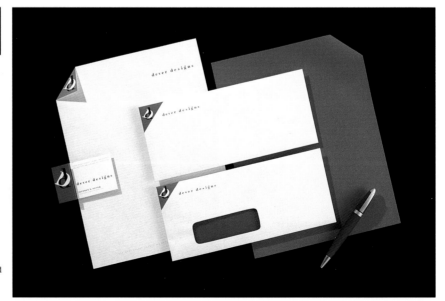

design firm
Dever Designs
Laurel, Maryland
client
Dever Designs

Federal Express

C - 90	C - 0
M - 100	M - 65
Y - 0	Y - 100
K - 0	K - 0

design firm
Addison
San Francisco, California
client
FedEx

C - 78	C - 10	C - 58
M - 38	M - 79	M - 46
Y - 18	Y - 98	Y - 40
K - 38	K - 0	K - 60

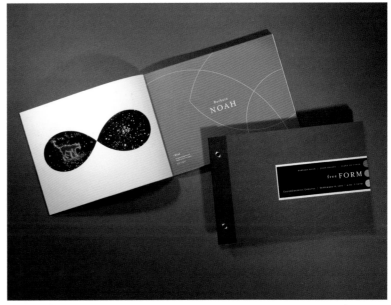

design firm
Belyea
Seattle, Washington
client
ColorGraphics

design firm
Addison
San Francisco, California
client
Alliant Energy

C - 95	C - 2
M - 71	M - 26
Y - 10	Y - 76
K - 1	K - 0

ALLIANT ENERGY™

C - 99
M - 91
Y - 7
K - 16

NEWTON LEARNING

design firm
Funk/Levis & Associates
Eugene, Oregon
client
Newton Learning Corp.

C - 93
M - 55
Y - 7
K - 5

C - 0
M - 66
Y - 99
K - 0

DataComm Plus

design firm
Lynn Cyr Design
Franklin, Massachusetts
client
Data Comm Plus

DISTINCTIVE
SOFTWARE

Better Ideas in Accounting!

C - 0
M - 15
Y - 94
K - 0

C - 94
M - 73
Y - 7
K - 1

design firm
The Wecker Group
Monterey, California

design firm
Tangram Strategic Design
Novara, Italy
client
IFM Infomaster

C - 8	C - 88
M - 100	M - 89
Y - 86	Y - 32
K - 11	K - 18

1.2.1
RELATIONSHIP
BANKING

嘉 惠 银 行 服 务

design firm
Design Objectives Pte Ltd
Singapore (Singapore)
client
United Overseas Bank

C - 40	C - 99
M - 69	M - 98
Y - 99	Y - 22
K - 0	K - 22

design firm
ZGraphics, Ltd.
East Dundee, Illinois
client
ASAP Software Express

License Technologies Group

C - 76
M - 22
Y - 41
K - 7

C - 0
M - 0
Y - 0
K - 100

Ridgewood Power

C - 0
M - 0
Y - 0
K - 65

C - 100
M - 0
Y - 70
K - 45

design firm
Straightline Int'l.
New York, New York
client
Ridgewood Power

design firm
Corey McPherson Nash
Watertown, Massachusetts
client
Tribecca

C - 45
M - 29
Y - 32
K - 11

C - 95
M - 82
Y - 26
K - 14

TRIBECA SOFTWARE

C - 50
M - 20
Y - 40
K - 0

C - 100
M - 20
Y - 20
K - 10

C - 50
M - 30
Y - 30
K - 0

design firm
Grafik
Alexandria, Virginia
client
Thomas Arledge

LONDON *by* DESIGN

design firm
Becker Design
Milwaukee, Wisconsin
client
London by Design

C - 91 C - 61
M - 91 M - 47
Y - 33 Y - 67
K - 25 K - 45

THAT **I**
MAY DWELL
AMONG
You

C - 100 C - 70
M - 0 M - 100
Y - 35 Y - 0
K - 20 K - 40

design firm
Dever Designs
Laurel, Maryland
client
Sligo Seventh-Day Adventist Church

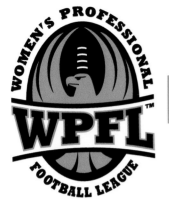

C - 0
M - 61
Y - 95
K - 0

C - 0
M - 0
Y - 0
K - 100

design firm
Compass Design
Minneapolis, Minnesota
client
Women's Professional Football League

design firm
Sayles Graphic Design
Des Moines, Iowa
client
"Art Fights Back"

C - 46
M - 46
Y - 81
K - 52

C - 100
M - 77
Y - 18
K - 15

C - 0
M - 89
Y - 93
K - 0

C - 0
M - 50
Y - 90
K - 0

C - 0
M - 72
Y - 90
K - 0

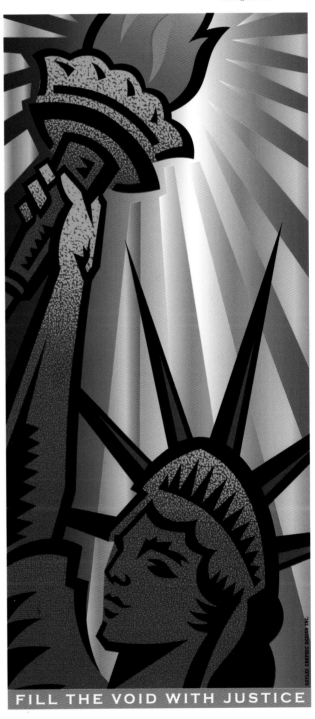

FILL THE VOID WITH JUSTICE

C - 0
M - 100
Y - 91
K - 0

C - 0
M - 27
Y - 100
K - 9

C - 51
M - 0
Y - 51
K - 69

C - 69
M - 0
Y - 60
K - 76

C - 0
M - 0
Y - 0
K - 100

design firm
Louis & Partners Design
Bath, Ohio

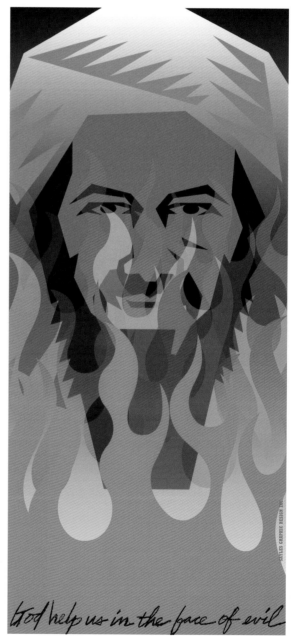

God help us in the face of evil

C - 47
M - 35
Y - 33
K - 14

C - 22
M - 70
Y - 89
K - 13

C - 0
M - 89
Y - 93
K - 0

C - 0
M - 72
Y - 90
K - 0

C - 1
M - 34
Y - 71
K - 0

design firm
Sayles Graphic Design
Des Moines, Iowa
client
"Art Fights Back"

ENERPHAZE

C - 20	C - 0
M - 70	M - 50
Y - 100	Y - 70
K - 0	K - 0

design firm
Klündt Hosmer Design
Spokane, Washington

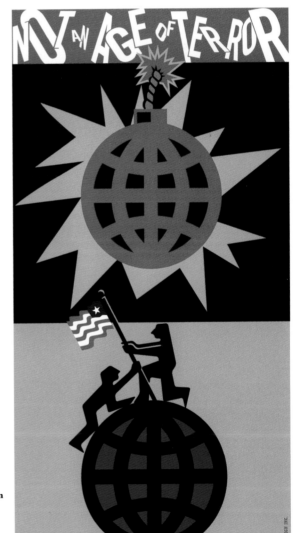

design firm
Sayles Graphic Design
Des Moines, Iowa
client
"Art Fights Back"

C - 0	C - 0	C - 99	C - 0
M - 89	M - 50	M - 62	M - 0
Y - 93	Y - 90	Y - 2	Y - 0
K - 0	K - 0	K - 1	K - 100

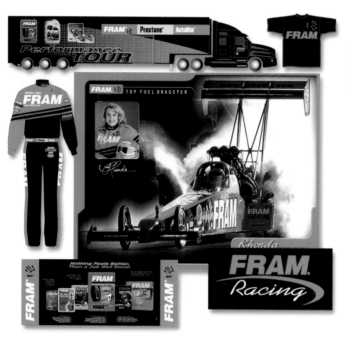

design firm
Tom Fowler, Inc.
Norwalk, Connecticut
client
Honeywell Consumer Products

C - 12
M - 91
Y - 86
K - 2

C - 0
M - 71
Y - 98
K - 0

C - 0
M - 11
Y - 92
K - 0

design firm
McCann-Erickson
Sydney (Australia)
client
Microsoft

C - 18
M - 81
Y - 31
K - 0

C - 39
M - 3
Y - 99
K - 1

C - 67
M - 27
Y - 3
K - 1

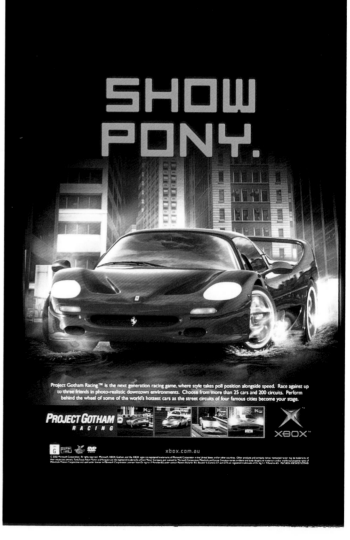

C - 0
M - 100
Y - 100
K - 0

C - 14
M - 100
Y - 100
K - 0

bad

design firm
After Hours Creative
Phoenix, Arizona

PASSION EVERLASTING

CARDIGAN RED™

(opposite) *design firm*
Design Guys
Minneapolis, Minnesota
client
Cambria

C - 18
M - 99
Y - 97
K - 13

C - 8
M - 25
Y - 87
K - 0

C - 99
M - 99
Y - 98
K - 99

C - 13
M - 92
Y - 71
K - 2

C - 1
M - 29
Y - 94
K - 0

WELLS FARGO

design firm
Addison
San Francisco, California
client
Wells Fargo

C - 9
M - 93
Y - 76
K - 8

C - 5
M - 18
Y - 89
K - 0

C - 0
M - 0
Y - 0
K - 100

design firm
Michael Osborne Design
San Francisco, California
client
Gymboree

C - 1
M - 72
Y - 7
K - 0

C - 11
M - 84
Y - 70
K - 0

C - 89
M - 75
Y - 26
K - 11

design firm
Sagmeister Inc.
New York, New York

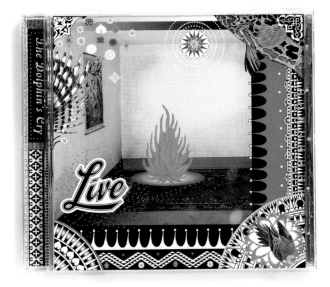

C - 1
M - 87
Y - 71
K - 23

C - 0
M - 86
Y - 72
K - 0

C - 0
M - 51
Y - 78
K - 0

design firm
Hornall Anderson Design Works
Seattle, Washington

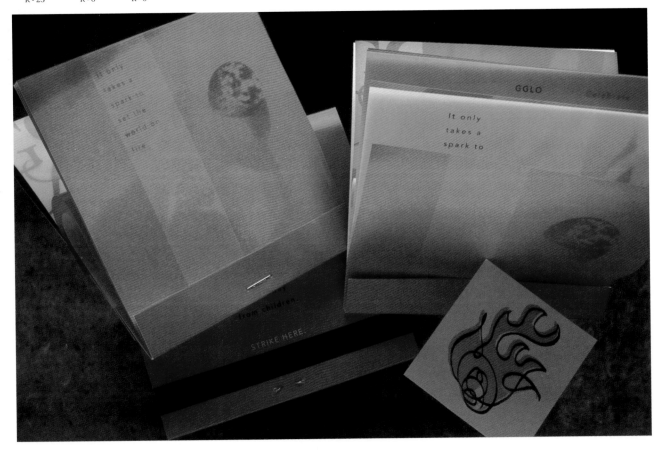

hot

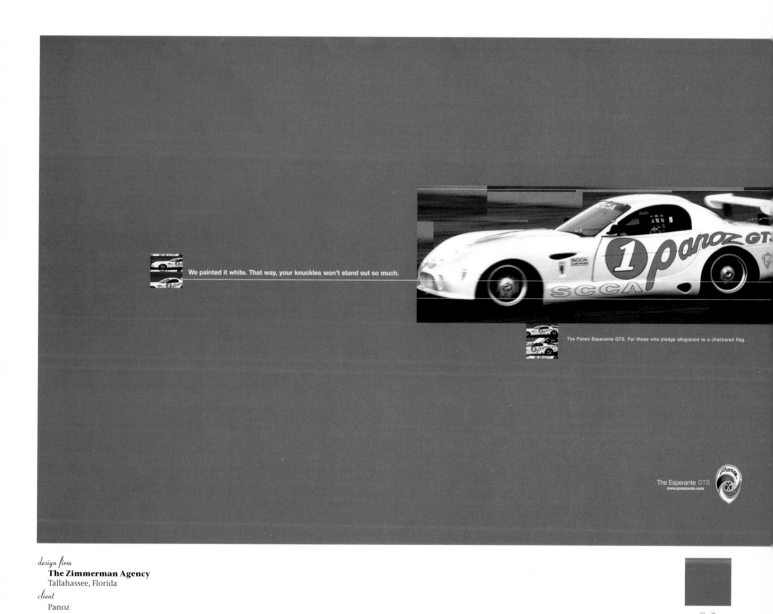

We painted it white. That way, your knuckles won't stand out so much.

The Panoz Esperante GTS. For those who pledge allegiance to a checkered flag.

The Esperante GTS
www.panozauto.com

design firm
The Zimmerman Agency
Tallahassee, Florida
client
Panoz

C - 0
M - 99
Y - 91
K - 5

it bursts when least expected

HERMAN SORGELOOS

snaps
its tether,
soars

"An explosion of energies ..." — Le Soir

Drumming, a percussion piece by noted minimalist composer Steve Reich, made its first appearance in De Keersmaeker's *Just Before*. Now, presented in full, it provides the title and material for the choreographer's latest creation. The music is based on rhythms— simple at first, then gradually gaining complexity as they multiply and overlap. So, too, the choreography. A single motion phrase, exhaustively explored through myriad combinations, variations, and transformations, is slowed down, speeded up, and reversed.

Rhythmic, unremitting, yet endlessly varied, as De Keersmaeker says, "*Drumming* is like a machine that is switched on and then goes its own way, like an unstoppable natural phenomenon."

9

C - 0	C - 0	C - 0
M - 70	M - 40	M - 0
Y - 80	Y - 90	Y - 0
K - 0	K - 0	K - 100

design firm
Agnew Moyer Smith Inc.
Pittsburgh, Pennsylvania
client
Pittsburgh Dance Council

C - 1	C - 33	C - 0
M - 50	M - 31	M - 0
Y - 89	Y - 27	Y - 0
K - 0	K - 6	K - 100

design firm
Full Steam Marketing & Design
Salinas, California
client
Stoked Media

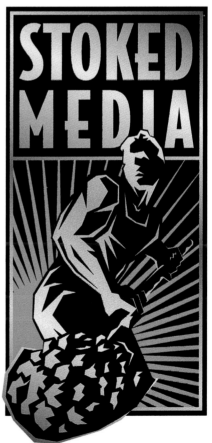

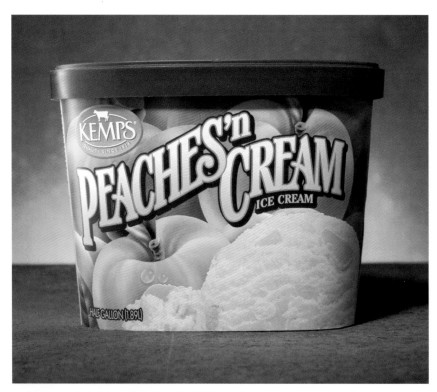

design firm
Compass Design
Minneapolis, Minnesota

C - 44	C - 0	C - 5
M - 29	M - 24	M - 78
Y - 91	Y - 86	Y - 91
K - 32	K - 0	K - 1

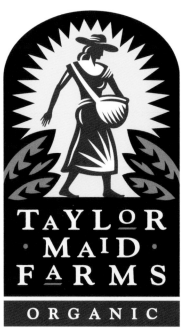

design firm
Greteman Group
Wichita, Kansas

C - 34	C - 0	C - 0
M - 0	M - 76	M - 5
Y - 72	Y - 76	Y - 43
K - 83	K - 60	K - 0

GreenTree

LENDING GROUP

C - 94	C - 35
M - 22	M - 31
Y - 80	Y - 49
K - 8	K - 15

design firm
Becker Design
Milwaukee, Wisconsin
client
HR Value Group

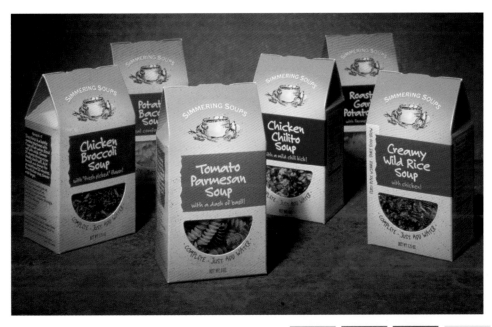

design firm
Compass Design
Minneapolis, Minnesota

C - 0	C - 12	C - 74	C - 1	C - 34	C - 74
M - 50	M - 91	M - 38	M - 7	M - 60	M - 50
Y - 85	Y - 100	Y - 29	Y - 67	Y - 85	Y - 25
K - 0	K - 2	K - 32	K - 0	K - 53	K - 47

joint replacement
center

C - 76	C - 35
M - 64	M - 14
Y - 64	Y - 22
K - 12	K - 0

 Alegent Health
Orthopaedic Services

design firm
Dotzler Creative Arts
Omaha, Nebraska

C - 95	C - 88
M - 85	M - 15
Y - 0	Y - 99
K - 2	K - 0

FOOD & SOCIETY

design firm
Levine & Associates
Washington, D.C.
client
The Kellog Foundation

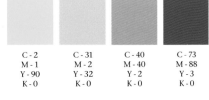

C - 2	C - 31	C - 40	C - 73
M - 1	M - 2	M - 40	M - 88
Y - 90	Y - 32	Y - 2	Y - 3
K - 0	K - 0	K - 0	K - 0

design firm
Tom Fowler, Inc.
Norwalk, Connecticut
client
Playtex Products, Inc.

design firm
Bald & Beautiful
Venice, California
client
Arby's

C - 33	C - 0
M - 86	M - 0
Y - 23	Y - 0
K - 17	K - 100

C - 35　　C - 44　　C - 43
M - 12　　M - 9　　 M - 96
Y - 2　　　Y - 89　　Y - 3
K - 0　　　K - 3　　　K - 1

design firm
Dever Designs
Laurel, Maryland
client
The Front Porch Magazine

design firm
Compass Design
Minneapolis, Minnesota
client
Kemps Marigold

C - 9　　 C - 78　　C - 44　　C - 36　　C - 5
M - 99　　M - 13　　M - 26　　M - 80　　M - 49
Y - 96　　Y - 0　　　Y - 76　　Y - 82　　Y - 88
K - 11　　K - 0　　　K - 0　　　K - 7　　　K - 0

148

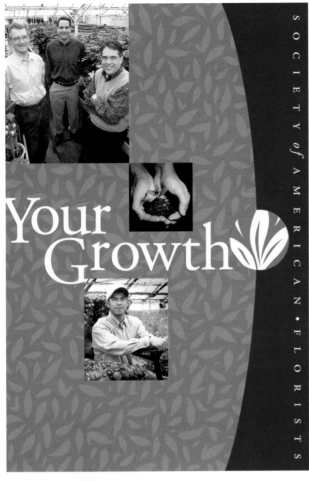

Your Growth

design firm
Dever Designs
Laurel, Maryland
client
Society of American Florists

C - 35	C - 100
M - 0	M - 35
Y - 100	Y - 0
K - 40	K - 60

design firm
Tom Ventress Design
Nashville, Tennessee
client
Walker Foods

C - 0	C - 0	C - 0	C - 100
M - 100	M - 0	M - 5	M - 0
Y - 100	Y - 0	Y - 50	Y - 100
K - 0	K - 100	K - 0	K - 0

C - 42	C - 59	C - 65	C - 45
M - 6	M - 20	M - 65	M - 6
Y - 53	Y - 74	Y - 21	Y - 20
K - 2	K - 17	K - 25	K - 10

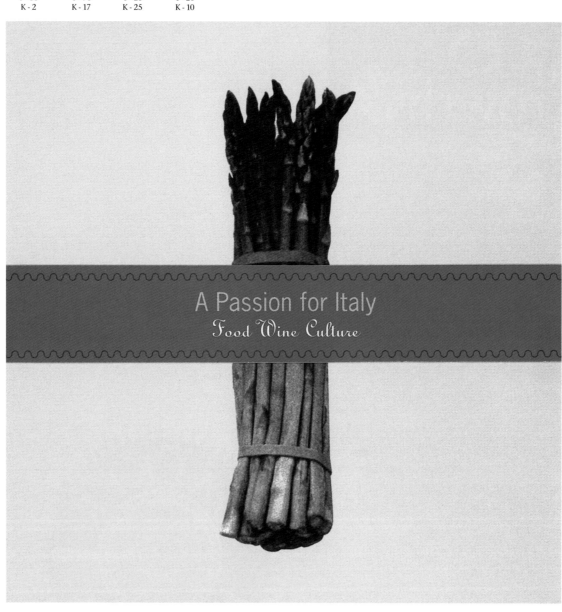

A Passion for Italy
Food Wine Culture

design firm
John Kneapler Design
New York, New York
client
The James Beard Foundation

C - 75
M - 38
Y - 71
K - 2

C - 36
M - 36
Y - 68
K - 0

spabotanica

SINGAPORE

design firm
Design Objectives Pte Ltd
Singapore (Singapore)
client
HKR Limited (Hong Kong)

design firm
Tangram Strategic Design
Novara (Italy)
client
Prénatal

C - 48
M - 28
Y - 4
K - 0

C - 85
M - 80
Y - 20
K - 0

C - 1
M - 38
Y - 54
K - 0

design firm
Hornall Anderson Design Works
Seattle, Washington

C - 2
M - 62
Y - 71
K - 3

C - 6
M - 87
Y - 67
K - 20

C - 44
M - 38
Y - 42
K - 48

Medical
Rehabilitation
Consultants
Contain Costs. Add Value. Improve Care.

design firm
Klündt Hosmer Design
Spokane, Washington

C - 80
M - 60
Y - 0
K - 0

C - 0
M - 0
Y - 0
K - 100

MONTEREY PACIFIC

APPLIED
AGRICULTURAL
TECHNOLOGIES

design firm
The Wecker Group
Monterey, California

C - 0	C - 100	C - 50
M - 0	M - 50	M - 0
Y - 0	Y - 100	Y - 100
K - 100	K - 0	K - 0

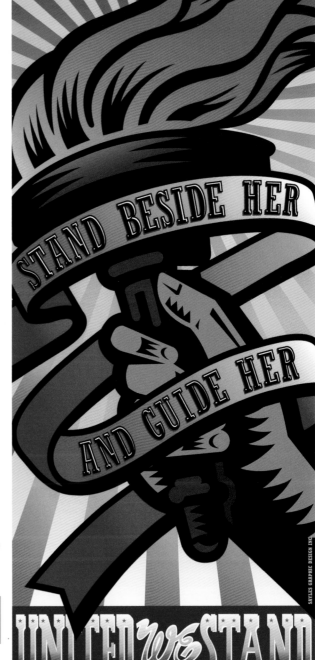

design firm
Sayles Graphic Design
Des Moines, Iowa
client
"Art Fights Back"

C - 0	C - 61	C - 47	C - 74	C - 0
M - 89	M - 31	M - 35	M - 92	M - 50
Y - 93	Y - 83	Y - 33	Y - 15	Y - 90
K - 0	K - 54	K - 14	K - 4	K - 0

153

design firm
Lemley Design Company
Seattle, Washington
client
REI

C - 38	C - 22	C - 0
M - 89	M - 62	M - 0
Y - 99	Y - 99	Y - 0
K - 16	K - 0	K - 100

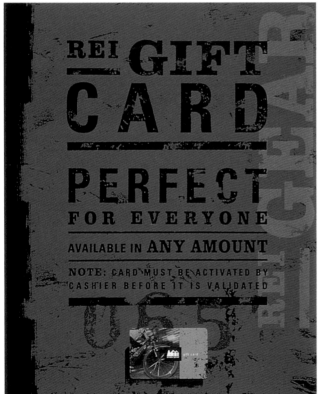

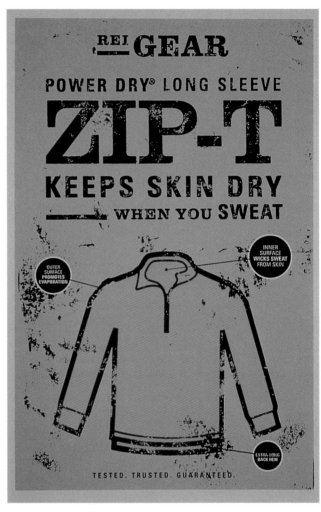

C - 58	C - 15	C - 31
M - 37	M - 73	M - 41
Y - 58	Y - 99	Y - 58
K - 2	K - 0	K - 0

design firm
Lemley Design Company
Seattle, Washington
client
REI

C - 25 C - 16
M - 57 M - 43
Y - 83 Y - 61
K - 25 K - 6

design firm
Klündt Hosmer Design
Spokane, Washington
client
Telect

C - 45 C - 15 C - 91
M - 37 M - 43 M - 78
Y - 82 Y - 88 Y - 22
K - 38 K - 5 K - 24

design firm
Burrows
Shenfield (United Kingdom)
client
Ford Motor Company

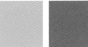
durable

design firm
Designation
New York, New York

C - 25 C - 41
M - 25 M - 45
Y - 25 Y - 48
K - 2 K - 24

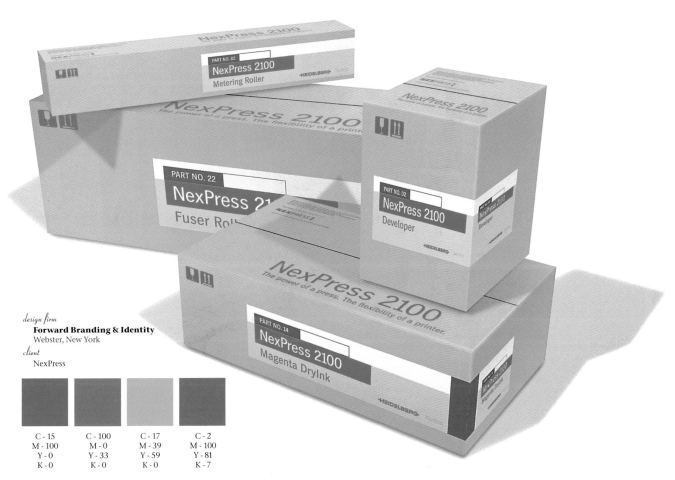

design firm
Forward Branding & Identity
Webster, New York
client
NexPress

C - 15 C - 100 C - 17 C - 2
M - 100 M - 0 M - 39 M - 100
Y - 0 Y - 33 Y - 59 Y - 81
K - 0 K - 0 K - 0 K - 7

C - 0
M - 26
Y - 95
K - 0

C - 0
M - 99
Y - 84
K - 13

C - 0
M - 0
Y - 0
K - 100

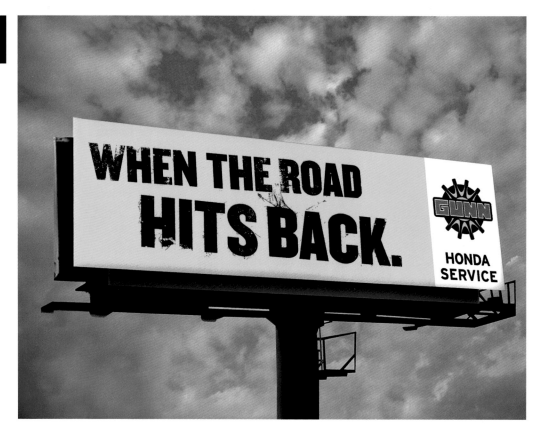

WHEN THE ROAD HITS BACK.

GUNN
HONDA SERVICE

design firm
Toolbox Studios, Inc.
San Antonio, Texas
client
Gunn Automotive

design firm
Baer Design Group
Evanston, Illinois
client
Appropriate Temporaries, Inc.

C - 88
M - 71
Y - 45
K - 9

C - 20
M - 39
Y - 71
K - 0

C - 39
M - 82
Y - 80
K - 0

C - 13
M - 47
Y - 62
K - 0

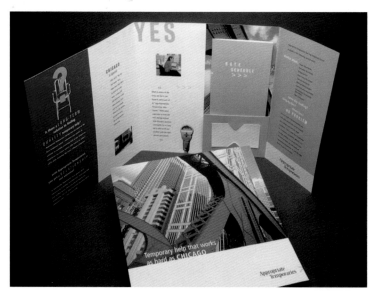

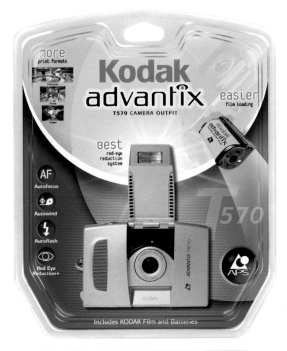

design firm
McElveney & Palozzi Design Group
Rochester, New York
client
Eastman Kodak Company

C - 0	C - 0	C - 41	C - 76
M - 100	M - 18	M - 89	M - 95
Y - 100	Y - 100	Y - 0	Y - 0
K - 0	K - 0	K - 0	K - 0

design firm
Dever Designs
Laurel, Maryland
client
Liberty Magazine

design firm
Supon Design Group
Washington, D.C.
client
Ulman Paper Bag Company

C - 0
M - 0
Y - 0
K - 100

C - 0	C - 5	C - 46	C - 0
M - 10	M - 59	M - 19	M - 0
Y - 100	Y - 80	Y - 25	Y - 0
K - 0	K - 15	K - 48	K - 100

C - 75	C - 0	C - 0	C - 72	C - 83	C - 100	C - 2
M - 28	M - 89	M - 72	M - 8	M - 23	M - 77	M - 20
Y - 3	Y - 93	Y - 90	Y - 64	Y - 83	Y - 18	Y - 25
K - 2	K - 0	K - 0	K - 2	K - 18	K - 15	K - 0

design firm
Sayles Graphic Design
Des Moines, Iowa
client
"Art Fights Back"

Meta • **logic**

C - 0	C - 0	C - 0
M - 100	M - 0	M - 0
Y - 100	Y - 0	Y - 0
K - 0	K - 42	K - 100

design firm
Ron Bartels Design
Lincoln, Nebraska
client
Meta•Logic Software Developer

C - 8
M - 93
Y - 85
K - 1

C - 32
M - 25
Y - 32
K - 2

C - 0
M - 0
Y - 0
K - 100

design firm
Studio Archetype
San Francisco, California
client
Studio Archetype

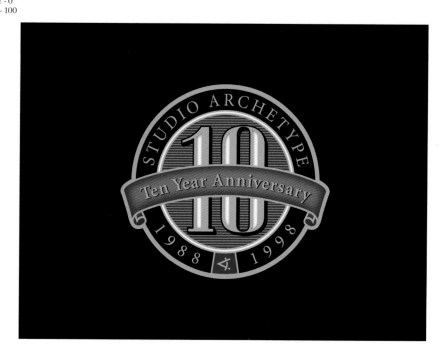

UNIVERSITY SQUARE

design firm
Bailey Design Group
Plymouth Meeting, Pennsylvania

C - 80
M - 36
Y - 0
K - 0

C - 3
M - 4
Y - 100
K - 6

C - 30
M - 70
Y - 0
K - 19

C - 0
M - 0
Y - 0
K - 70

Keiler & Company is proud to present this book of trees. We have been privileged to explore and communicate many topics and points of view for corporate and business clients since 1973. **AMONG TREES** is an inspiring example of creative collaboration at its best, and a reminder that the art of communication is as much alive as the science. We hope you enjoy this unique photographic journey.

Spokane Chamber
SPOKANE REGIONAL CHAMBER OF COMMERCE

design firm
Klündt Hosmer Design
Spokane, Washington

C - 79 C - 0
M - 72 M - 87
Y - 100 Y - 83
K - 0 K - 30

C - 23 C - 0
M - 15 M - 0
Y - 15 Y - 0
K - 1 K - 100

design firm
Tiffany + Company
New York, New York
client
Tiffany + Company

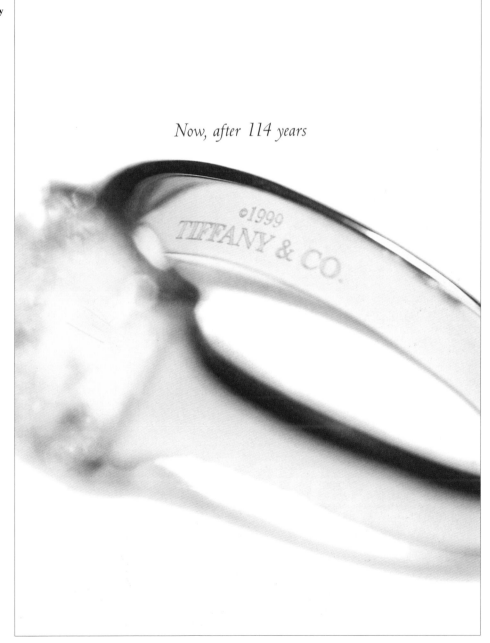

Now, after 114 years

©1999
TIFFANY & CO.

(opposite) design firm
Keiler & Company
Farmington, Connecticut
client
Sean Kernan Photo/
Keiler & Allied Printing

C - 40 C - 54 C - 0
M - 50 M - 46 M - 0
Y - 60 Y - 43 Y - 0
K - 10 K - 35 K - 100

design firm
Louis & Partners Design
Bath, Ohio
client
San Francisco Oven

C - 0	C - 0	C - 6
M - 91	M - 24	M - 9
Y - 100	Y - 76	Y - 24
K - 40	K - 0	K - 0

C - 60	C - 10
M - 50	M - 15
Y - 15	Y - 40
K - 0	K - 0

BRUSCHETTA COMBO

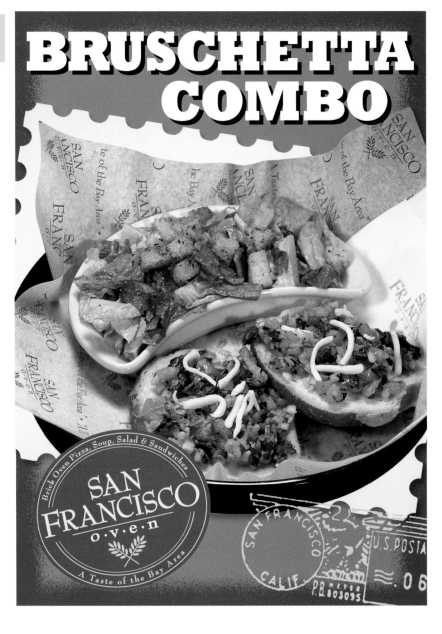

C - 0	C - 57	C - 16	C - 0
M - 100	M - 0	M - 31	M - 0
Y - 91	Y - 100	Y - 56	Y - 0
K - 0	K - 0	K - 0	K - 100

design firm
Louis & Partners Design
Bath, Ohio
client
Eat N' Park

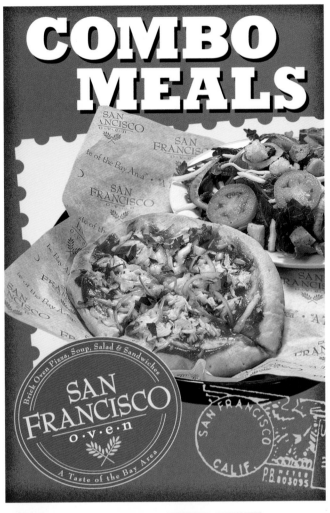

COMBO MEALS

C - 0 M - 91 Y - 100 K - 40	C - 0 M - 24 Y - 76 K - 0	C - 6 M - 9 Y - 24 K - 0	C - 0 M - 50 Y - 50 K - 50	C - 10 M - 25 Y - 45 K - 0

design firm
Louis & Partners Design
Bath, Ohio
client
San Francisco Oven

design firm
Louis & Partners Design
Bath, Ohio
client
San Francisco Oven

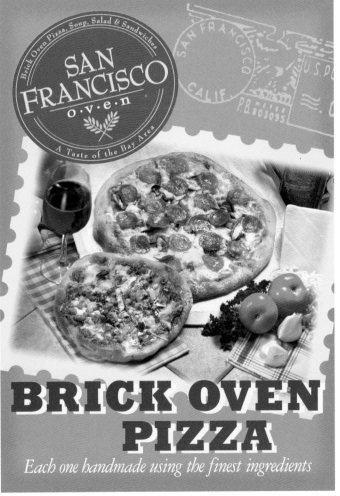

BRICK OVEN
PIZZA
Each one handmade using the finest ingredients

C - 0 M - 91 Y - 100 K - 40	C - 0 M - 24 Y - 76 K - 0	C - 6 M - 9 Y - 24 K - 0
C - 40 M - 25 Y - 50 K - 0	C - 0 M - 65 Y - 65 K - 70	C - 10 M - 25 Y - 45 K - 0

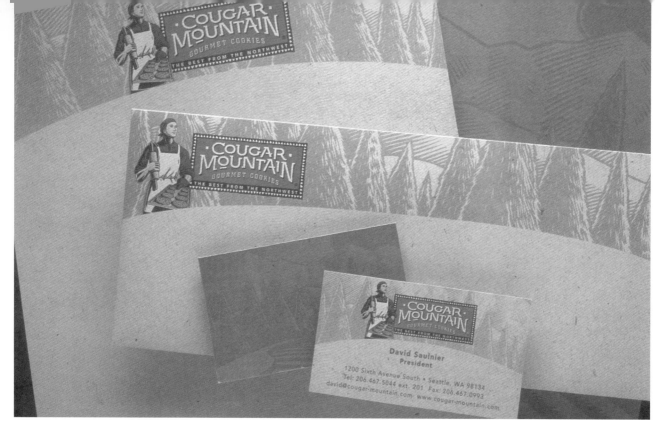

David Saulnier
President

1200 Sixth Avenue South • Seattle, WA 98134
Tel: 206.467.5044 ext. 201 Fax: 206.467.0993
david@cougar-mountain.com www.cougar-mountain.com

design firm
Hornall Anderson Design Works
Seattle, Washington

C - 0	C - 36	C - 0
M - 58	M - 13	M - 26
Y - 31	Y - 3	Y - 35
K - 46	K - 55	K - 45

design firm
Pearlfisher
London (England)

C - 16	C - 69	C - 20	C - 30
M - 89	M - 80	M - 100	M - 44
Y - 84	Y - 35	Y - 30	Y - 100
K - 5	K - 20	K - 1	K - 7

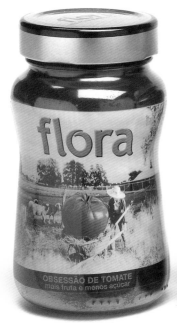 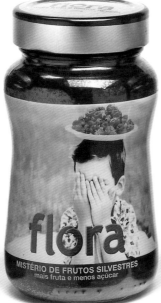

OBSESSÃO DE TOMATE
mais fruta e menos açúcar

MISTÉRIO DE FRUTOS SILVESTRES
mais fruta e menos açúcar

FÚRIA DE 4 FRUTOS
mais fruta e menos açúcar

PÊSSEGO EM CALMA
mais fruta e menos açúcar

design firm
Klündt Hosmer Design
Spokane, Washington
client
Maryhill Winery

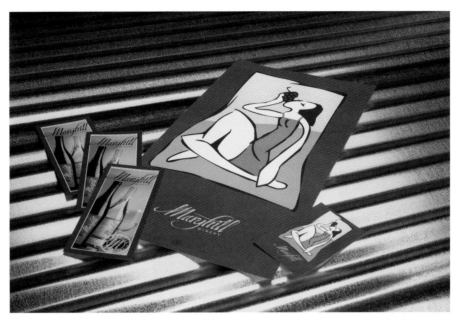

C - 17	C - 18	C - 0	C - 0
M - 80	M - 20	M - 71	M - 17
Y - 54	Y - 58	Y - 81	Y - 50
K - 52	K - 13	K - 10	K - 4

C - 27	C - 38	C - 12	C - 2
M - 88	M - 0	M - 86	M - 36
Y - 10	Y - 75	Y - 80	Y - 86
K - 0	K - 0	K - 2	K - 0

design firm
Pearlfisher
London (England)

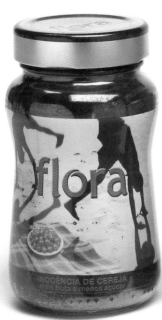
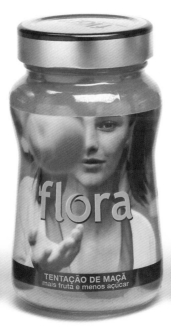

INOCÊNCIA DE CEREJA
mais fruta e menos açúcar

TENTAÇÃO DE MAÇÃ
mais fruta e menos açúcar

ATREVIMENTO DE MORANGO
mais fruta e menos açúcar

IMPULSOS DE LARANJA
mais fruta e menos açúcar

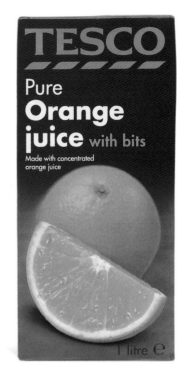

C - 46	C - 33	C - 28	C - 11	C - 100	C - 74	C - 19
M - 5	M - 5	M - 91	M - 86	M - 85	M - 27	M - 39
Y - 83	Y - 50	Y - 61	Y - 57	Y - 3	Y - 12	Y - 78
K - 0	K - 0	K - 16	K - 1	K - 0	K - 0	K - 1

design firm
Pearlfisher
London (England)

C - 25	C - 18	C - 65	C - 69
M - 99	M - 63	M - 113	M - 66
Y - 100	Y - 99	Y - 61	Y - 15
K - 19	K - 7	K - 6	K - 21

design firm
Tom Fowler, Inc.
Norwalk, Connecticut
client
Tom Fowler

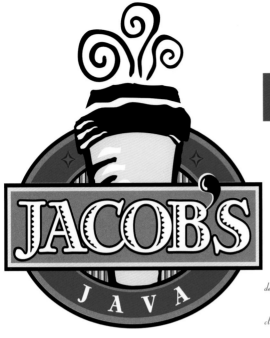

C - 100	C - 0	C - 0	C - 0
M - 43	M - 60	M - 11	M - 0
Y - 0	Y - 100	Y - 47	Y - 0
K - 18	K - 18	K - 0	K - 100

design firm
Klündt Hosmer Design
Spokane, Washington
client
Jacob's Java

design firm
Hornall Anderson Design Works
Seattle, Washington

C - 2	C - 73	C - 58	C - 5
M - 91	M - 62	M - 29	M - 31
Y - 65	Y - 43	Y - 59	Y - 52
K - 1	K - 20	K - 15	K - 1

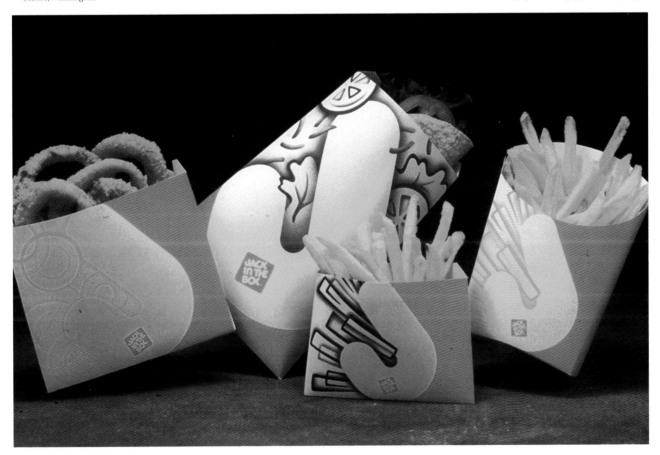

C - 14	C - 12	C - 91
M - 44	M - 91	M - 78
Y - 98	Y - 86	Y - 22
K - 5	K - 2	K - 24

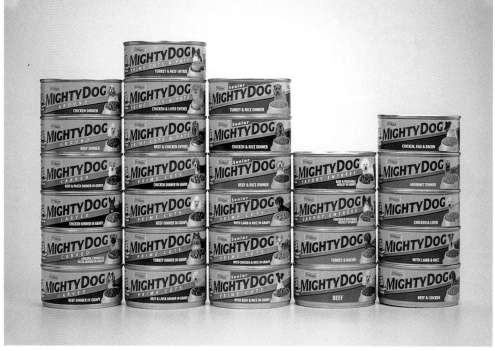

design firm
Thompson Design Group
San Francisco, California
client
Nestlé Purina Pet Care Division

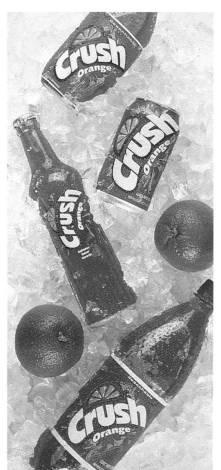

C - 67	C - 14	C - 39
M - 78	M - 34	M - 88
Y - 27	Y - 82	Y - 67
K - 8	K - 0	K - 5

C - 20	C - 10	C - 66
M - 66	M - 28	M - 52
Y - 75	Y - 75	Y - 69
K - 0	K - 0	K - 15

design firm
LIFT Creative
Atlanta, Georgia
client
Cadbury Beverages

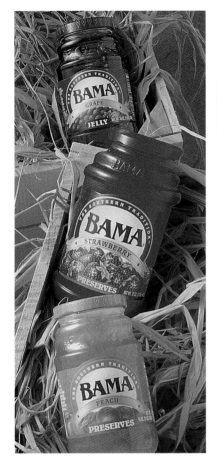

C - 15	C - 33	C - 61	C - 78
M - 43	M - 86	M - 90	M - 78
Y - 88	Y - 23	Y - 22	Y - 9
K - 5	K - 17	K - 0	K - 1

design firm
LIFT Creative
Atlanta, Georgia

client
Welch

design firm
Be.Design
San Rafael, California

client
Williams-Sonoma, Inc.

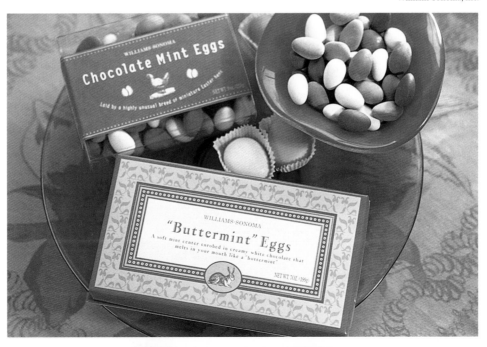

C - 81	C - 27	C - 13	C - 63
M - 42	M - 4	M - 45	M - 9
Y - 36	Y - 5	Y - 20	Y - 42
K - 0	K - 0	K - 0	K - 0

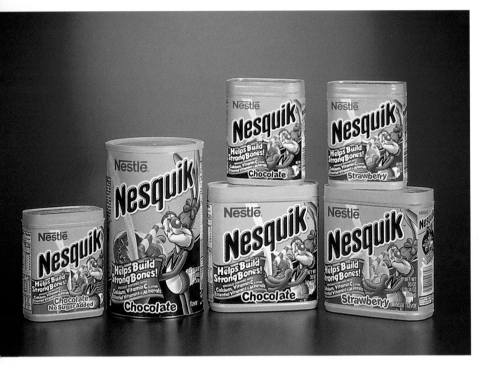

C - 0	C - 62	C - 93
M - 25	M - 51	M - 54
Y - 94	Y - 49	Y - 0
K - 0	K - 63	K - 0

design firm
Thompson Design Group
San Francisco, California
client
Nestle USA, Inc – Beverage

C - 91	C - 11	C - 1	C - 8	C - 73
M - 78	M - 98	M - 6	M - 63	M - 69
Y - 22	Y - 85	Y - 72	Y - 83	Y - 52
K - 24	K - 2	K - 0	K - 0	K - 32

design firm
Cornerstone
New York, New York
client
Goodmark Foods

172

design firm
Thompson Design Group
San Francisco, California
client
Foster Farms

C - 11 C - 0
M - 98 M - 51
Y - 85 Y - 95
K - 2 K - 0

design firm
Thompson Design Group
San Francisco, California
client
Nestlé USA, Inc.—Beverage Division

C - 0 C - 11 C - 65
M - 25 M - 98 M - 74
Y - 94 Y - 85 Y - 35
K - 0 K - 2 K - 70

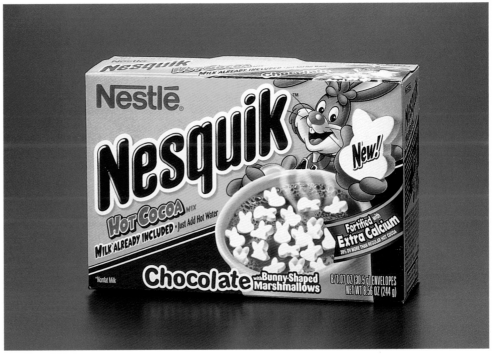

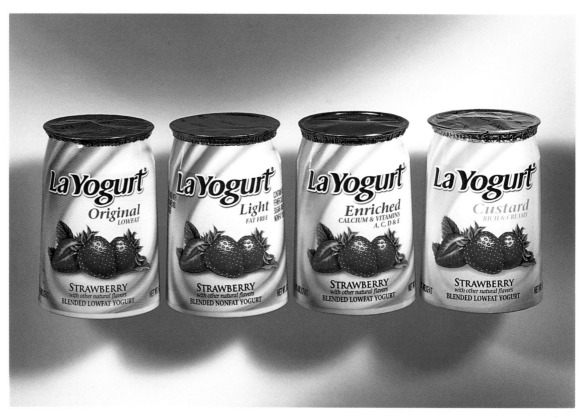

design firm
Cornerstone
New York, New York
client
Johanna Foods

C - 4	C - 56	C - 29	C - 12	C - 0
M - 55	M - 24	M - 99	M - 68	M - 13
Y - 7	Y - 0	Y - 77	Y - 0	Y - 65
K - 0	K - 0	K - 0	K - 0	K - 0

C - 19	C - 89	C - 0	C - 95
M - 98	M - 36	M - 4	M - 1
Y - 74	Y - 14	Y - 66	Y - 40
K - 0	K - 0	K - 0	K - 0

design firm
Gammon Ragonesi Associates
New York, New York
client
Beer Nuts

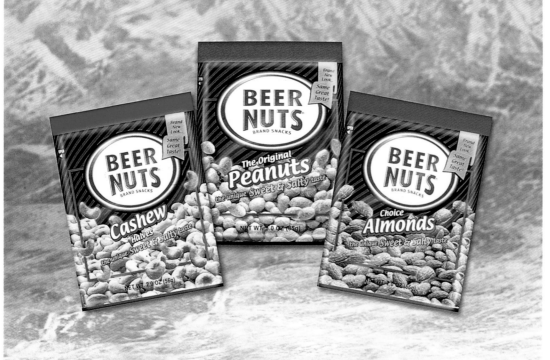

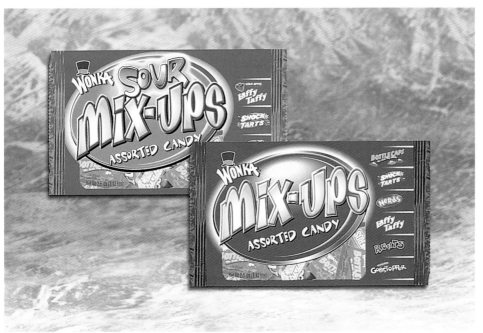

C - 45 C - 81 C - 1
M - 64 M - 13 M - 6
Y - 7 Y - 74 Y - 72
K - 5 K - 4 K - 0

design firm
Gammon Ragonesi Associates
New York, New York
client
Nestlé USA

C - 58 C - 80 C - 21 C - 99
M - 99 M - 47 M - 34 M - 60
Y - 27 Y - 99 Y - 97 Y - 6
K - 0 K - 0 K - 0 K - 2

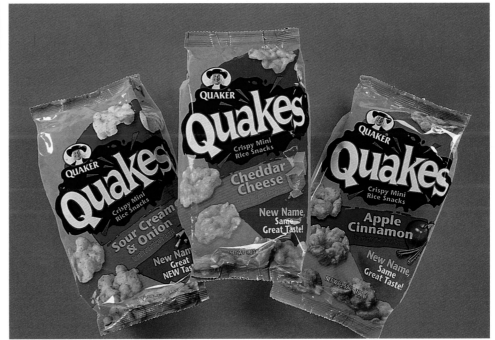

design firm
Haugaard Creative Group
Chicago, Illinois
client
Quaker Oats

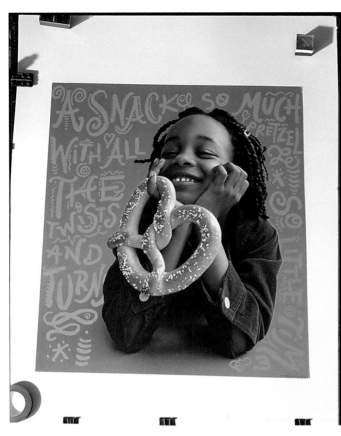

C - 12
M - 83
Y - 79
K - 2

C - 69
M - 44
Y - 0
K - 0

C - 5
M - 31
Y - 78
K - 0

C - 49
M - 27
Y - 89
K - 0

C - 31
M - 78
Y - 40
K - 2

C - 18
M - 66
Y - 78
K - 2

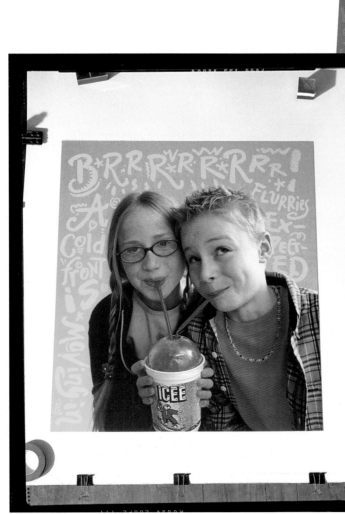

design firm
Graphiculture
Minneapolis, Minnesota
client
Target

Wholes**o**me Go**o**dnes**s** Natura**ll**y!

C - 96	C - 0	C - 0
M - 74	M - 97	M - 47
Y - 3	Y - 97	Y - 100
K - 0	K - 0	K - 0

English Hotbreads
Established 1966

design firm
Fixgo Advertising (M) Sdn Bhd
Subang Jaya (Malaysia)
client
English Hotbreads (Sel) Sdn Bhd

design firm
Zunda Design Group
South Norwalk, Connecticut
client
Sbarro Corporation

C - 96	C - 0	C - 0
M - 4	M - 100	M - 13
Y - 99	Y - 100	Y - 69
K - 0	K - 11	K - 0

mama sbarro
Cheesecake

C - 19	C - 64	C - 98	C - 83
M - 98	M - 39	M - 80	M - 54
Y - 100	Y - 99	Y - 39	Y - 0
K - 10	K - 26	K - 31	K - 0

design firm
Baer Design Group
Evanston, Illinois
client
Meijer

design firm
Praxis Diseñadores, S.C.
México City (Mexico)
client
Valle Redondo

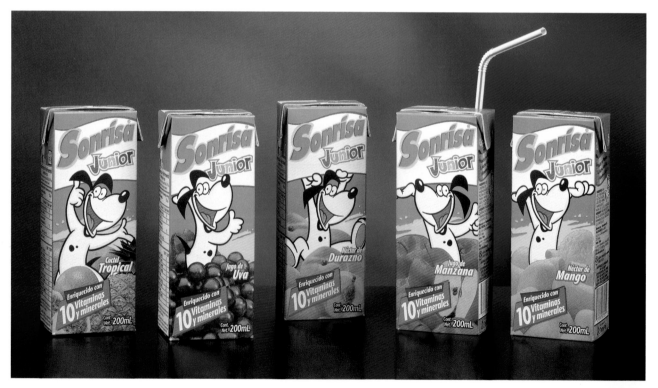

C - 80	C - 0
M - 0	M - 10
Y - 90	Y - 100
K - 0	K - 0

tasty

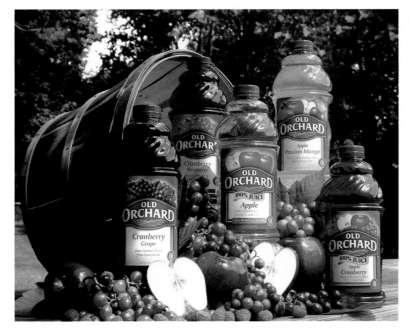

C - 72
M - 0
Y - 100
K - 0

C - 11
M - 100
Y - 97
K - 3

design firm
Bailey Design Group Inc.
Plymouth Meeting, Pennsylvania

design firm
McElveney & Palozzi Design Group
Rochester, New York
client
Ahold USA—Tops Division

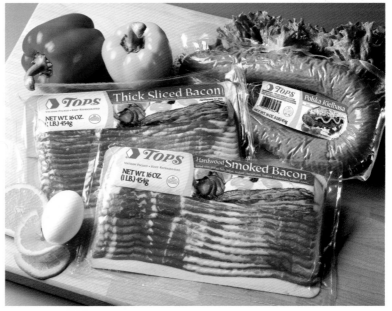

C - 0
M - 22
Y - 100
K - 0

C - 0
M - 100
Y - 100
K - 0

C - 0
M - 9
Y - 23
K - 0

179

design firm
Tangram Strategic Design
Novara, Italy
client
MDO

C - 9
M - 51
Y - 74
K - 0

C - 82
M - 36
Y - 87
K - 11

C - 100
M - 85
Y - 0
K - 0

C - 16
M - 100
Y - 83
K - 3

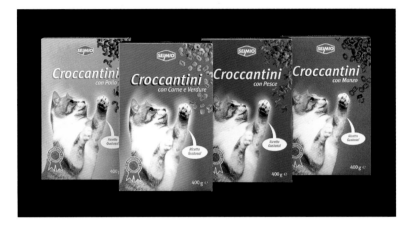

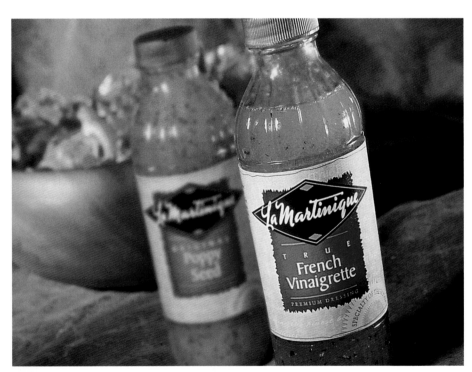

C - 83
M - 14
Y - 43
K - 4

C - 12
M - 91
Y - 86
K - 2

C - 13
M - 72
Y - 88
K - 3

design firm
Interbrand
New York, New York
client
Reily Foods

180

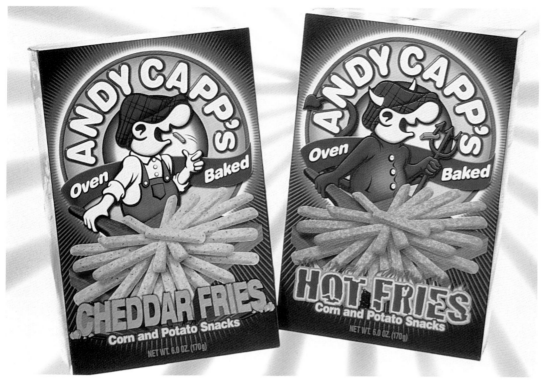

C - 26　　C - 0　　C - 91
M - 99　　M - 25　　M - 78
Y - 73　　Y - 67　　Y - 22
K - 20　　K - 0　　K - 24

design firm
Cornerstone
New York, New York
client
Goodmark Foods

C - 62　　C - 11　　C - 20
M - 51　　M - 98　　M - 12
Y - 49　　Y - 85　　Y - 71
K - 63　　K - 2　　K - 3

design firm
Gauger + Santz
San Francisco, California
client
Atkins Nutritionals

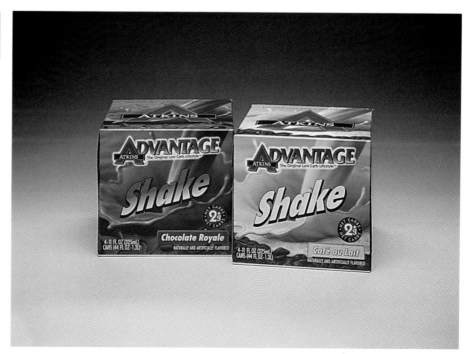

design firm
Design Forum
Dayton, Ohio
client
Dunkin' Donuts

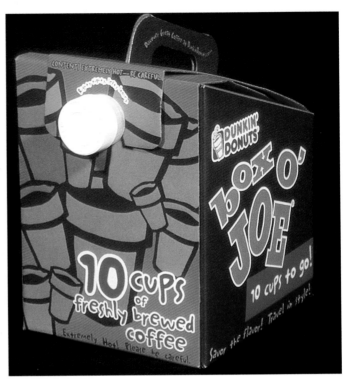

C - 13	C - 11	C - 47
M - 72	M - 98	M - 92
Y - 88	Y - 85	Y - 73
K - 3	K - 2	K - 15

C - 0	C - 0	C - 25	C - 29
M - 14	M - 40	M - 93	M - 85
Y - 78	Y - 84	Y - 93	Y - 84
K - 0	K - 0	K - 21	K - 48

design firm
Compass Design
Minneapolis, Minnesota

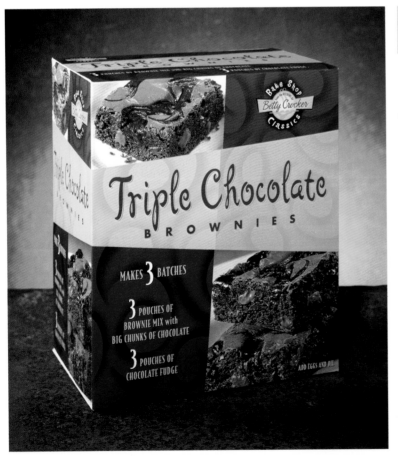

C - 29
M - 29
Y - 39
K - 0

C - 79
M - 60
Y - 51
K - 23

C - 45
M - 99
Y - 76
K - 5

C - 0
M - 21
Y - 75
K - 0

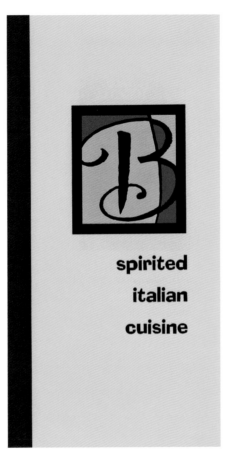

spirited

italian

cuisine

design firm
The Lemonides Design Group, Inc.
Glen Mills, Pennsylvania
client
Bellissimo

design firm
Wallace Church, Inc.
New York, New York
client
Ciao Bella Gelato Co., Inc.

C - 15
M - 82
Y - 100
K - 0

C - 73
M - 80
Y - 29
K - 20

C - 41
M - 95
Y - 66
K - 6

C - 10	C - 10	C - 0
M - 100	M - 0	M - 10
Y - 60	Y - 70	Y - 80
K - 10	K - 20	K - 10

design firm
McElveney & Palozzi Design Group
Rochester, New York
client
Wegmans Food Markets

C - 10	C - 0	C - 65	C - 0
M - 0	M - 100	M - 0	M - 65
Y - 100	Y - 0	Y - 100	Y - 83
K - 0	K - 24	K - 0	K - 0

C - 33	C - 0
M - 86	M - 25
Y - 23	Y - 67
K - 17	K - 0

design firm
Gammon Ragonesi Associates
New York, New York
client
Nestlé Ice Cream Company

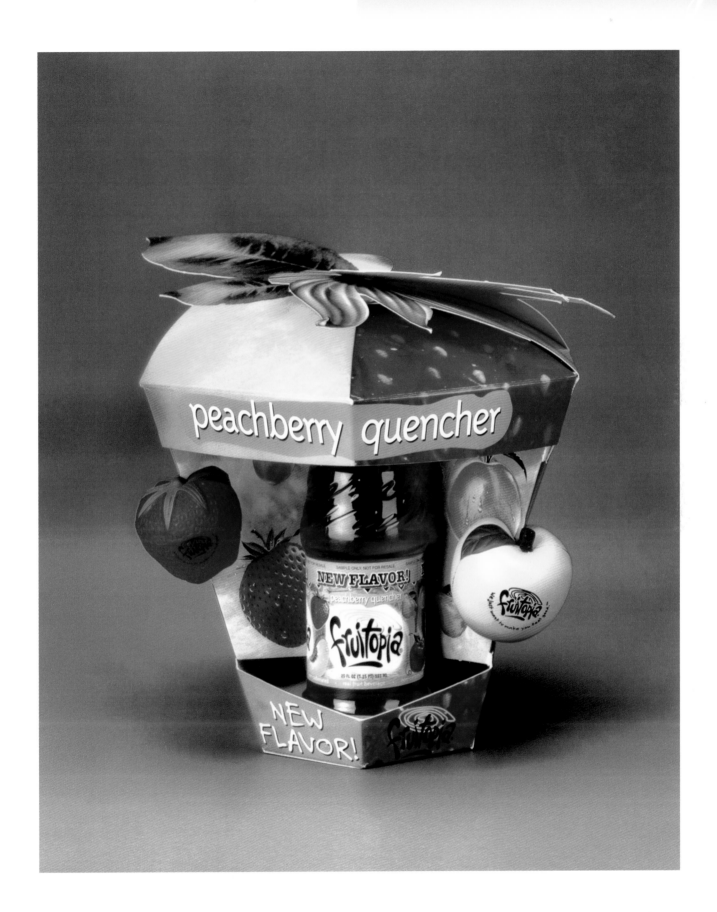

BioForm

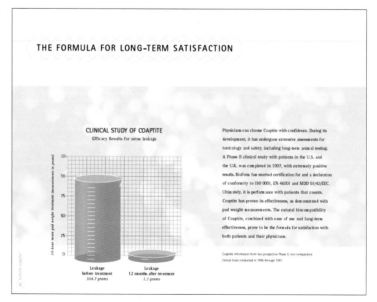

Coaptite® *soft tissue bulking material*

THE NEW FORMULA FOR THE TREATMENT OF STRESS INCONTINENCE.

BioForm

C - 100	C - 14	C - 32	C - 58
M - 60	M - 3	M - 11	M - 12
Y - 0	Y - 3	Y - 95	Y - 13
K - 6	K - 0	K - 3	K - 3

design firm
Becker Design
Milwaukee, Wisconsin
client
BioForm

THE FORMULA FOR LONG-TERM SATISFACTION

CLINICAL STUDY OF COAPTITE
Efficacy Results for urine leakage

Physicians can choose Coaptite with confidence. During its development, it has undergone extensive assessments for toxicology and safety, including long-term animal testing. A Phase II clinical study with patients in the U.S. and the U.K. was completed in 1997, with extremely positive results. BioForm has received certification for and a declaration of conformity to ISO 9001, EN 46001 and MDD 93/42/EEC. Ultimately, it is performance with patients that counts. Coaptite has proven its effectiveness, as demonstrated with pad weight measurements. The natural biocompatibility of Coaptite, combined with ease of use and long-term effectiveness, prove to be the formula for satisfaction with both patients and their physicians.

Coaptite information from two prospective Phase II, non-comparative clinical trials conducted in 1996 through 1997

Leakage
before treatment
104.7 grams

Leakage
12 months after treatment
1.1 grams

design firm
Sayles Graphic Design
Des Moines, Iowa
client
"Art Fights Back"

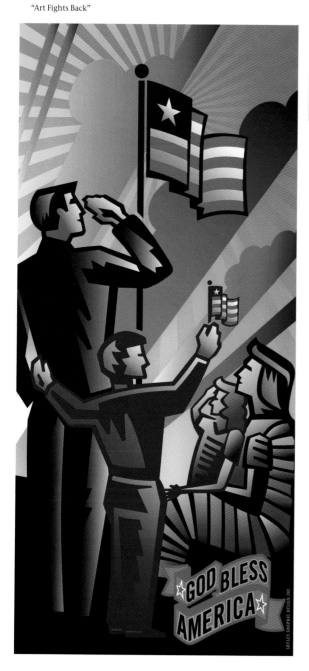

C - 72	C - 94	C - 0	C - 1	C - 13
M - 5	M - 81	M - 89	M - 34	M - 84
Y - 4	Y - 25	Y - 93	Y - 71	Y - 74
K - 1	K - 42	K - 0	K - 0	K - 3

C - 0	C - 71
M - 42	M - 60
Y - 82	Y - 13
K - 0	K - 27

design firm
Hornall Anderson Design Works
Seattle, Washington

ecri i

EARLY CHILDHOOD RESEARCH INSTITUTE ON INCLUSION

design firm
Vanderbilt University Publication & Design
Nashville, Tennessee
client
Early Childhood Research Institute on Inclusion

C - 50
M - 65
Y - 0
K - 0

C - 0
M - 0
Y - 0
K - 100

C - 0
M - 9
Y - 86
K - 0

C - 98
M - 81
Y - 1
K - 0

design firm
MackeySzar
Minneapolis, Minnesota
client
CNS

C - 97	C - 67	C - 6	C - 64
M - 100	M - 27	M - 35	M - 100
Y - 22	Y - 3	Y - 80	Y - 2
K - 7	K - 1	K - 0	K - 0

design firm
Forward Branding & Identity
Webster, New York
client
Bausch & Lomb

design firm
Cornerstone
New York, New York
client
Santher

C - 98	C - 70	C - 18	C - 74
M - 81	M - 21	M - 82	M - 28
Y - 1	Y - 4	Y - 11	Y - 72
K - 0	K - 0	K - 0	K - 0

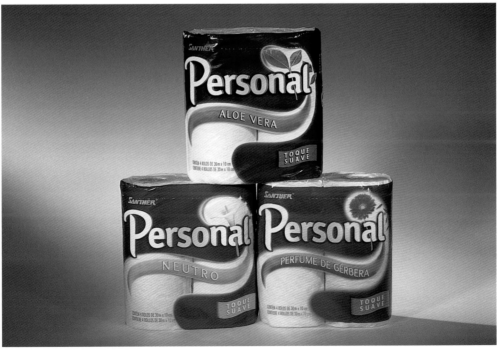

MONTEREY PENINSULA CHAMBER OF COMMERCE

C - 14	C - 50	C - 100
M - 19	M - 100	M - 60
Y - 80	Y - 90	Y - 100
K - 0	K - 0	K - 0

design firm
The Wecker Group
Monterey, California

design firm
Klündt Hosmer Design
Spokane, Washington
client
Whitworth

C - 0	C - 13	C - 0
M - 49	M - 72	M - 6
Y - 60	Y - 88	Y - 35
K - 0	K - 3	K - 2

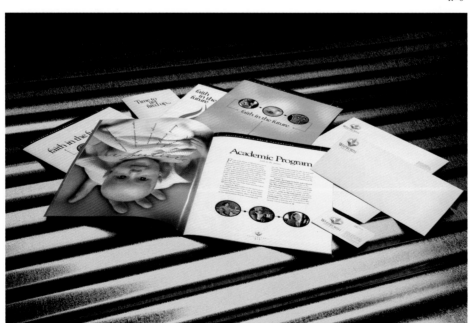

soothing

C - 0
M - 70
Y - 100
K - 0

C - 0
M - 27
Y - 80
K - 6

C - 0
M - 0
Y - 0
K - 100

design firm
Praxis Diseñadores, S.C.
México City (Mexico)
client
Alegro Internacional

C - 6
M - 94
Y - 91
K - 1

C - 0
M - 44
Y - 85
K - 0

C - 2
M - 58
Y - 3
K - 0

design firm
Compass Design
Minneapolis, Minnesota

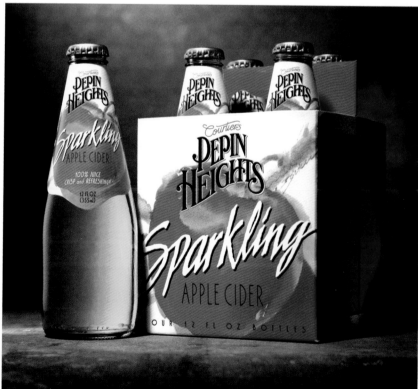

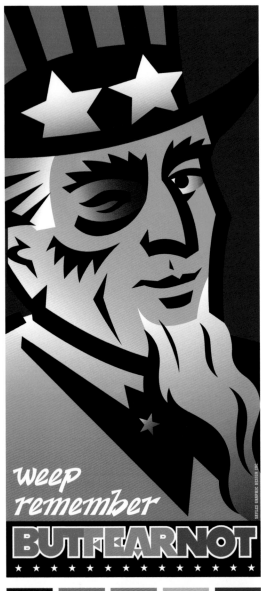

design firm
Mike Salisbury L.L.C.
Venice, California
client
Merv Griffin

C - 97
M - 66
Y - 1
K - 0

C - 20	C - 57	C - 84	C - 15	C - 76
M - 86	M - 46	M - 37	M - 56	M - 75
Y - 73	Y - 40	Y - 79	Y - 64	Y - 16
K - 2	K - 9	K - 0	K - 0	K - 15

C - 61	C - 47	C - 0	C - 4	C - 100
M - 31	M - 35	M - 89	M - 48	M - 77
Y - 83	Y - 33	Y - 93	Y - 59	Y - 18
K - 54	K - 14	K - 0	K - 1	K - 15

design firm
Sayles Graphic Design
Des Moines, Iowa
client
"Art Fights Back"

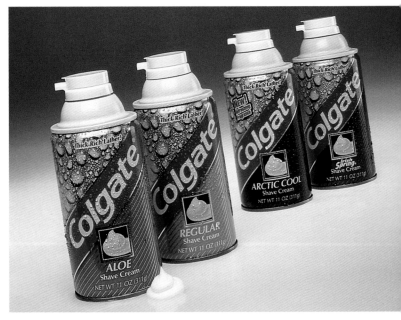

design firm
Bronz/Esposito Inc.
New York, New York
client
Colgate-Palmolive Company

C - 80
M - 60
Y - 20
K - 0

C - 80
M - 20
Y - 0
K - 20

C - 10
M - 0
Y - 90
K - 10

continuum

Girard College

A college preparatory boarding school
for grades 1 - 12

Volume 1, Spring 1999

design firm
kor group
Boston, Massachusetts
client
Girard College

mike**salisbury**

p 310 392 877f 310 392 9488
p o box 2309venice ca 90294

mikesalisbury@attbi.comwww.mikesalisbury.com

foreffectivebrandesignglobalbrandturntothemanwithonehellofago

C - 0	C - 27	C - 0	C - 74	C - 66
M - 90	M - 99	M - 32	M - 8	M - 20
Y - 10	Y - 67	Y - 4	Y - 38	Y - 61
K - 0	K - 1	K - 42	K - 0	K - 2

mike**salisbury**llc
p o box 2309 venice ca 90294

foreffectivebrandesignglobalbrandturntothemanwithonehellofagoodeye

design firm
Mike Salisbury L.L.C.
Venice, California

f 310 392 8779 f 310392 9488

p.o. box 2309 venice ca 90294

foreffectivebrandesignglobalbrandsturntothemanwithonehellofagoodeye

po box 2309 venice ca 90294

C - 1	C - 0
M - 96	M - 0
Y - 91	Y - 0
K - 0	K - 100

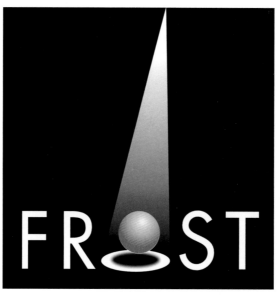

FR⊙ST
SPECIALTY RISK

design firm
Tom Ventress Design
Nashville, Tennessee
client
Frost Specialty Risk

design firm
Klündt Hosmer Design
Spokane, Washington
client
Itronix

C - 97	C - 10	C - 25	C - 40
M - 70	M - 29	M - 87	M - 19
Y - 16	Y - 70	Y - 84	Y - 67
K - 13	K - 2	K - 22	K - 13

design firm
Mike Salisbury L.L.C.
Venice, California
client
Universal Pictures Amblin

C - 95	C - 0	C - 0
M - 89	M - 100	M - 36
Y - 89	Y - 99	Y - 91
K - 86	K - 29	K - 0

C - 0
M - 0
Y - 0
K - 100

design firm
Supon Design Group
Washington, D.C.
client
Charles Button Company

design firm
Tom Ventress Design
Nashville, Tennessee
client
Quarterlight Productions

C - 0	C - 0
M - 100	M - 0
Y - 100	Y - 0
K - 0	K - 100

C - 27
M - 0
Y - 63
K - 0

C - 0
M - 0
Y - 0
K - 100

C - 3
M - 0
Y - 49
K - 0

C - 0
M - 49
Y - 80
K - 0

design firm
Louis & Partners Design
Bath, Ohio
client
Sound Addict

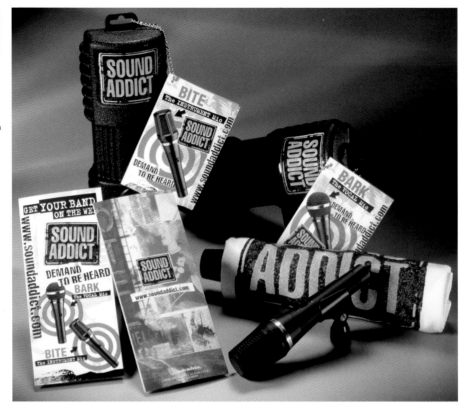

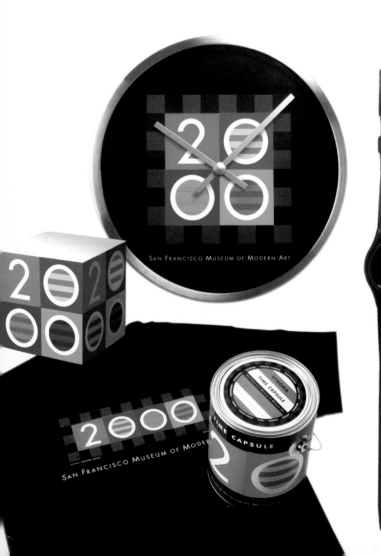

design firm
Michael Osborne Design
San Francisco, California
client
San Francisco Museum of Modern Art

C - 0
M - 100
Y - 100
K - 0

C - 100
M - 10
Y - 0
K - 0

C - 70
M - 70
Y - 0
K - 0

C - 75
M - 60
Y - 70
K - 14

C - 0
M - 65
Y - 87
K - 0

C - 39
M - 5
Y - 100
K - 0

C - 0
M - 0
Y - 0
K - 100

powerful

design firm
The Riordon Design Group Inc.
Oakville, Ontario
(Canada)
client
Canadian Opera Company

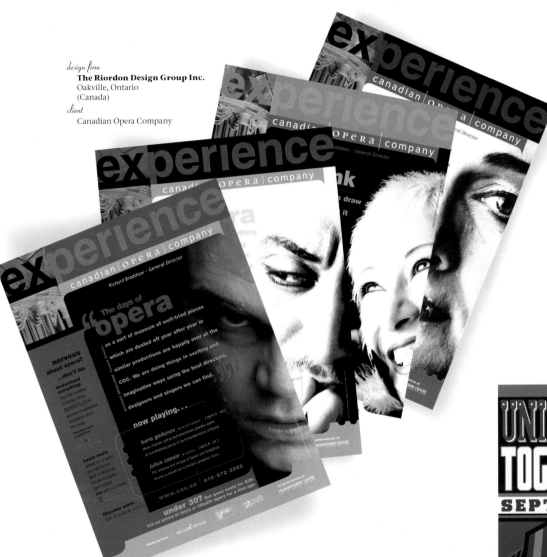

C - 0	C - 65	C - 50
M - 100	M - 45	M - 10
Y - 100	Y - 0	Y - 0
K - 20	K - 15	K - 0

C - 0	C - 30
M - 0	M - 0
Y - 0	Y - 0
K - 100	K - 75

C - 10	C - 0
M - 10	M - 30
Y - 100	Y - 100
K - 30	K - 10

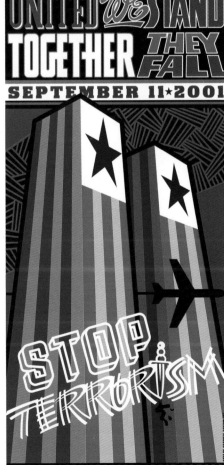

design firm
Sayles Graphic Design
Des Moines, Iowa
client
"Art Fights Back"

C - 1	C - 99	C - 99	C - 61
M - 93	M - 62	M - 75	M - 50
Y - 93	Y - 2	Y - 21	Y - 49
K - 0	K - 1	K - 27	K - 59

199

C - 41　　C - 91　　C - 0　　C - 0
M - 27　　M - 36　　M - 50　　M - 89
Y - 25　　Y - 0　　Y - 90　　Y - 93
K - 6　　K - 0　　K - 0　　K - 0

C - 61　　C - 94　　C - 0　　C - 0　　C - 0
M - 31　　M - 81　　M - 50　　M - 89　　M - 72
Y - 83　　Y - 25　　Y - 90　　Y - 93　　Y - 90
K - 54　　K - 42　　K - 0　　K - 0　　K - 0

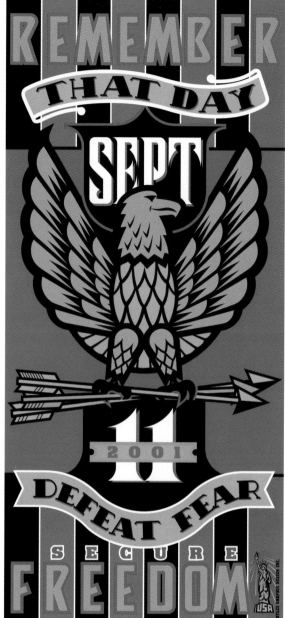

design firm
Sayles Graphic Design
Des Moines, Iowa
client
"Art Fights Back"

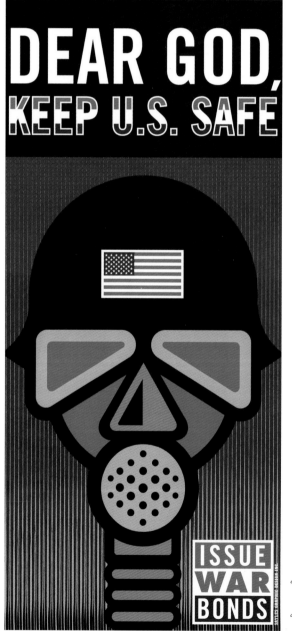

design firm
Sayles Graphic Design
Des Moines, Iowa
client
"Art Fights Back"

200

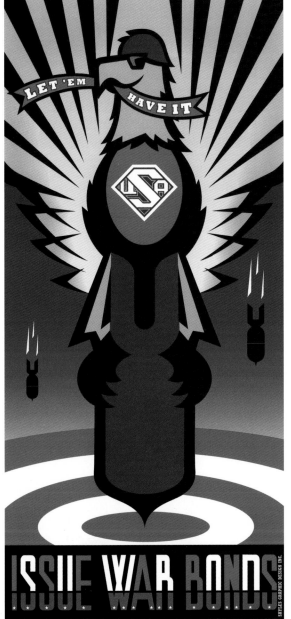

C - 61	C - 99	C - 0	C - 0
M - 31	M - 62	M - 50	M - 89
Y - 83	Y - 2	Y - 90	Y - 93
K - 54	K - 1	K - 0	K - 0

design firm
Sayles Graphic Design
Des Moines, Iowa

client
"Art Fights Back"

C - 100	C - 56	C - 0
M - 72	M - 11	M - 6
Y - 0	Y - 0	Y - 6
K - 38	K - 18	K - 27

design firm
Greteman Group
Wichita, Kansas

THE WAR ON FEAR BEGINS HERE

C - 94
M - 81
Y - 25
K - 42

C - 28
M - 91
Y - 58
K - 34

C - 0
M - 72
Y - 90
K - 0

C - 85
M - 27
Y - 14
K - 14

C - 0
M - 81
Y - 81
K - 0

design firm
Sayles Graphic Design
Des Moines, Iowa
client
"Art Fights Back"

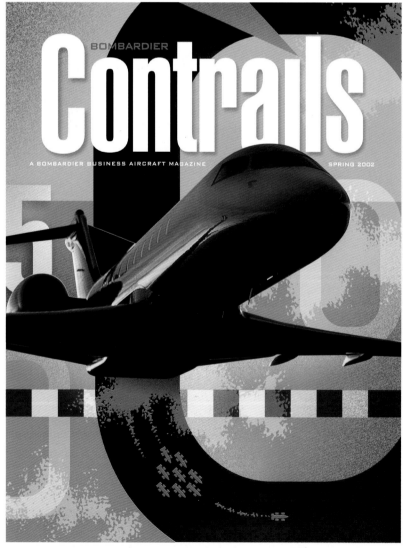

design firm
Greteman Group
Wichita, Kansas

C - 64
M - 69
Y - 4
K - 8

C - 0
M - 74
Y - 95
K - 0

C - 18
M - 31
Y - 56
K - 0

powerful

C - 91
M - 78
Y - 22
K - 24

C - 45
M - 37
Y - 82
K - 38

C - 44
M - 40
Y - 51
K - 90

design firm
Klündt Hosmer Design
Spokane, Washington
client
PAML

THE CONNECTICUT GRAND OPERA & ORCHESTRA PRESENTS VERDI'S

La Forza del Destino

DIRECTOR:
ELIZABETH BACHMAN
CONDUCTOR:
LAURENCE GILGORE

SATURDAY MAY 4, 2002
8:00PM

THE PALACE THEATRE,
STAMFORD
FOR TICKETS CALL
203 325 4466

C - 11
M - 98
Y - 85
K - 2

C - 0
M - 0
Y - 0
K - 100

design firm
Tom Fowler, Inc.
Norwalk, Connecticut
client
Connecticut Grand Opera & Orchestra

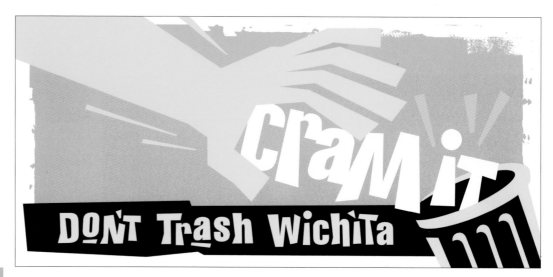

C - 0
M - 0
Y - 100
K - 0

C - 0
M - 0
Y - 0
K - 100

C - 0
M - 56
Y - 87
K - 0

design firm
Greteman Group
Wichita, Kansas

C - 0
M - 65
Y - 78
K - 0

C - 55
M - 22
Y - 60
K - 50

design firm
Hornall Anderson Design Works
Seattle, Washington

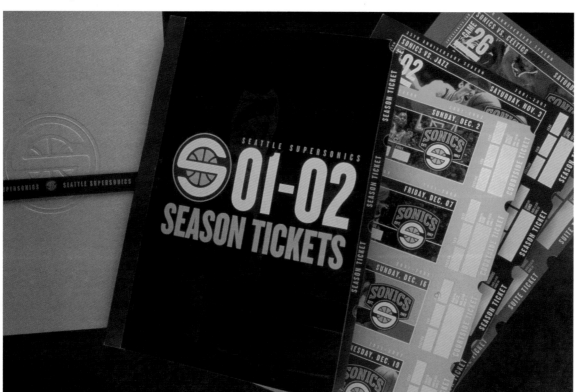

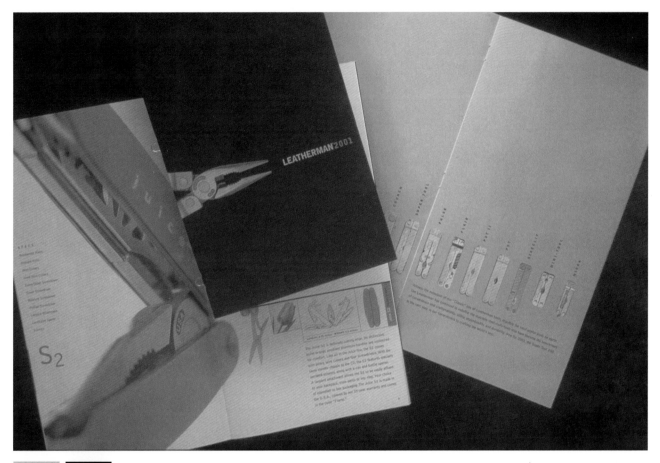

design firm
Hornall Anderson Design Works
Seattle, Washington

C - 0
M - 60
Y - 85
K - 0

C - 0
M - 0
Y - 0
K -10 0

design firm
Greteman Group
Wichita, Kansas

C - 0
M - 0
Y - 100
K - 0

C - 0
M - 0
Y - 0
K - 100

C - 43
M - 0
Y - 79
K - 15

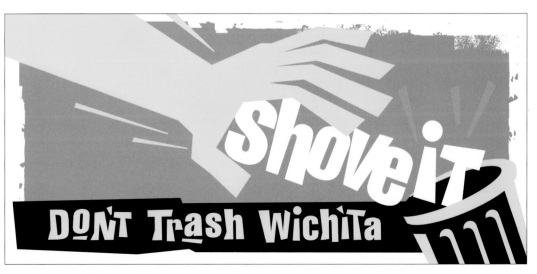

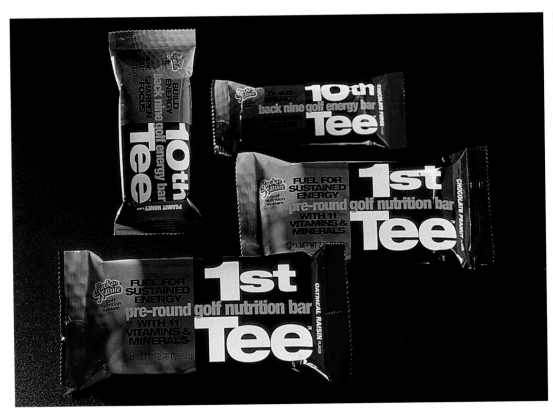

C - 97
M - 100
Y - 22
K - 7

C - 9
M - 56
Y - 99
K - 0

C - 50
M - 90
Y - 75
K - 10

design firm
Mark Oliver, Inc.
Solvang, California
client
Organic Milling, Co.

C - 93
M - 86
Y - 7
K - 29

C - 82
M - 49
Y - 2
K - 0

C - 75
M - 15
Y - 17
K - 0

C - 34
M - 100
Y - 20
K - 0

C - 3
M - 79
Y - 36
K - 0

C - 22
M - 36
Y - 2
K - 0

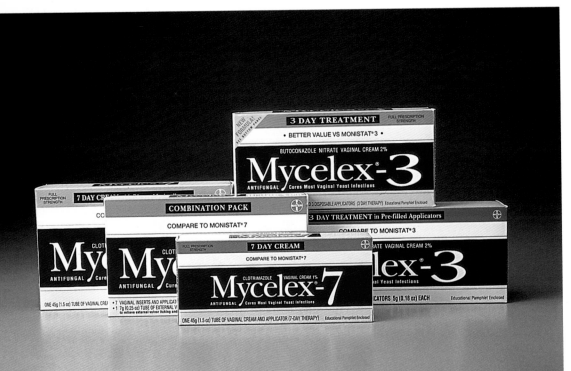

design firm
Szylinski Associates Inc.
New York, New York
client
Bayer Corporation

powerful

PPL CORPORATION 2001 ANNUAL REPORT **ppl**

A solid strategy

C - 79	C - 93
M - 33	M - 83
Y - 0	Y - 75
K - 0	K - 85

design firm
Boller Coates & Neu
Chicago, Illinois
client
PPL Corporation

design firm
**Colgate–Palmolive
In-House Design Studio**
New York, New York
client
Colgate–Palmolive Company

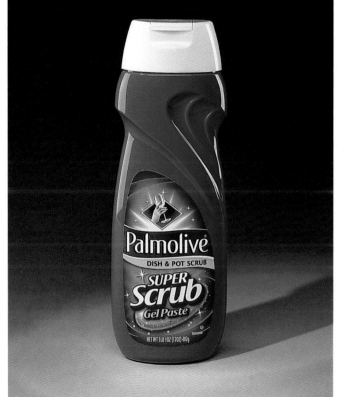

C - 98	C - 82	C - 0
M - 81	M - 34	M - 24
Y - 1	Y - 61	Y - 86
K - 0	K - 14	K - 0

207

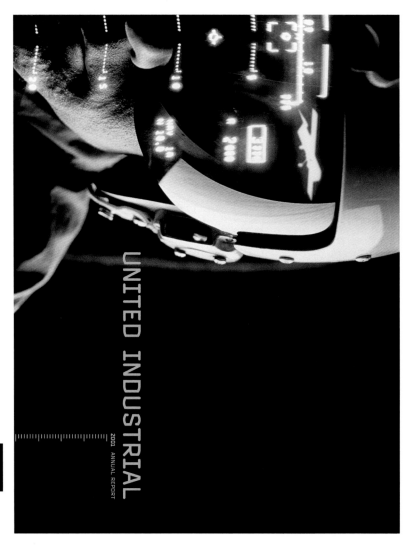

UNITED INDUSTRIAL

2001 ANNUAL REPORT

C - 73 C - 91
M - 45 M - 86
Y - 78 Y - 78
K - 18 K - 85

design firm
Taylor & Ives Incorporated
New York, New York
client
United Industrial Corporation

design firm
Sagmeister Inc.
New York, New York

C - 2 C - 67
M - 100 M - 1
Y - 95 Y - 67
K - 4 K - 0

C - 12
M - 66
Y - 95
K - 0

C - 42
M - 31
Y - 30
K - 9

C - 11
M - 98
Y - 85
K - 2

design firm
Resco Print Graphics
Hudson, Wisconsin
client
Resco Print Graphics

design firm
The Sloan Group
New York, New York
client
B.M.I.

C - 13
M - 98
Y - 89
K - 26

C - 2
M - 95
Y - 82
K - 6

C - 21
M - 0
Y - 13
K - 0

C - 16
M - 10
Y - 1
K - 0

C - 30
M - 28
Y - 1
K - 0

C - 74
M - 50
Y - 20
K - 4

C - 2
M - 47
Y - 84
K - 0

design firm
Sagmeister Inc.
New York, New York

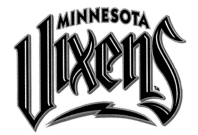

design firm
Compass Design
Minneapolis, Minnesota
client
Women's Professional Football League

C - 1
M - 99
Y - 88
K - 2

C - 46
M - 36
Y - 30
K - 0

C - 0
M - 0
Y - 0
K - 100

design firm
Praxis Diseñadores, S.C.
México City (Mexico)
client
SmithKline Beecham

C - 100
M - 60
Y - 0
K - 0

C - 80
M - 10
Y - 0
K - 0

210

C - 0
M - 0
Y - 0
K - 100

design firm
Mike Salisbury L.L.C.
Venice, California
client
Gotcha

C - 2
M - 91
Y - 86
K - 0

C - 39
M - 0
Y - 0
K - 100

design firm
Addison
San Francisco, California
client
The Good Guys

good guys ™

C - 65	C - 18	C - 7	C - 6
M - 69	M - 98	M - 99	M - 43
Y - 64	Y - 66	Y - 79	Y - 62
K - 69	K - 18	K - 16	K - 4

design firm
Dever Designs
Laurel, Maryland
client
Liberty Magazine

K U · K L U X I C O N

C - 0
M - 96
Y - 73
K - 0

C - 9
M - 59
Y - 77
K - 0

SERVER FAILURES
HARD DISK CRASHES
POWER INTERRUPTIONS
NATURAL DISASTERS
MALICIOUS ACTS

Is Your Data
PROTECTED
Throughout
The Day?

design firm
Ad Formula Design Studio
Singapore (Singapore)
client
C.A.

C - 84
M - 55
Y - 0
K - 0

C - 11
M - 98
Y - 85
K - 2

C - 0
M - 24
Y - 86
K - 0

C - 81
M - 13
Y - 74
K - 4

design firm
**Szylinski Associates Inc./
Protocol**
New York, New York
client
Bayer—Pursell, LLC

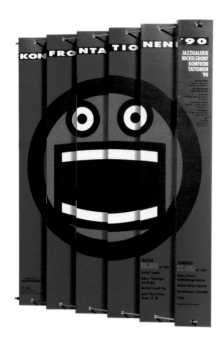

C - 0	C - 96	C - 92
M - 100	M - 66	M - 89
Y - 86	Y - 5	Y - 90
K - 0	K - 0	K - 82

design firm
Sagmeister Inc.
New York, New York

design firm
Designation
New York, New York

C - 1	C - 1	C - 91
M - 90	M - 21	M - 60
Y - 88	Y - 91	Y - 21
K - 0	K - 0	K - 47

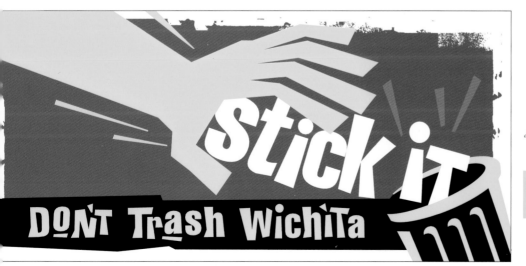

design firm
Greteman Group
Wichita, Kansas

C - 0	C - 91	C - 0
M - 0	M - 51	M - 0
Y - 100	Y - 0	Y - 0
K - 0	K - 0	K - 100

213

C - 30
M - 20
Y - 20
K - 0

C - 60
M - 60
Y - 40
K - 0

C - 70
M - 60
Y - 50
K - 0

C - 0
M - 0
Y - 0
K - 100

design firm
Tom Fowler, Inc.
Norwalk, Connecticut

client
Connecticut Grand Opera & Orchestra

THE CONNECTICUT GRAND OPERA & ORCHESTRA PRESENTS CHARLES GOUNOD'S

R O M É O E T

L A U R E N C E G I I G O R E · C O N D U C T O R

J U L I E T T E

SATURDAY
NOVEMBER 10, 2001
8:00PM

SUNDAY
NOVEMBER 11, 2001
4:00PM

THE PALACE THEATRE
STAMFORD
FOR TICKETS CALL
203 325 4466

high heels

design firm
After Hours Creative
Phoenix, Arizona

C - 0
M - 0
Y - 100
K - 0

C - 0
M - 100
Y - 100
K - 0

C - 0
M - 35
Y - 0
K - 0

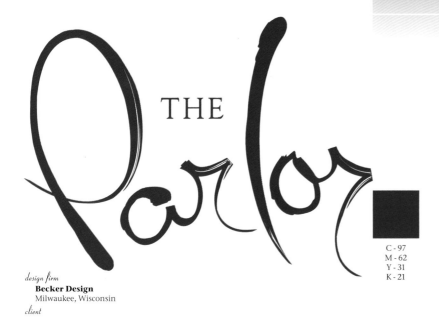

THE *Parlor*

C - 97
M - 62
Y - 31
K - 21

design firm
Becker Design
Milwaukee, Wisconsin
client
Parlor

design firm
After Hours Creative
Phoenix, Arizona

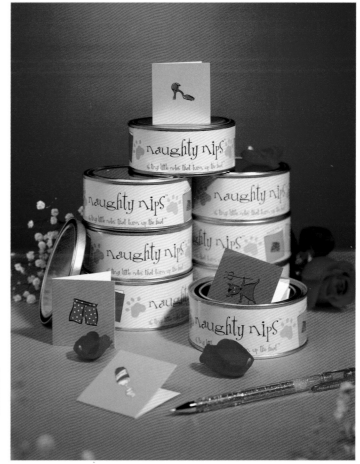

C - 16
M - 98
Y - 66
K - 9

C - 7
M - 58
Y - 0
K - 0

C - 24
M - 70
Y - 4
K - 0

design firm
Mike Salisbury L.L.C.
Venice (California)
client
20th Century Fox

C - 5	C - 83	C - 18
M - 99	M - 88	M - 48
Y - 73	Y - 86	Y - 96
K - 9	K - 73	K - 1

C - 0	C - 0
M - 79	M - 31
Y - 94	Y - 94
K - 0	K - 0

design firm
Greteman Group
Wichita, Kansas

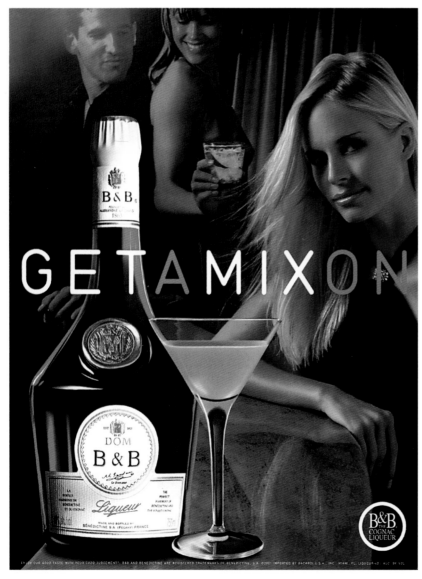

design firm
Pinkhaus
Miami, Florida
client
Bacardi USA, Inc.

C - 0	C - 12	C - 0
M - 94	M - 75	M - 0
Y - 79	Y - 89	Y - 0
K - 0	K - 0	K - 100

216

Netscape: Zoomstock Home

Back Forward Reload Home Search Netscape Images Print Security Shop Stop

Location: http://www.zoomstock.com/default2.htm What's Related

Setlist.Com For

ZOOMSTOCK

Welcome to **Zoomstock.com**.

The one stop shop for images of cool cars. Classics, hot rods, dream cars. We've got them all in stock.

So take our collection of hundreds of top-notch automotive images for a test drive.

Contact us with your inquiries and orders.

Check out Cars 101 to learn more about everything automotive.

Click Below To See Cars Contact Cars 101 Links

Antiques Classics Hot Rods Late Model Exotics Other

C - 0
M - 100
Y - 100
K - 0

C - 0
M - 0
Y - 0
K - 100

design firm
Liska + Associates, Inc.
Chicago, Illinois
client
Zoomstock Stock Photography

C - 0	C - 10	C - 0
M - 40	M - 10	M - 0
Y - 60	Y - 10	Y - 0
K - 40	K - 200	K - 100

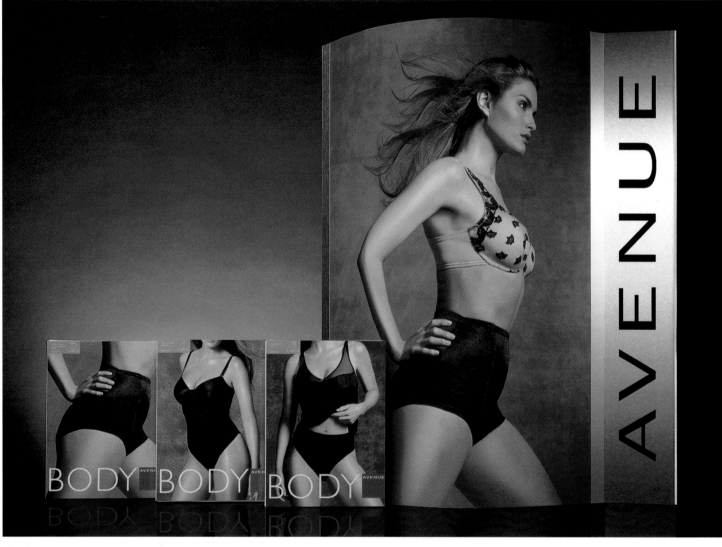

design firm
United Retail Group
Rochelle Park, New Jersey
client
Urgi

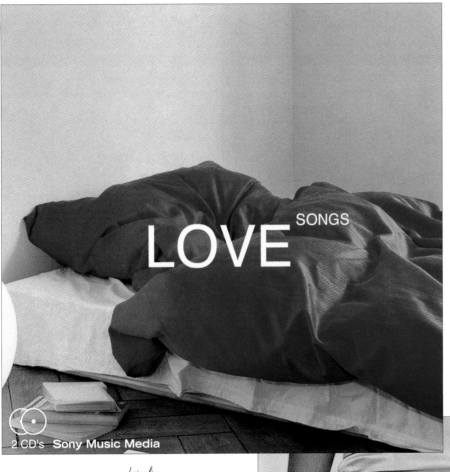

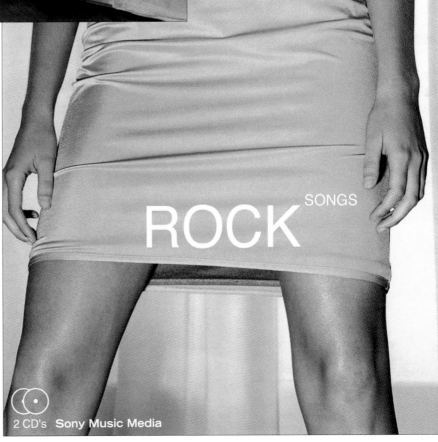

C - 0	C - 0	C - 50
M - 100	M - 20	M - 8
Y - 100	Y - 50	Y - 15
K - 0	K - 10	K - 0

design firm
Heye + Partner GmbH
Unterhaching (Germany)
client
McDonald's Promotion GmbH

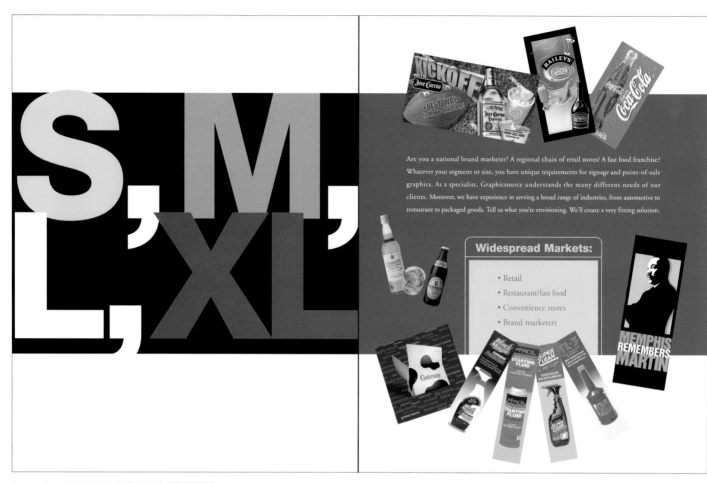

Are you a national brand marketer? A regional chain of retail stores? A fast food franchise? Whatever your segment or size, you have unique requirements for signage and point-of-sale graphics. As a specialist, Graphicsource understands the many different needs of our clients. Moreover, we have experience in serving a broad range of industries, from automotive to restaurant to packaged goods. Tell us what you're envisioning. We'll create a very fitting solution.

Widespread Markets:

• Retail
• Restaurant/fast food
• Convenience stores
• Brand marketers

C - 2	C - 37	C - 78	C - 0
M - 8	M - 22	M - 68	M - 0
Y - 91	Y - 24	Y - 7	Y - 0
K - 0	K - 5	K - 2	K - 100

design firm
Becker Design
Milwaukee, Wisconsin
client
Graphic Source

C - 0	C - 60
M - 14	M - 0
Y - 34	Y - 0
K - 60	K - 30

Traveleze.com
Changing the way the world travels

design firm
The Wecker Group
Monterey, California
client
Traveleze.com

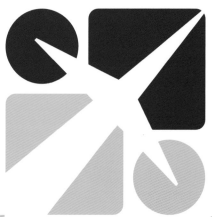

design firm
Greteman Group
Wichita, Kansas

C - 100 C - 0
M - 72 M - 34
Y - 0 Y - 91
K - 38 K - 0

C - 67 C - 12 C - 0
M - 39 M - 71 M - 54
Y - 23 Y - 74 Y - 82
K - 15 K - 25 K - 0

design firm
Hornall Anderson Design Works
Seattle, Washington

design firm
Becker Design
Milwaukee, Wisconsin
client
RediHelp

design firm
Hornall Anderson Design Works
Seattle, Washington

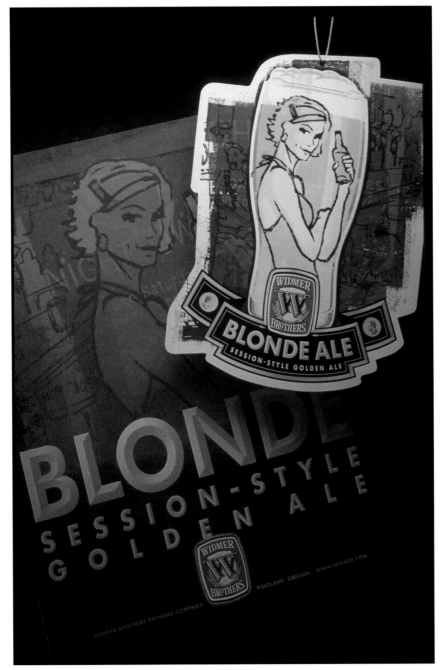

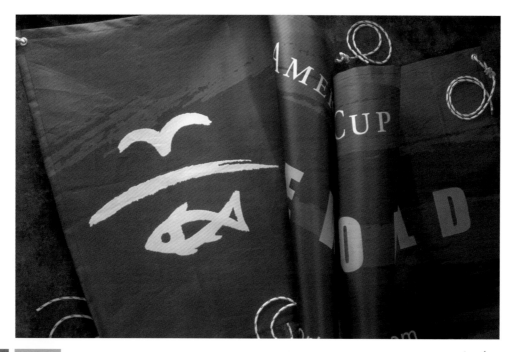

design firm
Hornall Anderson Design Works
Seattle, Washington

C - 57	C - 62	C - 0
M - 44	M - 43	M - 59
Y - 27	Y - 15	Y - 95
K - 43	K - 22	K - 2

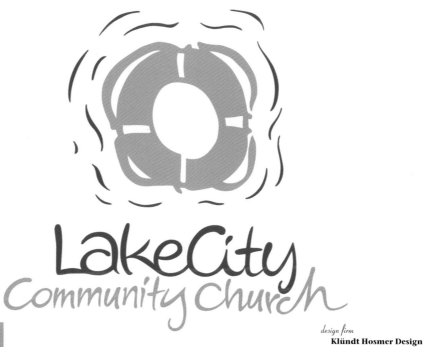

design firm
Klündt Hosmer Design
Spokane, Washington
client
LakeCity Community Church

C - 93	C - 2
M - 58	M - 69
Y - 15	Y - 91
K - 4	K - 0

WOOFSTOCK

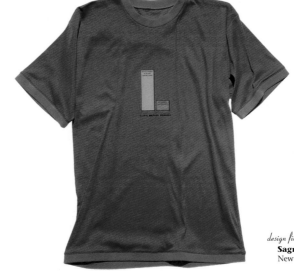

C - 10
M - 90
Y - 53
K - 2

C - 3
M - 64
Y - 81
K - 1

C - 88
M - 65
Y - 0
K - 0

C - 91
M - 25
Y - 76
K - 10

design firm
Sagmeister Inc.
New York, New York

design firm
Tom Fowler, Inc.
Norwalk, Connecticut
client
Unilever Home & Personal Care USA

C - 71
M - 30
Y - 0
K - 1

C - 38
M - 82
Y - 2
K - 1

C - 25
M - 93
Y - 74
K - 16

C - 4
M - 83
Y - 99
K - 1

(opposite) design firm
Greteman Group
Wichita, Kansas

C - 79
M - 76
Y - 0
K - 0

C - 6
M - 0
Y - 100
K - 8

C - 0
M - 27
Y - 76
K - 0

C - 0
M - 56
Y - 87
K - 0

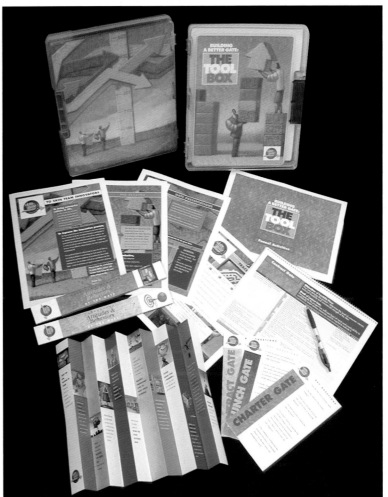

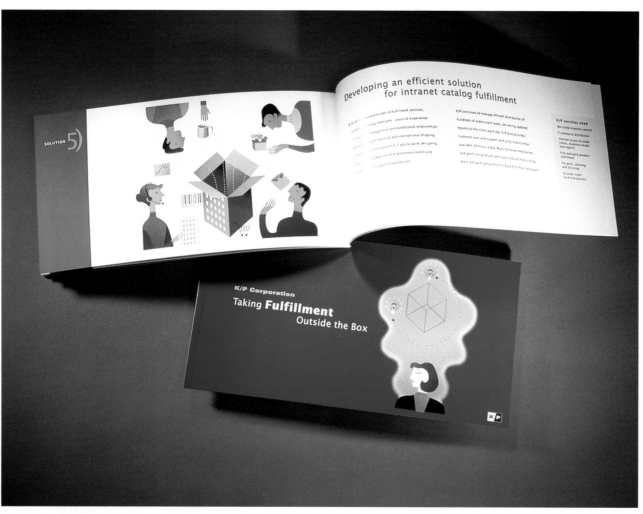

**Developing an efficient solution
for intranet catalog fulfillment**

SOLUTION 5)

K/P Corporation
Taking Fulfillment
Outside the Box

design firm
Belyea
Seattle, Washington
client
K/P Corporation

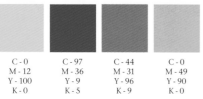

C - 0	C - 97	C - 44	C - 0
M - 12	M - 36	M - 31	M - 49
Y - 100	Y - 9	Y - 96	Y - 90
K - 0	K - 5	K - 9	K - 0

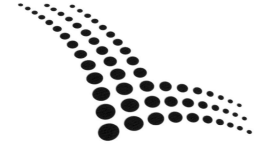

LEAP™

design firm
Addison
San Francisco, California
client
Leap

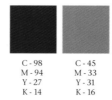

C - 98	C - 45
M - 94	M - 33
Y - 27	Y - 31
K - 14	K - 16

C - 5
M - 90
Y - 78
K - 0

C - 92
M - 21
Y - 11
K - 1

design firm
Addison
San Francisco, California
client
Domino's Pizza

AIRTOUCH™

design firm
Addison
San Francisco, California
client
AirTouch

C - 1
M - 33
Y - 91
K - 0

C - 94
M - 62
Y - 6
K - 0

C - 0
M - 91
Y - 76
K - 0

C - 0
M - 0
Y - 0
K - 1090

design firm
Addison
San Francisco, California
client
ConocoPhillips

ConocoPhillips

momentum ®

® Built by Belyea

C - 0
M - 0
Y - 50
K - 0

C - 0
M - 0
Y - 0
K - 100

STRATEGY + MESSAGING

passion ®

® Built by Belyea

G N

belyea.

206.682.4895 belyea.com

design firm
Belyea
Seattle, Washington
client
Belyea

wow ®

® Built by Belyea

STRATEGY + MESSAGING + DESIGN

belyea.

206.682.4895 belyea.com

design firm
Pat Taylor Inc.
Washington, D.C.
client
Northern Va. Comm. College

C - 0
M - 0
Y - 0
K - 100

C - 100 C - 10
M - 0 M - 20
Y - 79 Y - 70
K - 60 K - 0

design firm
The Wecker Group
Monterey, California
client
Del Monte Aviation

DEL MONTE
AVIATION

design firm
LarsonLogosEtc
Rockford, Illinois
client
Washington Park Christian Church

C - 0
M - 0
Y - 0
K - 25

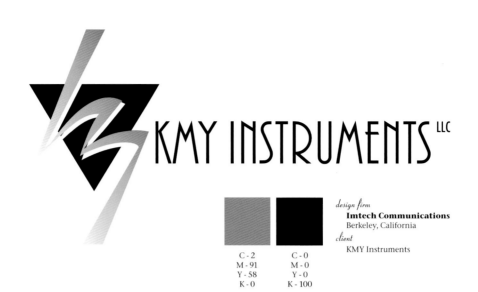

KMY INSTRUMENTS LLC

design firm
Imtech Communications
Berkeley, California
client
KMY Instruments

C - 2	C - 0
M - 91	M - 0
Y - 58	Y - 0
K - 0	K - 100

C - 20	C - 30
M - 40	M - 90
Y - 50	Y - 100
K - 5	K - 5

design firm
über, inc
New York, New York
client
Utopia Marketing

C - 89 C - 38
M - 89 M - 35
Y - 31 Y - 100
K - 25 K - 25

design firm
merish design
New York, New York
client
Riverside Symphony

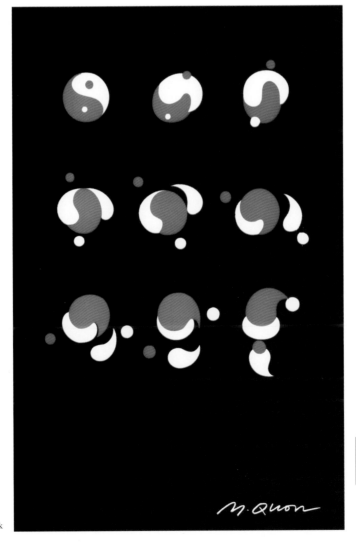

design firm
Designation
New York, New York

C - 2 C - 63
M - 92 M - 52
Y - 97 Y - 50
K - 1 K - 90

C - 44 C - 100
M - 4 M - 50
Y - 70 Y - 10
K - 1 K - 10

C - 0 C - 0 C - 5
M - 100 M - 50 M - 25
Y - 100 Y - 100 Y - 100
K - 0 K - 0 K - 0

visual asylum 205 WEST DATE SAN DIEGO CA 92101 T 619.233.9633 F 619.233.9637

33.9637

design firm
Visual Asylum
San Diego, California
client
Visual Asylum

visual asylum 205 WEST DATE SAN DIEGO CA 92101 T 619.233.9633 F 619.233.9637

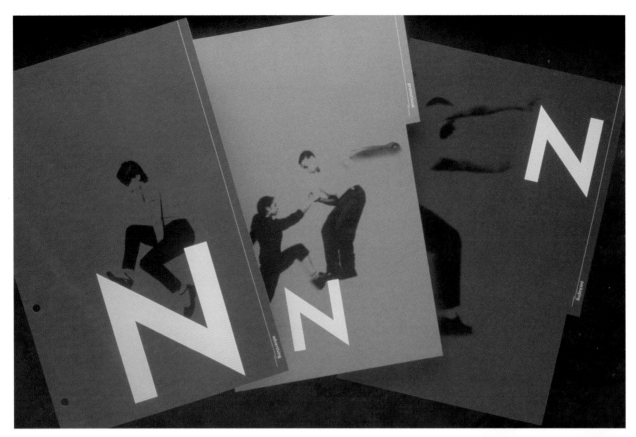

design firm
Hornall Anderson Design Works
Seattle, Washington

C - 32	C - 42	C - 70
M - 53	M - 7	M - 37
Y - 17	Y - 21	Y - 3
K - 50	K - 15	K - 44

MORGAN
WINERY

design firm
The Wecker Group
Monterey, California
client
Morgan Winery

C - 100	C - 100	C - 0
M - 0	M - 50	M - 0
Y - 100	Y - 0	Y - 0
K - 0	K - 0	K - 100



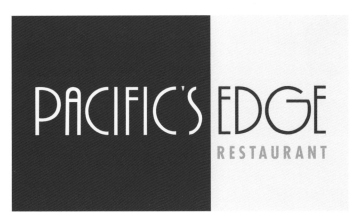

design firm
The Wecker Group
Monterey, California
client
Pacific's Edge

C - 96 / M - 78 / Y - 3 / K - 0
C - 9 / M - 7 / Y - 7 / K - 0

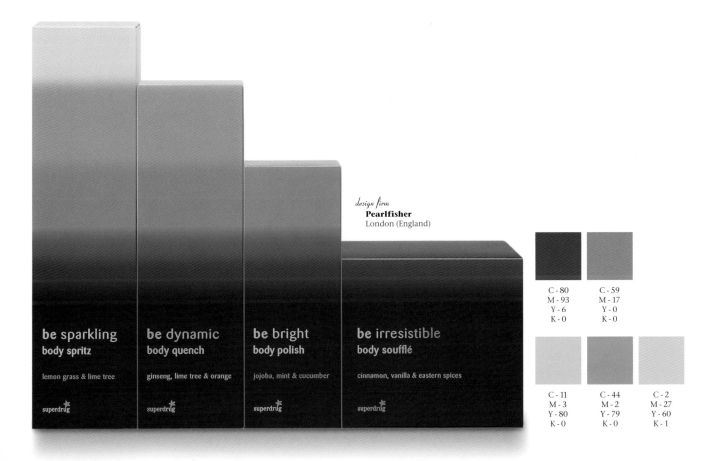

be sparkling
body spritz
lemon grass & lime tree
superdrug

be dynamic
body quench
ginseng, lime tree & orange
superdrug

be bright
body polish
jojoba, mint & cucumber
superdrug

be irresistible
body soufflé
cinnamon, vanilla & eastern spices
superdrug

design firm
Pearlfisher
London (England)

C - 80 / M - 93 / Y - 6 / K - 0
C - 59 / M - 17 / Y - 0 / K - 0
C - 11 / M - 3 / Y - 80 / K - 0
C - 44 / M - 2 / Y - 79 / K - 0
C - 2 / M - 27 / Y - 60 / K - 1

I

i am powerful

i am the fastest thing on a mountain

AM

i am speed and precision rolled into one

i am a 5-time gold medalist

AN AVALANCHE.

U.S. PARALYMPICS
I AM ABLE
www.paralympics2002.com

A division of the US Olympic Committee

design firm
After Hours Creative
Phoenix, Arizona

C - 47	C - 14
M - 22	M - 2
Y - 6	Y - 1
K - 0	K - 0

design firm
Interbrand
New York, New York
client
Proctor & Gamble

C - 12	C - 97	C - 56
M - 94	M - 89	M - 12
Y - 73	Y - 1	Y - 1
K - 0	K - 22	K - 0

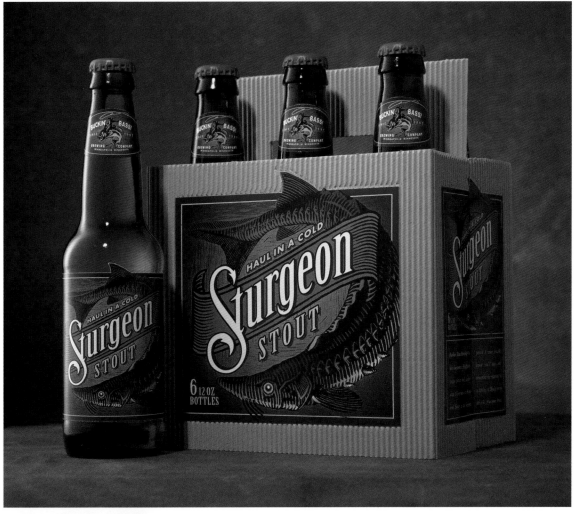

design firm
Compass Design
Minneapolis, Minnesota

C - 42	C - 69	C - 34
M - 31	M - 55	M - 70
Y - 30	Y - 9	Y - 54
K - 9	K - 9	K - 52

design firm
Becker Design
Milwaukee, Wisconsin
client
Suburban

C - 66	C - 92
M - 17	M - 33
Y - 23	Y - 40
K - 3	K - 21

Suburban
COUNSELING SERVICES

C - 88
M - 50
Y - 3
K - 1

C - 100
M - 100
Y - 28
K - 16

C - 5
M - 28
Y - 100
K - 0

C - 1
M - 2
Y - 23
K - 0

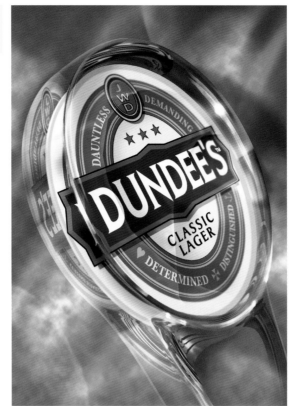

design firm
McElveney & Palozzi Design Group
Rochester, New York
client
High Falls Brewing Co.

design firm
American Airlines Publishing
Ft. Worth, Texas
client
American Way Magazine

C - 7
M - 23
Y - 99
K - 0

C - 31
M - 23
Y - 25
K - 0

ALTERNATIVE AUTOS

CARMAKERS' LATEST VENTURES INTO HIGH-TECH ENGINES MAKE AUTOS THE LEADING EDGE OF ALTERNATIVE ENERGY SOURCES. BY BARRY LYNN

At the controls of a General Motors electric-powered EV1, cruising nose to nose with a pickup truck, I stared at the point in the road where two lanes become one. Rather than carefully sliding behind my neighbor, I tapped the accelerator. By the time I glanced at the dashboard a few seconds later, the speedometer read 85 and the truck was a distant reflection.

It was at that moment, hurtling toward the morning sun on Washington's Southwest Freeway, that I first really began to wonder why automakers seemingly don't want to build or sell powerful electric cars.

Nor was my borrowed EV1 simply a fine highway machine. Cruising the winding upper stretches of Rock Creek Park, I floated forward in near silence, through sunlight dappled by leafless branches. Not a bad way, all in all, to run errands or get to work, tucked in a smooth, snug roadster that on any stretch of empty asphalt will, with the slightest of prodding, shoot forward like one of those wheeled rockets that set land-speed records at the Bonneville Salt Flats.

64 | AMERICAN WAY | 03.15.02

C - 60
M - 10
Y - 85
K - 0

C - 6
M - 58
Y - 82
K - 0

C - 5
M - 81
Y - 78
K - 0

design firm
Julia Tam Design
Palos Verdes, California
client
Coolava Islands

design firm
Stan Gellman Graphic Design
St. Louis, Missouri
client
FMC Technologies

C - 94
M - 76
Y - 9
K - 1

C - 44
M - 17
Y - 2
K - 0

C - 11
M - 96
Y - 85
K - 2

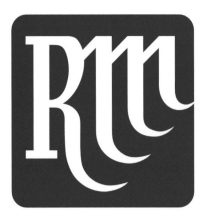

design firm
Klündt Hosmer Design
Spokane, Washington

RiverMill
PLAZA

C - 95	C - 0
M - 75	M - 0
Y - 13	Y - 0
K - 3	K - 100

design firm
Compass Design
Minneapolis, Minnesota

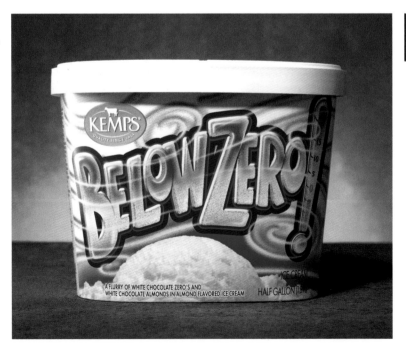

C - 99	C - 23
M - 86	M - 16
Y - 24	Y - 16
K - 29	K - 1

By Thy Rivers Gently Flowing,

Illinois
Illinois

Music from the University of Illinois
Presented by the University of Illinois Foundation

C - 5	C - 80	C - 100
M - 0	M - 40	M - 70
Y - 0	Y - 0	Y - 0
K - 0	K - 30	K - 30

design firm
Stan Gellman Graphic Design Inc.
St. Louis, Missouri

client
University of Illinois Foundation

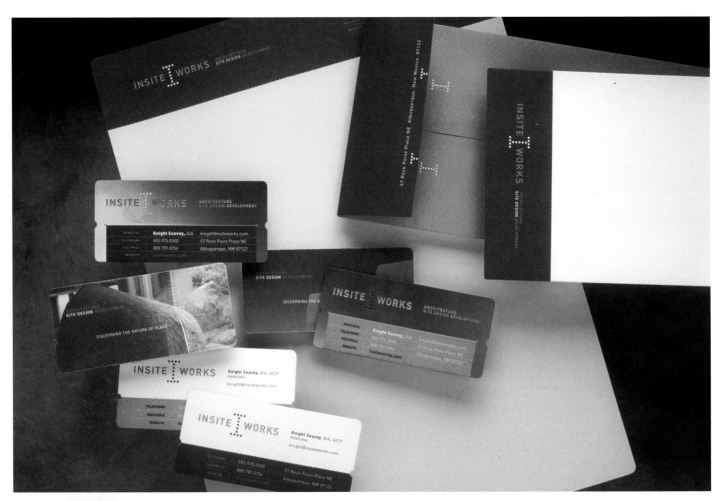

design firm
Hornall Anderson Design Works
Seattle, Washington

Community
Foundation
for Monterey County

design firm
The Wecker Group
Monterey, California

client
Community Foundation
for Monterey County

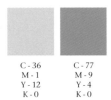

C - 100
M - 77
Y - 0
K - 0

C - 1
M - 87
Y - 99
K - 0

C - 8
M - 20
Y - 89
K - 1

design firm
Tom Fowler, Inc.
Norwalk, Connecticut
client
Unilever Home & Personal Care USA

Sky Financial Group, Inc.

2001 Annual Report

Proven
performance
with a focus on the
future

design firm
Lesniewicz Associates
Toldeo, Ohio
client
Sky Bank

C - 98
M - 49
Y - 3
K - 0

243

BOMBARDIER

Contrails

FALL 2000

A BOMBARDIER BUSINESS AIRCRAFT MAGAZINE

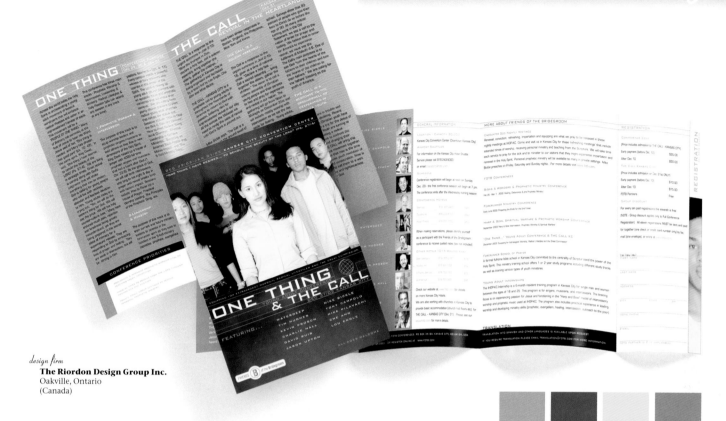

design firm
The Riordon Design Group Inc.
Oakville, Ontario
(Canada)

C - 0	C - 35	C - 0	C - 65
M - 50	M - 50	M - 10	M - 30
Y - 100	Y - 80	Y - 60	Y - 0
K - 5	K - 40	K - 0	K - 0

C - 85	C - 40	C - 53	C - 15
M - 71	M - 25	M - 40	M - 17
Y - 35	Y - 32	Y - 27	Y - 70
K - 34	K - 8	K - 13	K - 0

design firm
5D Studio
Malibu, California
client
Brown Jordan

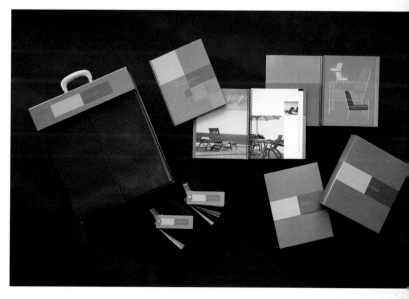

(opposite) design firm
Greteman Group
Wichita, Kansas

C - 61	C - 10	C - 55	C - 11	C - 24
M - 63	M - 46	M - 57	M - 92	M - 97
Y - 7	Y - 76	Y - 16	Y - 95	Y - 88
K - 11	K - 2	K - 56	K - 10	K - 44

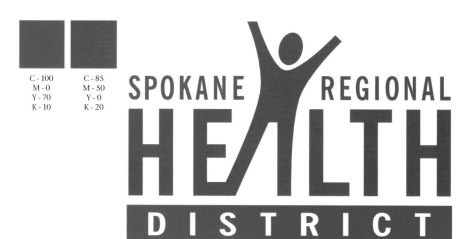

C - 100 C - 85
M - 0 M - 50
Y - 70 Y - 0
K - 10 K - 20

design firm
Klündt Hosmer Design
Spokane, Washington
client
Spokane Regional Health District

C - 31 C - 60
M - 39 M - 66
Y - 39 Y - 63
K - 0 K - 34

CORNETS

SNARE DRUMS

FRENCH HORNS

TUBAS

VIBRAPHONES CELLOS

TIMPANI

BASSOONS PICCOLOS

VIOLINS

TROMBONES

FLUTES

TRUMPETS SAXOPHONES

OBOES

PIANOS

CLARINETS

2001
ANNUAL REPORT

STEINWAY MUSICAL INSTRUMENTS, INC.

design firm
The Wyant Simboli Group, Inc.
Norwalk, Connecticut
client
Steinway Musical Instruments, Inc.

Julie Scholz
Certified Clinical Hypnotherapist

C - 100	C - 0
M - 87	M - 0
Y - 0	Y - 0
K - 13	K - 100

design firm
Jiva Creative
Alameda, California
client
Julie Scholz, CCHT

Veo
THE ONLINE BUSINESS PLATFORM FOR
INDEPENDENT ADVISORS

TD WATERHOUSE
Institutional Services

design firm
Berni Marketing & Design
Greenwich, Connecticut
client
TD Waterhouse

C - 34	C - 65
M - 24	M - 3
Y - 23	Y - 82
K - 0	K - 0

design firm
Designation
New York, New York

C - 1
M - 14
Y - 91
K - 0

C - 24
M - 92
Y - 100
K - 18

C - 86
M - 28
Y - 32
K - 30

THE SIXTY-SECOND ANNUAL EXHIBITION OF THE ART DIRECTORS CLUB

C - 95
M - 71
Y - 10
K - 1

C - 0
M - 0
Y - 0
K - 100

design firm
Addison
San Francisco, California
client
Trusted Choice

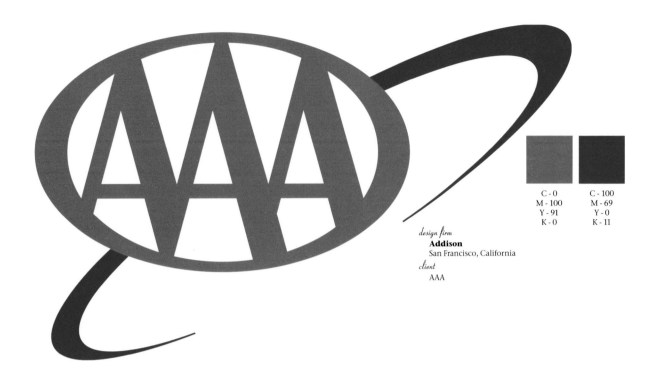

C - 0
M - 100
Y - 91
K - 0

C - 100
M - 69
Y - 0
K - 11

design firm
Addison
San Francisco, California
client
AAA

C - 94
M - 69
Y - 5
K - 0

C - 5
M - 13
Y - 94
K - 0

design firm
Addison
San Francisco, California
client
Guidance Financial Group

C - 8
M - 15
Y - 40
K - 0

C - 0
M - 0
Y - 0
K - 100

C - 54
M - 35
Y - 76
K - 4

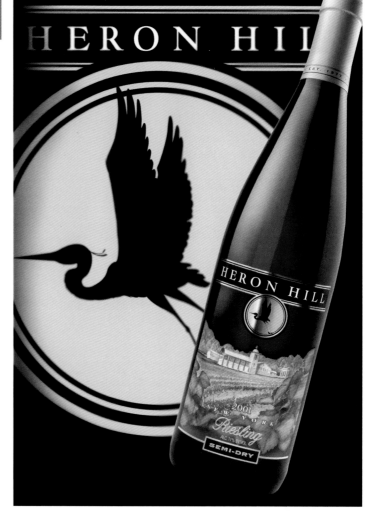

design firm
McElveney & Palozzi Design Group
Rochester, New York
client
Heron Hill Winery

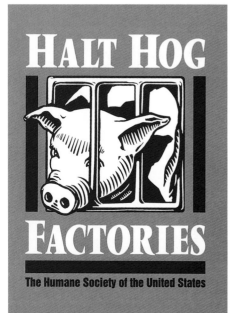

HALT HOG

FACTORIES

The Humane Society of the United States

HOGS ARE SENTIENT,
INTELLIGENT, AND
SOCIAL CREATURES,
BUT THEY ARE DENIED
THEIR MOST BASIC NEEDS
ON FACTORY FARMS.

design firm
The Humane Society of the United States
Washington, D.C.
client
The Humane Society of the United States

C - 91
M - 78
Y - 22
K - 24

C - 13
M - 72
Y - 88
K - 3

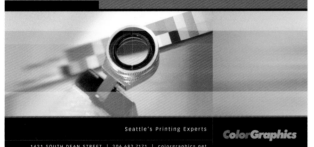

PERFECTION

It's not too much to ask.

design firm
Belyea
Seattle, Washington
client
ColorGraphics

Seattle's Printing Experts **Color Graphics**

1421 SOUTH DEAN STREET | 206.682.7171 | colorgraphics.net

OBSESSIVE COMPULSIVE

It's a good thing.

Seattle's Printing Experts **Color Graphics**

1421 SOUTH DEAN STREET | 206.682.7171 | colorgraphics.net

PEACE OF MIND

By far the most popular service we provide.

Seattle's Printing Experts **Color Graphics**

1421 SOUTH DEAN STREET | 206.682.7171 | colorgraphics.net

PICKY PICKY PICKY

Thanks for the compliment.

Seattle's Printing Experts **Color Graphics**

1421 SOUTH DEAN STREET | 206.682.7171 | colorgraphics.net

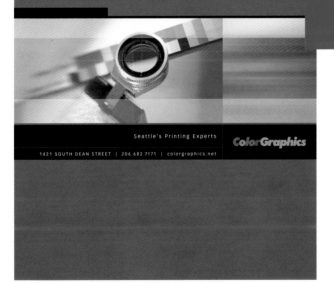

C - 10	C - 100	C - 85	C - 30	C - 0	C - 89
M - 85	M - 0	M - 50	M - 70	M - 40	M - 18
Y - 50	Y - 30	Y - 0	Y - 0	Y - 53	Y - 81
K - 30	K - 30	K - 10	K - 35	K - 7	K - 16

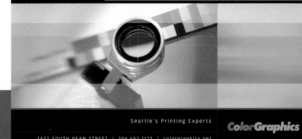

WASHINGTON FEDERAL

EXPECT MORE.

design firm
Desbrow
Pittsburgh, Pennsylvania
client
Washington Federal

C - 95	C - 46	C - 27	C - 7
M - 86	M - 15	M - 84	M - 40
Y - 6	Y - 80	Y - 55	Y - 98
K - 33	K - 0	K - 3	K - 0

LaserCosmedics
REVEAL A WHOLE NEW YOU

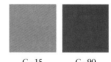

C - 15	C - 90
M - 70	M - 65
Y - 90	Y - 0
K - 0	K - 10

design firm
Klündt Hosmer Design
Spokane, Washington
client
LaserCosmedics

Netscape: Shockwave

Back Forward Reload Home Search Netscape Images Print Security Stop

Location: http://www.northcap.com/index1.htm What's Related

WebMail Contact People Yellow Pages Download Find Sites

C - 10 C - 20 C - 0 C - 100
M - 45 M - 10 M - 0 M - 50
Y - 100 Y - 60 Y - 40 Y - 50
K - 0 K - 0 K - 0 K - 10

design firm
Suka & Friends Design, Inc.
New York, New York
client
Northstar Capital Investment Corp.

C - 50
M - 100
Y - 20
K - 30

C - 40
M - 95
Y - 65
K - 20

C - 100
M - 0
Y - 50
K - 55

C - 10
M - 40
Y - 100
K - 10

CISCO SYSTEMS
®

The Brand

Logo Standards

Tag Line/Program Logos

Merchandising/Ingredient Brands

Building the

Cisco brand

from the **inside out**

design firm
Cisco Systems
San Jose, California
client
Cisco Systems

design firm
LarsonLogosEtc
Rockford, Illinois
client
Gloria Dei Lutheran Church

C - 100
M - 100
Y - 0
K - 0

C - 72
M - 100
Y - 0
K - 0

NATROL®

design firm
Gauger & Silva
San Francisco, California
client
Natrol

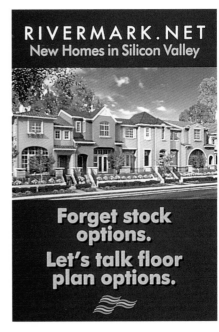

design firm
Gauger + Santz
San Francisco, California
client
Rivermark

C - 71
M - 99
Y - 21
K - 7

C - 0
M - 25
Y - 67
K - 0

C - 80
M - 19
Y - 6
K - 3

JANIE
AND
JACK
™

C - 29	C - 28	C - 16	C - 0	C - 22	C - 3
M - 1	M - 16	M - 4	M - 22	M - 23	M - 12
Y - 17	Y - 4	Y - 26	Y - 11	Y - 4	Y - 40
K - 0	K - 1	K - 0	K - 0	K - 0	K - 0

design firm
Michael Osborne Design
San Francisco, California
client
Janie and Jack

Sempre comodi
con body e tutine

C - 0
M - 18
Y - 13
K - 0

C - 27
M - 18
Y - 4
K - 0

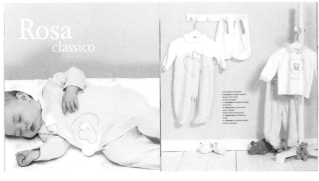

Rosa
classico

design firm
Tangram Strategic Design
Novara, Italy
client
Prénatal

C - 86
M - 67
Y - 1
K - 2

design firm
Mike Salisbury L.L.C.
Venice, California
client
Blue Note Records

Blue Note

C - 75
M - 0
Y - 100
K - 40

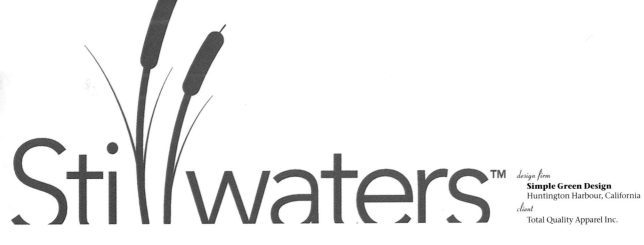

Stillwaters™

design firm
Simple Green Design
Huntington Harbour, California
client
Total Quality Apparel Inc.

refineyoursenses

enjoytheexperience

C - 0
M - 95
Y - 90
K - 25

C - 80
M - 20
Y - 0
K - 10

defineyourenvironment

definitivesound

C - 55
M - 10
Y - 80
K - 30

design firm
The Riordon Design Group Inc.
Oakville, Ontario
(Canada)
client
Definitive Sound

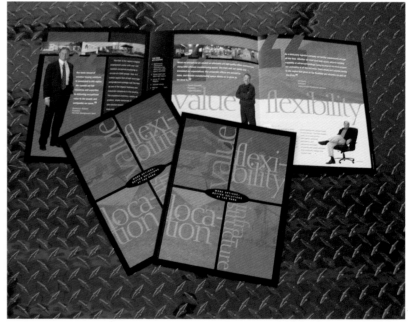

design firm
Klündt Hosmer Design
Spokane, Washington
client
Spokane Industrial

C - 45	C - 59	C - 15	C - 26
M - 37	M - 17	M - 43	M - 87
Y - 82	Y - 68	Y - 88	Y - 79
K - 38	K - 12	K - 5	K - 21

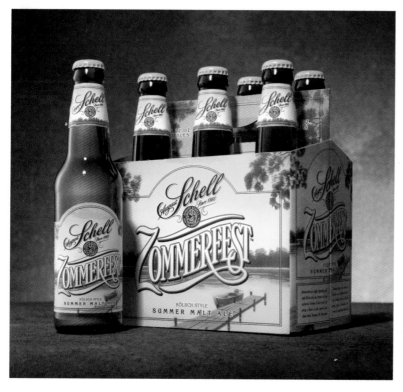

C - 0
M - 9
Y - 86
K - 0

C - 12
M - 91
Y - 86
K - 2

C - 19
M - 83
Y - 95
K - 9

design firm
Compass Design
Minneapolis, Minnesota

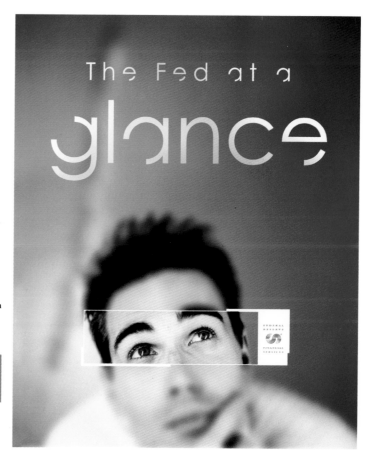

The Fed at a

glance

design firm
Stan Gellman Graphic Design
St. Louis, Missouri
client
Federal Reserve Bank of St. Louis

C - 100
M - 80
Y - 26
K - 22

C - 76
M - 13
Y - 20
K - 0

An eye for our world

All the sand on our beaches is made up of individual grains.

From tiny droplets come all our oceans' waters.

At bpTT, we're committed to addressing the problem of global pollution, by acting locally to promote safer personal and industrial use of the environment.

After all, it's our world too.

Investing beyond petroleum...

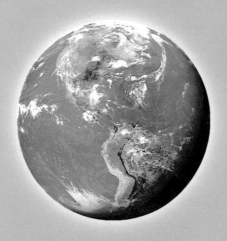

bp

Trinidad and Tobago

bpTT – Education • Culture • Environment • Community

C - 4	C - 33	C - 65	C - 70
M - 0	M - 2	M - 11	M - 27
Y - 64	Y - 74	Y - 65	Y - 24
K - 0	K - 0	K - 0	K - 0

C - 4	C - 2	C - 40	C - 63	C - 35
M - 72	M - 37	M - 55	M - 0	M - 25
Y - 69	Y - 82	Y - 3	Y - 70	Y - 22
K - 0	K - 0	K - 0	K - 0	K - 6

THE JEWISH
HOME & HOSPITAL
LIFECARE SYSTEM

MANHATTAN ▪ BRONX ▪ SARAH NEUMAN CENTER/WESTCHESTER ▪ LIFECARE SERVICES

C - 11	C - 18	C - 43	C - 0
M - 31	M - 99	M - 86	M - 0
Y - 100	Y - 95	Y - 10	Y - 0
K - 0	K - 1	K - 3	K - 100

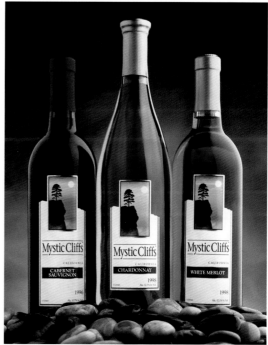

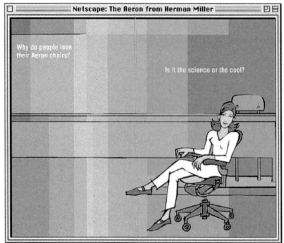

C - 20
M - 30
Y - 0
K - 10

C - 20
M - 60
Y - 50
K - 10

C - 0
M - 30
Y - 70
K - 10

C - 0
M - 10
Y - 20
K - 50

C - 30
M - 50
Y - 70
K - 0

C - 10
M - 60
Y - 70
K - 0

design firm
BBK Studio
Grand Rapids, Michigan
client
Herman Miller

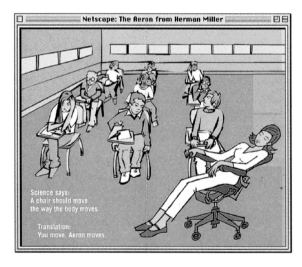

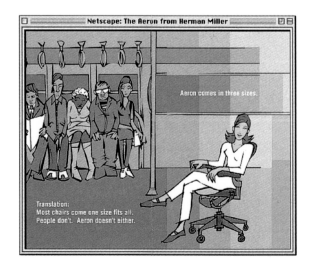

continuum

Girard College

A college preparatory boarding school
for grades 1–12

Volume 2, Spring 2000

design firm
kor group
Boston, Massachusetts
client
Girard College

C - 80	C - 90	C - 0
M - 40	M - 20	M - 0
Y - 20	Y - 0	Y - 0
K - 0	K - 30	K - 100

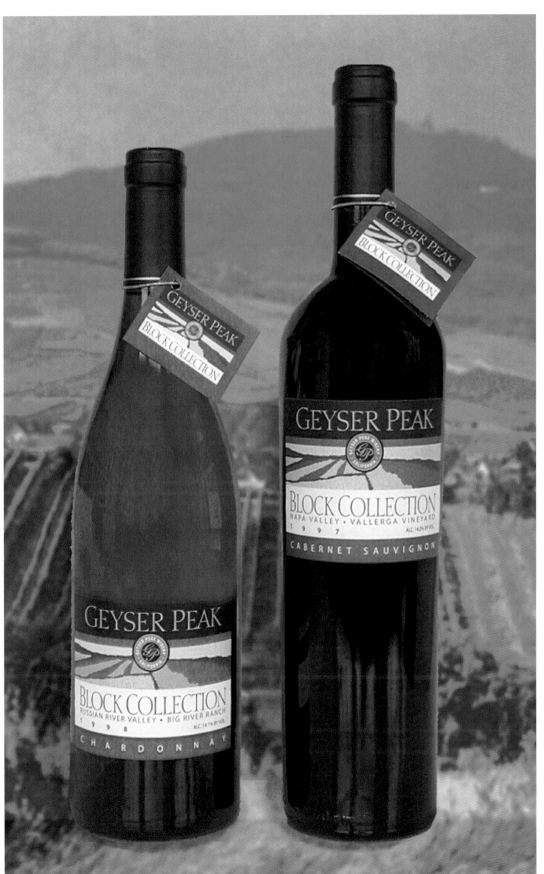

design firm
Di Donato Associates
Chicago, Illinois
client
Jim Beam Brands Company

C - 60
M - 10
Y - 40
K - 40

C - 20
M - 10
Y - 50
K - 10

C - 60
M - 60
Y - 30
K - 20

C - 30
M - 60
Y - 10
K - 20

design firm
Becker Design
Milwaukee, Wisconsin
client
Good Printing

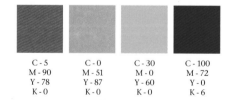

7933 North 73rd Street Milwaukee, Wisconsin 53223 Phone 414 355-4444 Fax 414 355-7746 www.itsgoodprinting.com

C - 5	C - 0	C - 30	C - 100
M - 90	M - 51	M - 0	M - 72
Y - 78	Y - 87	Y - 60	Y - 0
K - 0	K - 0	K - 0	K - 6

PUBLIC SERVANTS

P.S. WE ♥ YOU

SAYLES GRAPHIC DESIGN INC.

C - 0	C - 0	C - 55	C - 100	C - 28
M - 50	M - 89	M - 28	M - 77	M - 91
Y - 90	Y - 93	Y - 4	Y - 18	Y - 58
K - 0	K - 0	K - 1	K - 15	K - 34

design firm
Sayles Graphic Design
Des Moines, Iowa

client
"Art Fights Back"

design firm
Michael Osborne Design
San Francisco, California

client
Gymboree

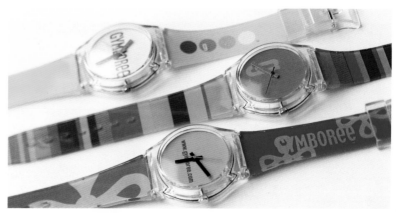

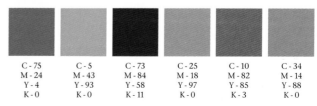

C - 75	C - 5	C - 73	C - 25	C - 10	C - 34
M - 24	M - 43	M - 84	M - 18	M - 82	M - 14
Y - 4	Y - 93	Y - 58	Y - 97	Y - 85	Y - 88
K - 0	K - 0	K - 11	K - 0	K - 3	K - 0

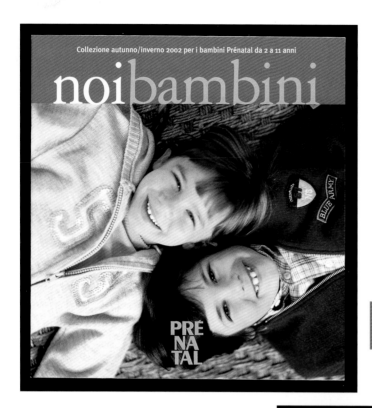

Collezione autunno/inverno 2002 per i bambini Prénatal da 2 a 11 anni

noibambini

PRÉ NA TAL

C - 0
M - 91
Y - 57
K - 13

C - 0
M - 50
Y - 35
K - 0

Piccoli bimbi crescono. A partire dai due anni c'è sempre più voglia di essere grandi e un po' indipendenti, anche nella scelta degli abiti: quelli di tutti i giorni e quelli delle occasioni speciali. È un momento affascinante in cui i bambini cominciano a sviluppare il proprio gusto personale e la tua guida, i tuoi consigli e il tuo amore lo accompagneranno in questa come in ogni altra esperienza. Fare acquisti con il tuo bimbo e scegliere insieme i capi più comodi e più belli renderà ancora più ricco e intenso il vostro rapporto di complicità. In questo catalogo trovi una selezione della nuova collezione autunno/inverno Prénatal dedicata alle bambine e ai bambini dai due agli undici anni. Abiti dai colori e dalle forme più attuali e alla moda senza mai dimenticare la praticità e il comfort. Una vasta scelta per tutte le occasioni, dalla scuola alla casa, dal tempo libero al momento del sonno. E infine tutti gli accessori di cui puoi aver bisogno, nei colori e nei motivi più allegri e vivaci: proprio come i bambini.

design firm
Tangram Strategic Design
Novara (Italy)
client
Prénatal

 school

design firm
Klündt Hosmer Design
Spokane, Washington
client
Discovery School

C - 80 C - 0
M - 40 M - 60
Y - 0 Y - 100
K - 0 K - 0

clink

design firm
After Hours Creative
Phoenix, Arizona

C - 0 C - 0 C - 30
M - 100 M - 12 M - 0
Y - 100 Y - 90 Y - 90
K - 0 K - 0 K - 15

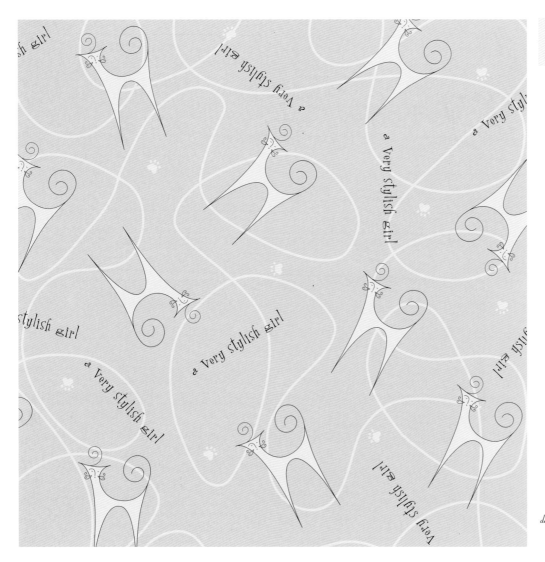

C - 0
M - 14
Y - 0
K - 0

C - 3
M - 27
Y - 3
K - 0

design firm
After Hours Creative
Phoenix, Arizona

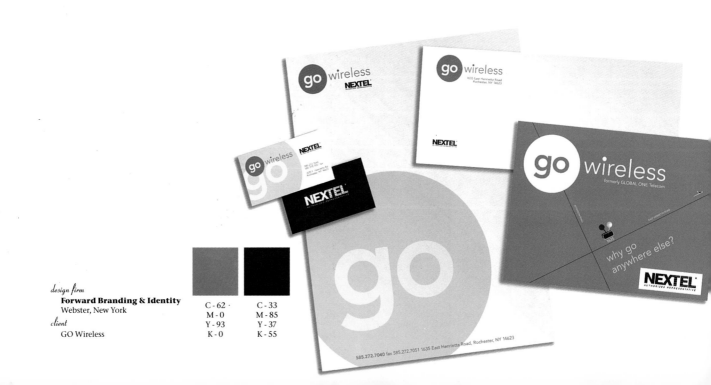

design firm
Forward Branding & Identity
Webster, New York
client
GO Wireless

C - 62
M - 0
Y - 93
K - 0

C - 33
M - 85
Y - 37
K - 55

C - 0	C - 12	C - 71	C - 85	C - 40
M - 71	M - 91	M - 99	M - 16	M - 2
Y - 83	Y - 86	Y - 21	Y - 7	Y - 93
K - 0	K - 2	K - 7	K - 3	K - 1

design firm
Tom Fowler, Inc.
Norwalk, Connecticut

client
Pfizer

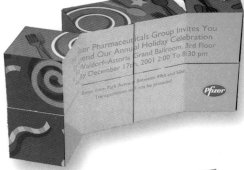

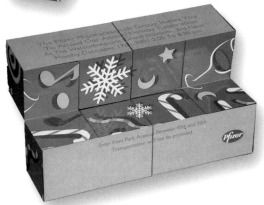

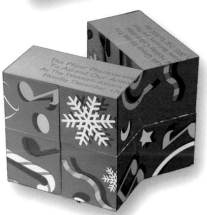

design firm
Greenfield/Belser Ltd.
Washington, D.C.

client
Local Initiatives Support Group

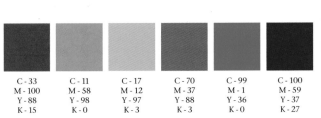

C - 33	C - 11	C - 17	C - 70	C - 99	C - 100
M - 100	M - 58	M - 12	M - 37	M - 1	M - 59
Y - 88	Y - 98	Y - 97	Y - 88	Y - 36	Y - 37
K - 15	K - 0	K - 3	K - 3	K - 0	K - 27

2002 • 2003

Your complete calendar to

THE **Performing Arts** *at Miami*

The best way to experience the **THRILL** *of a live performance is to* **BE THERE.**

MUSIC
THEATRE
PERFORMING ARTS SERIES

ARTS
AT MIAMI

(opposite) design firm
Five Visual Communication and Design
West Chester, Ohio

C - 40	C - 95	C - 0	C - 0	C - 100	C - 83
M - 2	M - 95	M - 32	M - 84	M - 65	M - 11
Y - 93	Y - 14	Y - 92	Y - 89	Y - 0	Y - 21
K - 1	K - 4	K - 0	K - 0	K - 0	K - 2

C - 91	C - 25	C - 12
M - 78	M - 18	M - 91
Y - 22	Y - 0	Y - 86
K - 24	K - 0	K - 2

design firm
Compass Design
Minneapolis, Minnesota

design firm
Greteman Group
Wichita, Kansas

C - 18	C - 100
M - 0	M - 69
Y - 100	Y - 0
K - 18	K - 0

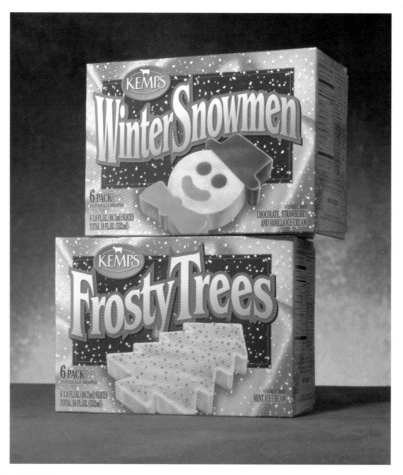

design firm
Compass Design
Minneapolis, Minnesota

C - 60
M - 30
Y - 60
K - 25

C - 91
M - 78
Y - 22
K - 24

C - 25
M - 18
Y - 0
K - 0

C - 12
M - 91
Y - 86
K - 2

design firm
Sagmeister Inc.
New York, New York

C - 72
M - 15
Y - 67
K - 13

C - 1
M - 17
Y - 66
K - 0

C - 14
M - 76
Y - 35
K - 2

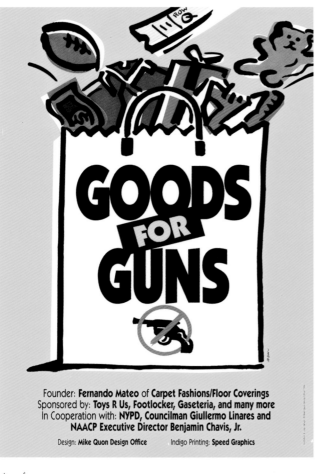

GOODS FOR GUNS

Founder: **Fernando Mateo** of **Carpet Fashions/Floor Coverings**
Sponsored by: **Toys R Us, Footlocker, Gaseteria, and many more**
In Cooperation with: **NYPD, Councilman Giullermo Linares** and
NAACP Executive Director Benjamin Chavis, Jr.

Design: **Mike Quon Design Office** Indigo Printing: **Speed Graphics**

C - 6
M - 0
Y - 95
K - 0

C - 74
M - 49
Y - 0
K - 0

C - 24
M - 100
Y - 76
K - 15

C - 71
M - 24
Y - 100
K - 13

C - 0
M - 72
Y - 99
K - 0

design firm
Designation
New York, New York

design firm
Compass Design
Minneapolis, Minnesota

C - 0
M - 9
Y - 86
K - 0

C - 40
M - 2
Y - 93
K - 1

C - 29
M - 62
Y - 72
K - 41

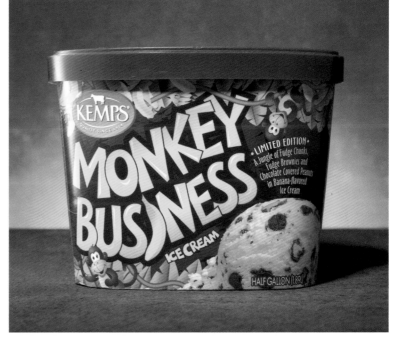

C - 100
M - 46
Y - 18
K - 12

C - 97
M - 83
Y - 15
K - 17

C - 12
M - 99
Y - 75
K - 18

C - 2
M - 42
Y - 88
K - 2

C - 21
M - 43
Y - 52
K - 15

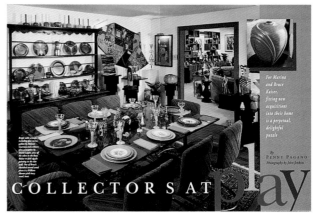

COLLECTORS AT play

design firm
Dever Designs
Laurel, Maryland

client
AmericanStyle Magazine

design firm
LarsonLogosEtc
Rockford, Illinois

C - 1
M - 23
Y - 99
K - 0

C - 100
M - 56
Y - 1
K - 34

C - 77
M - 95
Y - 22
K - 0

C - 1
M - 100
Y - 100
K - 0

C - 100
M - 0
Y - 91
K - 27

C - 0
M - 100
Y - 1
K - 0

C - 85
M - 14
Y - 1
K - 0

C - 1
M - 73
Y - 0
K - 0

C - 97
M - 94
Y - 95
K - 84

design firm
Supon Design Group
Washington, D.C.

client
M

276

design firm
Mike Salisbury L.L.C.
Venice, California
client
Merv Griffin

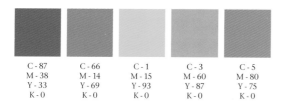

C - 87	C - 66	C - 1	C - 3	C - 5
M - 38	M - 14	M - 15	M - 60	M - 80
Y - 33	Y - 69	Y - 93	Y - 87	Y - 75
K - 0	K - 0	K - 0	K - 0	K - 0

design firm
Mike Salisbury L.L.C.
Venice, California
client
Montana Eyes

C - 95	C - 88	C - 16
M - 6	M - 80	M - 31
Y - 7	Y - 83	Y - 34
K - 0	K - 59	K - 0

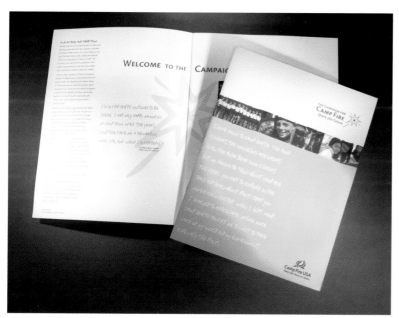

design firm
Belyea
Seattle, Washington
client
Campfire USA

C - 0	C - 74
M - 9	M - 45
Y - 69	Y - 0
K - 0	K - 21

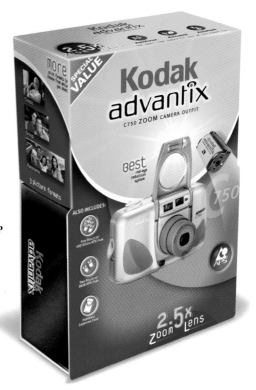

design firm
McElveney & Palozzi Design Group
Rochester, New York
client
Eastman Kodak Company

C - 0
M - 100
Y - 100
K - 0

C - 0
M - 18
Y - 100
K - 0

C - 74
M - 3
Y - 0
K - 0

C - 100
M - 60
Y - 0
K - 0

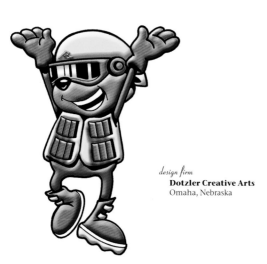

design firm
Dotzler Creative Arts
Omaha, Nebraska

C - 1
M - 0
Y - 87
K - 0

C - 100
M - 50
Y - 0
K - 16

C - 3
M - 87
Y - 90
K - 5

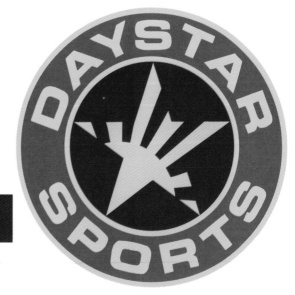

C - 12
M - 92
Y - 96
K - 2

C - 5
M - 19
Y - 95
K - 0

C - 85
M - 96
Y - 5
K - 0

design firm
The Wecker Group
Monterey, California

MICHAEL OSBORNE DESIGN

C - 4	C - 8	C - 39
M - 26	M - 67	M - 2
Y - 77	Y - 93	Y - 82
K - 0	K - 1	K - 0

design firm
Michael Osborne Design
San Francisco, California
client
Michael Osborne Design

design firm
Cahan and Associates
San Francisco, California
client
Fine Arts Museum

C - 0	C - 100	C - 4	C - 0
M - 100	M - 0	M - 3	M - 0
Y - 100	Y - 0	Y - 92	Y - 0
K - 0	K - 0	K - 0	K - 100

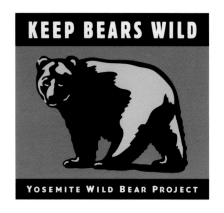

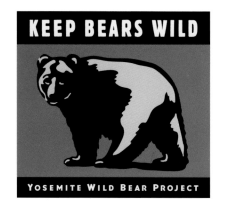

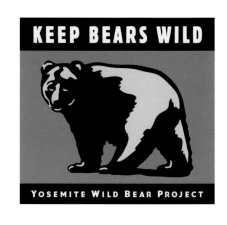

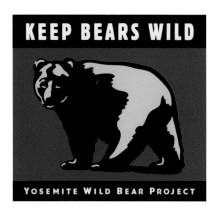

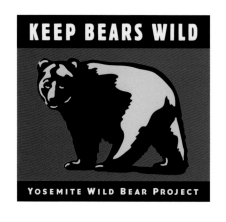

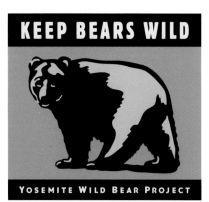

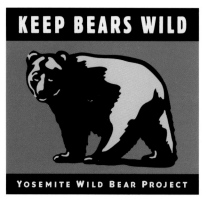

design firm
Michael Osborne Design
San Francisco, California

client
Yosemite Wild Bear Project

C - 0
M - 18
Y - 100
K - 43

C - 56
M - 0
Y - 91
K - 38

C - 65
M - 23
Y - 34
K - 0

C - 100
M - 72
Y - 0
K - 6

C - 79
M - 94
Y - 11
K - 0

C - 0
M - 91
Y - 72
K - 23

C - 0
M - 65
Y - 100
K - 0

C - 0
M - 56
Y - 100
K - 30

C - 0
M - 6
Y - 38
K - 18

280

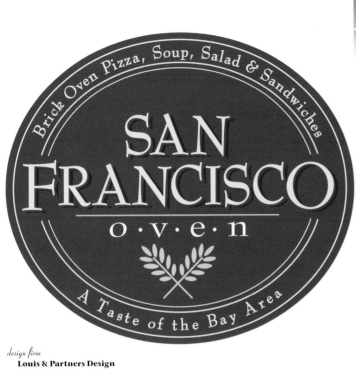

C - 0
M - 91
Y - 100
K - 40

C - 0
M - 24
Y - 76
K - 0

C - 6
M - 9
Y - 24
K - 0

design firm
Louis & Partners Design
Bath, Ohio
client
San Francisco Oven

C - 1
M - 8
Y - 58
K - 30

C - 11
M - 1
Y - 60
K - 44

C - 7
M - 23
Y - 43
K - 6

C - 34
M - 10
Y - 40
K - 74

design firm
Hornall Anderson Design Works
Seattle, Washington

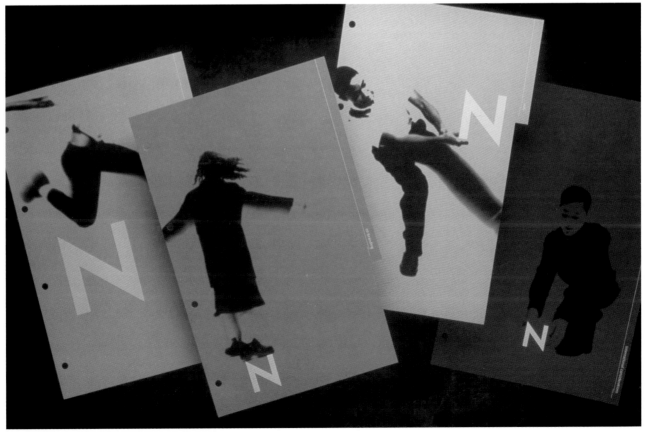

C - 35	C - 31	C - 2	C - 47
M - 0	M - 28	M - 14	M - 43
Y - 18	Y - 47	Y - 26	Y - 44
K - 51	K - 1	K - 38	K - 17

design firm
5D Studio
Malibu, California
client
Walker Zanger

design firm
**Hornall Anderson
Design Works**
Seattle, Washington

C - 0
M - 15
Y - 92
K - 26

C - 8 C - 57
M - 76 M - 29
Y - 55 Y - 15
K - 50 K - 47

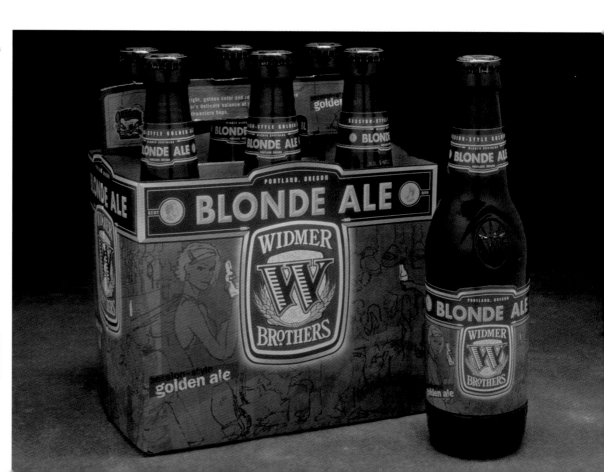

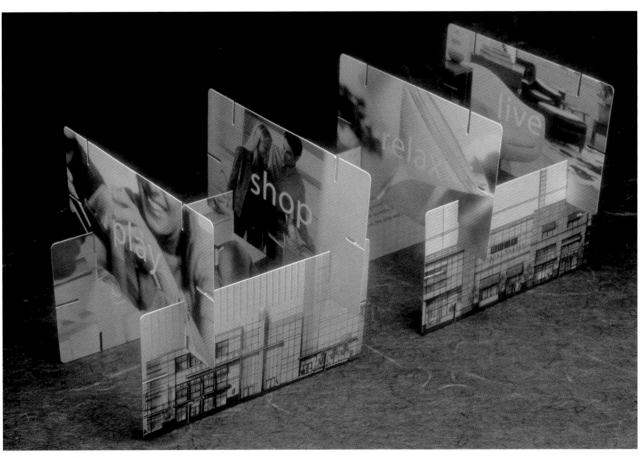

design firm
Hornall Anderson Design Works
Seattle, Washington

C - 2	C - 40	C - 5
M - 21	M - 24	M - 49
Y - 59	Y - 16	Y - 31
K - 44	K - 47	K - 60

design firm
Greteman Group
Wichita, Kansas

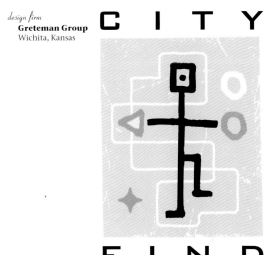

CITY

FIND

C - 57	C - 0	C - 12
M - 11	M - 0	M - 15
Y - 0	Y - 0	Y - 28
K - 18	K - 100	K - 2

design firm
Hornall Anderson Design Works
Seattle, Washington

C - 20 C - 12
M - 78 M - 62
Y - 65 Y - 81
K - 42 K - 34

C - 0 C - 60
M - 60 M - 0
Y - 100 Y - 100
K - 20 K - 22570

design firm
Klündt Hosmer Design
Spokane, Washington
client
Spokane Public Schools

Spokane Public Schools
excellence for everyone

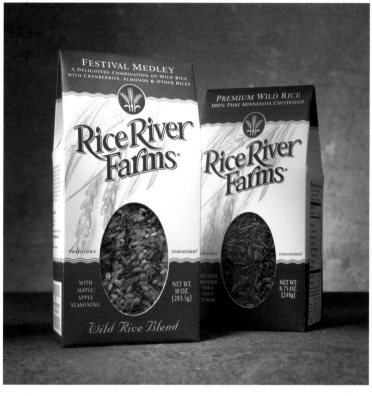

C - 26 C - 93 C - 68
M - 80 M - 70 M - 42
Y - 37 Y - 0 Y - 38
K - 19 K - 0 K - 40

design firm
Compass Design
Minneapolis, Minnesota

design firm
Compass Design
Minneapolis, Minnesota

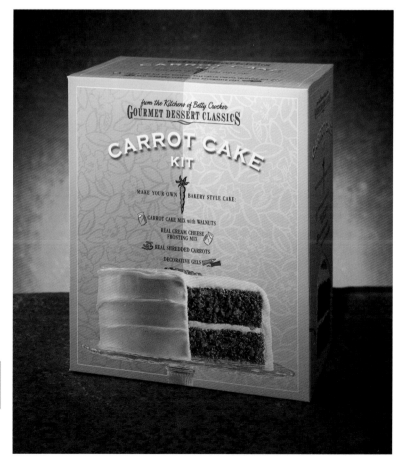

C - 42 C - 22 C - 0
M - 2 M - 14 M - 71
Y - 75 Y - 46 Y - 83
K - 1 K - 2 K - 0

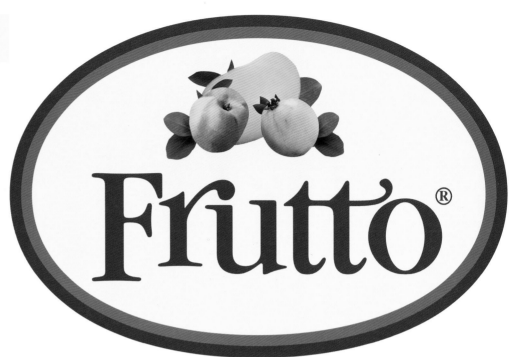

C - 0	C - 0
M - 76	M - 5
Y - 76	Y - 20
K - 60	K - 0

design firm
Praxis Diseñadores, S.C.
México City (Mexico)
client
Alegro Internacional

design firm
Designation
New York, New York

C - 1	C - 91	C - 62	C - 2
M - 31	M - 0	M - 3	M - 3
Y - 55	Y - 100	Y - 0	Y - 87
K - 0	K - 0	K - 0	K - 0

design firm
Mike Salisbury L.L.C.
Venice, California
client
DiviDivi

C - 45 C - 0
M - 23 M - 0
Y - 49 Y - 0
K - 0 K - 100

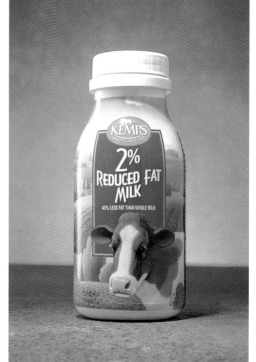

design firm
Compass Design
Minneapolis, Minnesota
client
Kemps Marigold

C - 99 C - 0
M - 33 M - 49
Y - 0 Y - 97
K - 2 K - 0

design firm
Belyea
Seattle, Washington
client
ColorGraphics

C - 31 C - 27 C - 41 C - 29
M - 15 M - 65 M - 23 M - 40
Y - 57 Y - 55 Y - 33 Y - 69
K - 3 K - 37 K - 5 K - 19

C - 33
M - 91
Y - 88
K - 15

C - 0
M - 0
Y - 0
K - 100

*i*Horses

design firm
Funk/Levis & Associates
Eugene, Oregon
client
iHorses

C - 0
M - 0
Y - 0
K - 100

C - 49
M - 37
Y - 38
K - 18

C - 33
M - 44
Y - 57
K - 21

design firm
Belyea
Seattle, Washington
client
Vue Lodge

vue
LODGE

HERON HILL

design firm
McElveney & Palozzi Design Group
Rochester, New York
client
Heron Hill Winery

C - 8
M - 15
Y - 40
K - 0

C - 0
M - 0
Y - 0
K - 100

C - 2	C - 16	C - 0
M - 60	M - 95	M - 0
Y - 91	Y - 95	Y - 0
K - 0	K - 4	K - 100

Riconoscerci come abitanti del pianeta. Prenderci cura del mondo in cui viviamo. Creare e difendere spazi aperti al confronto e alle differenze. Imparare il gioco della democrazia.

casa della cultura

Indignarci. Riscoprire il linguaggio elementare della meraviglia. Ascoltare oltre che affermare. Un percorso da fare insieme, alla ricerca dell'identità (perduta?) della sinistra.

design firm
Tangram Strategic Design
Novara (Italy)
client
Casa della Cultura

C - 1
M -54
Y - 78
K - 0

C - 29
M - 49
Y - 73
K - 25

C - 4
M - 29
Y - 56
K - 1

C - 0
M - 0
Y - 0
K - 100

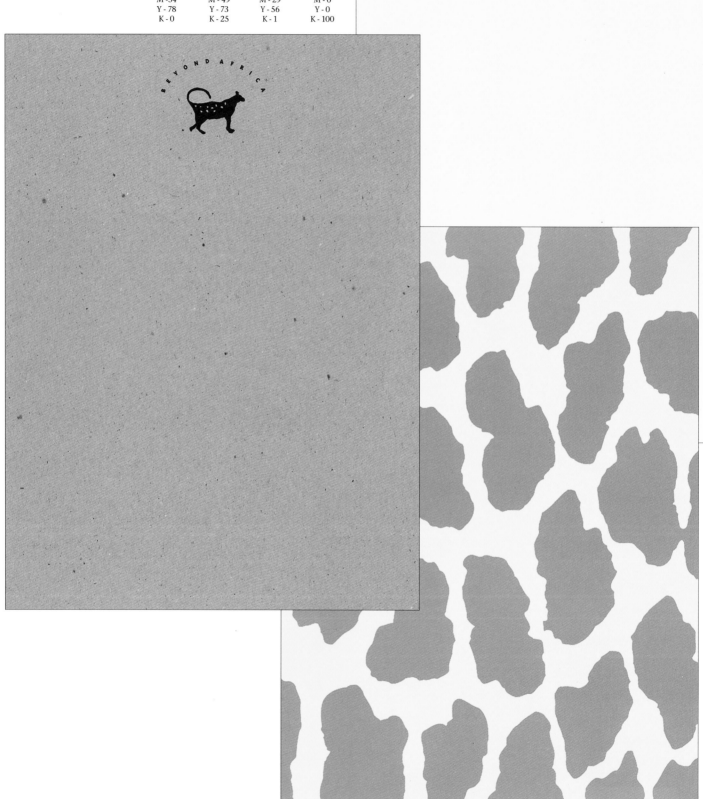

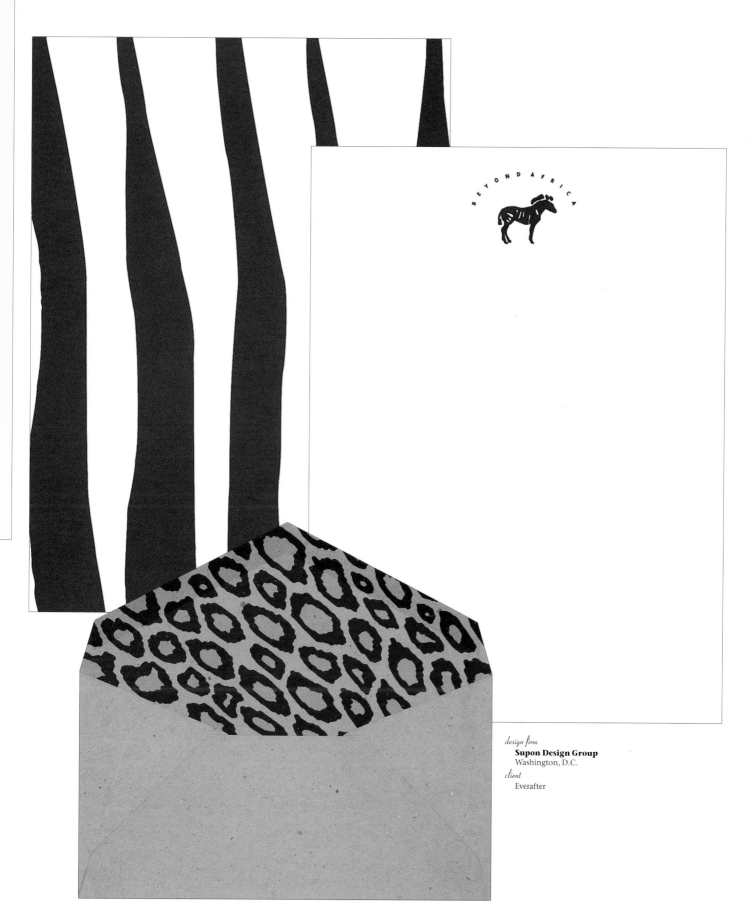

BEYOND AFRICA

design firm
Supon Design Group
Washington, D.C.
client
Everafter

C - 20
M - 70
Y - 80
K - 0

C - 80
M - 10
Y - 100
K - 0

C - 50
M - 40
Y - 50
K - 10

design firm
Tom Fowler, Inc.
Norwalk, Connecticut
client
Living with Elephants Foundation

whispering pines

The world is not all angles and edges.

C - 0	C - 60	C - 10	C - 80
M - 90	M - 40	M - 20	M - 40
Y - 60	Y - 30	Y - 80	Y - 20
K - 25	K - 0	K - 10	K - 40

design firm
Leslie Evans Design Associates
Portland, Maine
client
Robert Scott—David Brooks

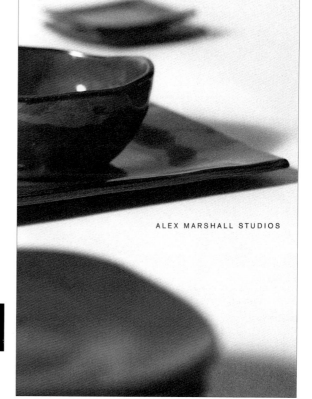

ALEX MARSHALL STUDIOS

design firm
Natalie Kitamura Design
San Francisco, California
client
Alex Marshall Studios

C - 20	C - 0
M - 90	M - 0
Y - 90	Y - 0
K - 20	K - 100

Since 1921

Family Pride Makes the Difference™

HUNTSINGER FARMS

Premium Hand Selected
U.S. No. 1
Size B

BABY RED SKIN POTATOES

Packed by **Huntsinger Farms, Inc.**
Hegins, PA 17938

Net Wt 5 lb (2.27kg)

C - 20
M - 90
Y - 60
K - 20

C - 100
M - 20
Y - 60
K - 0

C - 10
M - 10
Y - 60
K - 0

design firm
Dean Design/Marketing Group
Lancaster, Pennsylvania
client
Huntsinger Farms

NEWLEAF

C - 79	C - 71
M - 25	M - 28
Y - 90	Y - 73
K - 34	K - 52

design firm
Conover
San Diego, California
client
SD Malkin

C - 100	C - 20
M - 0	M - 75
Y - 100	Y - 100
K - 40	K - 0

GEORGIA ORGANICS

design firm
B-Man Design
Atlanta, Georgia
client
Georgia Organics

C - 30	C - 1	C - 16
M - 59	M - 56	M - 50
Y - 87	Y - 95	Y - 77
K - 44	K - 0	K - 6

design firm
AGC—Mktg. Comm. Dept.
Phoenix, Arizona
client
Deer Creek Golf Club at Meadow Ranch

DEER CREEK
GOLF CLUB
at Meadow Ranch

295

CAMPION WALKER
garden design

1044 PALMS
BOULEVARD
VENICE, CALIFORNIA
90291

❖

PHONE: 310 392 3535
FAX: 310 581 9405

design firm
Erbe Design
South Pasadena, California
client
Campion Walker

C - 45	C - 40	C - 15
M - 40	M - 100	M - 40
Y - 93	Y - 50	Y - 70
K - 47	K - 30	K - 5

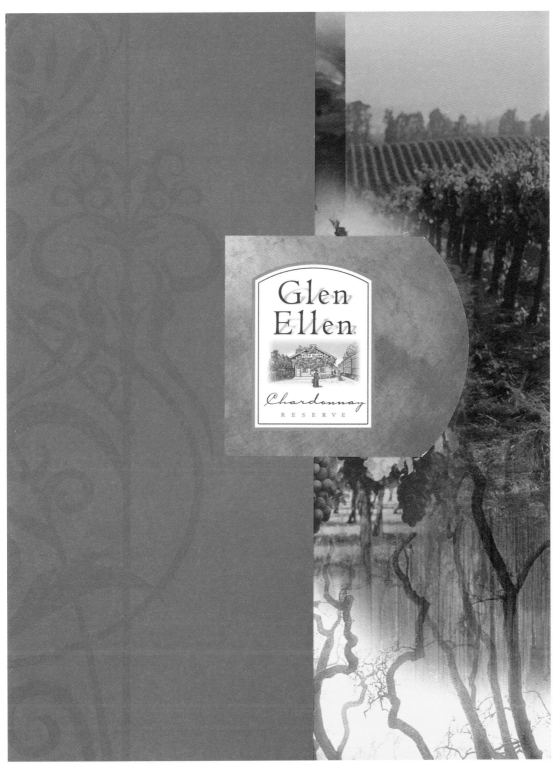

C - 5	C - 20	C - 81	C - 10
M - 59	M - 50	M - 26	M - 20
Y - 97	Y - 100	Y - 92	Y - 90
K - 1	K - 10	K - 42	K - 0

design firm
Halleck
Palo Alto, California

client
United Distillers & Vintners

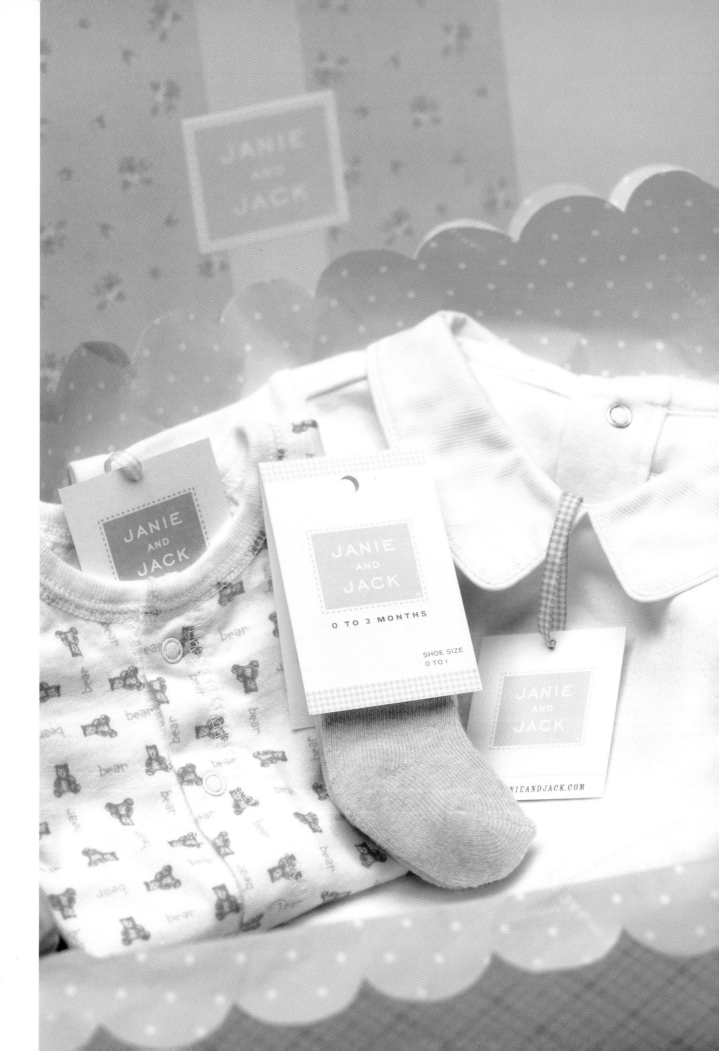

ReTReAT
Living the Spa Lifestyle

design firm
The Wecker Group
Monterey, California

C - 38
M - 2
Y - 26
K - 0

C - 38
M - 14
Y - 1
K - 0

C - 10
M - 4
Y - 3
K - 0

C - 9
M - 1
Y - 34
K - 0

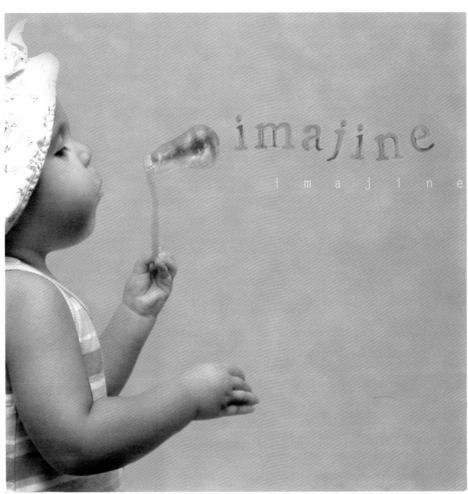

C - 3
M - 12
Y - 40
K - 0

C - 22
M - 23
Y - 4
K - 0

C - 0
M - 22
Y - 11
K - 0

C - 16
M - 4
Y - 26
K - 0

C - 28
M - 16
Y - 4
K - 1

C - 29
M - 1
Y - 17
K - 0

C - 13
M - 31
Y - 75
K - 0

C - 45
M - 27
Y - 53
K - 0

C - 19
M - 32
Y - 20
K - 0

design firm
Im-aj Communications & Design, Inc.
West Kingston, Rhode Island
client
Im-aj Communications & Design, Inc.

(opposite) design firm
Michael Osborne Design
San Francisco, California
client
Janie and Jack

C - 0 C - 0 C - 0
M - 0 M - 0 M - 0
Y - 0 Y - 0 Y - 0
K - 0 K - 0 K - 0

design firm
Bailey Design Group Inc.
Plymouth Meeting, Pennsylvania

C - 76 C - 70 C - 0
M - 60 M - 5 M - 15
Y - 0 Y - 50 Y - 35
K - 0 K - 0 K - 0

water·color℠
A Southern Coastal Landscape. **FLORIDA**

design firm
David Carter Design Assoc.
Dallas, Texas
client
Arvida

C - 0 C - 0
M - 0 M - 40
Y - 0 Y - 20
K - 0 K - 10

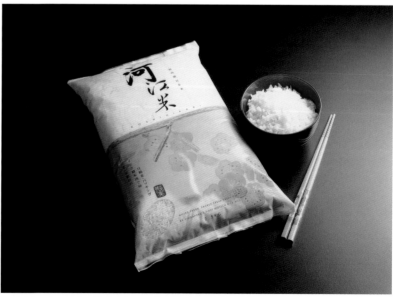

design firm
Ukulele Design Consultants Pte Ltd
Singapore (Singapore)
client
Ng Nam Bee Marketing Pte Ltd

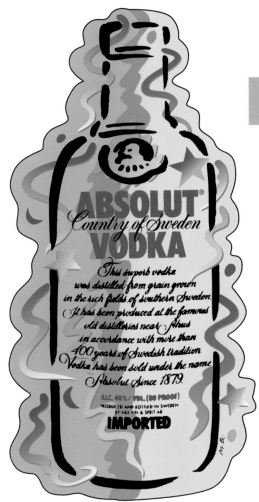

C - 63
M - 0
Y - 29
K - 0

C - 51
M - 81
Y - 1
K - 0

C - 1
M - 14
Y - 91
K - 0

C - 97
M - 56
Y - 3
K - 1

C - 0
M - 68
Y - 95
K - 0

C - 10
M - 50
Y - 90
K - 0

C - 0
M - 100
Y - 100
K - 0

C - 95
M - 75
Y - 35
K - 15

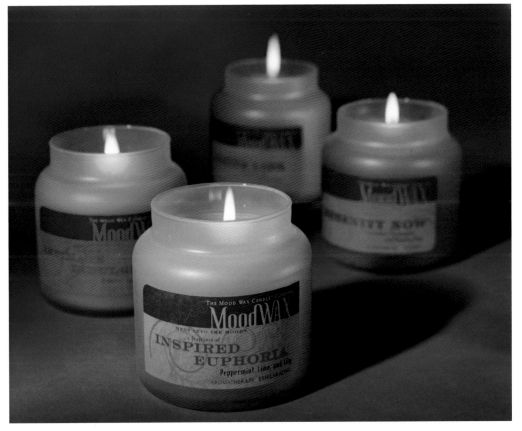

design firm
Interrobang Design Collaborative
Richmond, Virginia

client
Moodwax Candle Co.

C - 5
M - 91
Y - 93
K - 0

C - 61
M - 41
Y - 49
K - 32

C - 22
M - 13
Y - 13
K - 1

GRAPHICSOURCE
PRODUCTION/FULFILLMENT

design firm
Becker Design
Milwaukee, Wisconsin
client
Graphic Source

big deal.

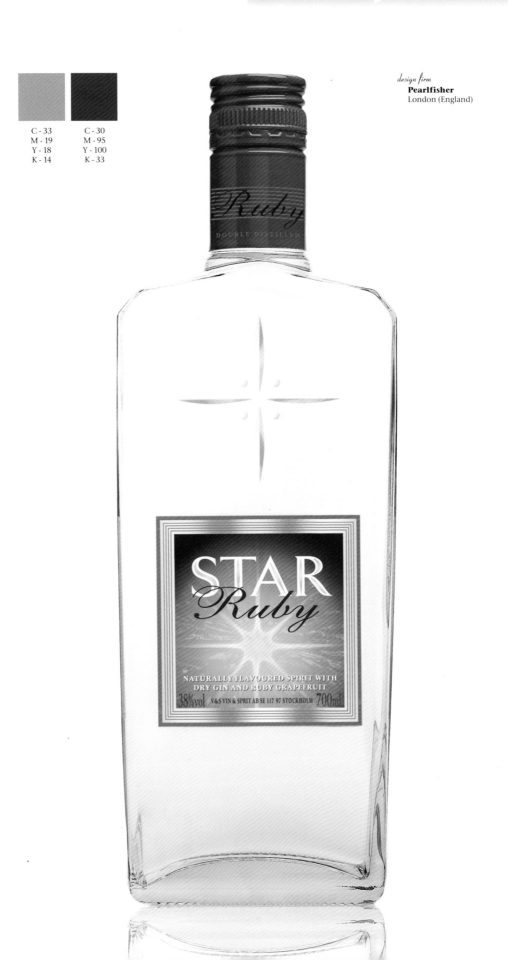

C - 33 C - 30
M - 19 M - 95
Y - 18 Y - 100
K - 14 K - 33

design firm
Pearlfisher
London (England)

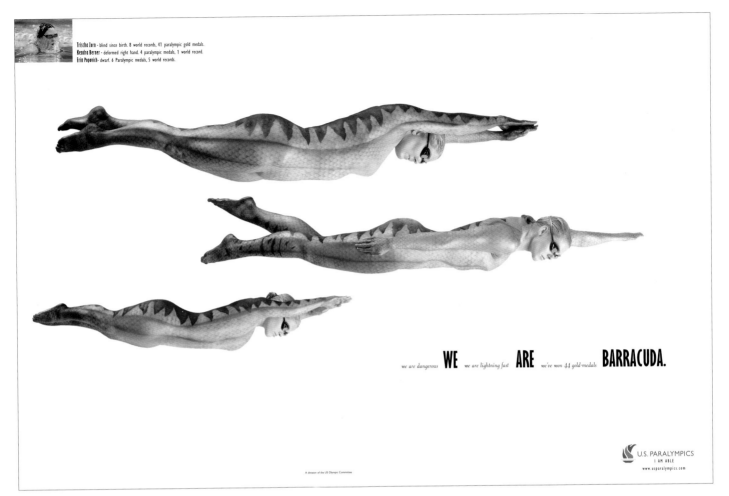

Trischa Zorn - blind since birth. 8 world records, 41 paralympic gold medals.
Kendra Berner - deformed right hand. 4 paralympic medals, 1 world record.
Erin Popovich - dwarf. 6 Paralympic medals, 5 world records.

we are dangerous **WE** *we are lightning fast* **ARE** *we've won 44 gold-medals* **BARRACUDA.**

U.S. PARALYMPICS
I AM ABLE
www.usparalympics.com

A division of the US Olympic Committee

design firm
After Hours Creative
Phoenix, Arizona

C - 80	C - 56	C - 27
M - 67	M - 39	M - 18
Y - 38	Y - 18	Y - 7
K - 17	K - 3	K - 0

C - 49	C - 57	C - 100	C - 0
M - 1	M - 0	M - 0	M - 0
Y - 0	Y - 100	Y - 44	Y - 0
K - 0	K - 0	K - 0	K - 100

Intelsat

design firm
Addison
San Francisco, California
client
Intelsat

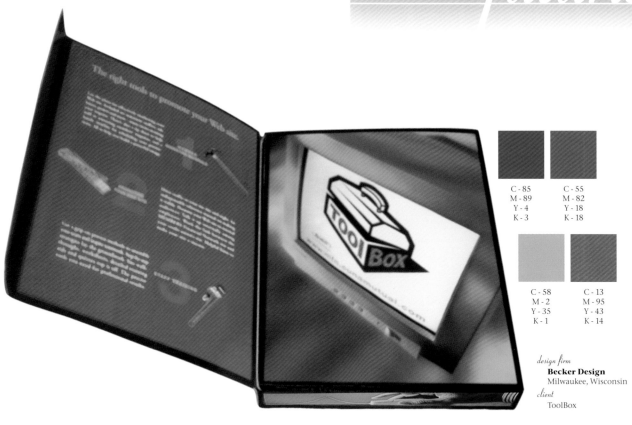

C - 85　　C - 55
M - 89　　M - 82
Y - 4　　　Y - 18
K - 3　　　K - 18

C - 58　　C - 13
M - 2　　　M - 95
Y - 35　　Y - 43
K - 1　　　K - 14

design firm
Becker Design
Milwaukee, Wisconsin
client
ToolBox

design firm
McElveney & Palozzi Design Group
Rochester, New York
client
Bausch & Lomb

C - 12　　C - 0
M - 1　　　M - 0
Y - 0　　　Y - 0
K - 1　　　K - 0

design firm
Sagmeister Inc.
New York, New York

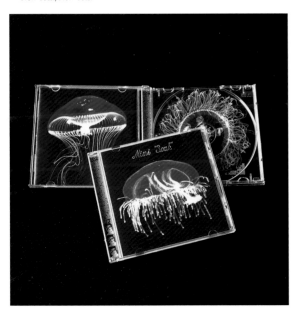

C - 93　　C - 11　　C - 82
M - 77　　M - 99　　M - 49
Y - 0　　　Y - 78　　Y - 0
K - 0　　　K - 0　　　K - 0

design firm
McElveney & Palozzi Design Group
Rochester, New York

client
UNYCoR

C - 100
M - 0
Y - 18
K - 18

C - 100
M - 94
Y - 0
K - 6

C - 0
M - 0
Y - 0
K - 100

design firm
Stan Gellman Graphic Design
St. Louis, Missouri

C - 27
M - 53
Y - 99
K - 18

C - 22
M - 36
Y - 99
K - 3

M A R K E T P L A C E V I S I O N

design firm
Dotzler Creative Arts
Omaha, Nebraska

C - 0 C - 100
M - 2 M - 100
Y - 67 Y - 0
K - 1 K - 0

design firm
5D Studio
Malibu, California
client
Vecta

C - 40 C - 4 C - 1 C - 75
M - 23 M - 0 M - 82 M - 16
Y - 25 Y - 83 Y - 95 Y - 46
K - 12 K - 0 K - 15 K - 15

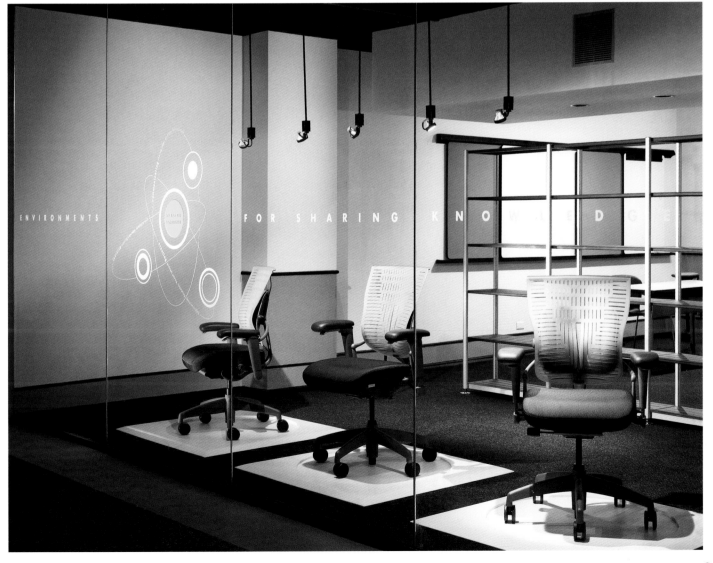

design firm
McElveney & Palozzi Design Group
Rochester, New York
client
Global Crossing

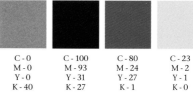

C - 0	C - 100	C - 80	C - 23
M - 0	M - 93	M - 24	M - 2
Y - 0	Y - 31	Y - 27	Y - 1
K - 40	K - 27	K - 1	K - 0

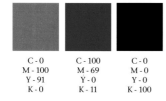

C - 0	C - 100	C - 0
M - 100	M - 69	M - 0
Y - 91	Y - 0	Y - 0
K - 0	K - 11	K - 100

design firm
Louis & Partners Design
Bath, Ohio
client
S3

show. secure. sell.

X E L U S

design firm
McElveney & Palozzi Design Group
Rochester, New York
client
Xelus

C - 87	C - 0
M - 54	M - 0
Y - 5	Y - 0
K - 1	K - 0

C - 67	C - 90	C - 87
M - 45	M - 94	M - 51
Y - 28	Y - 90	Y - 57
K - 0	K - 93	K - 16

design firm
Mike Salisbury L.L.C.
Venice, California
client
Bonsee Software

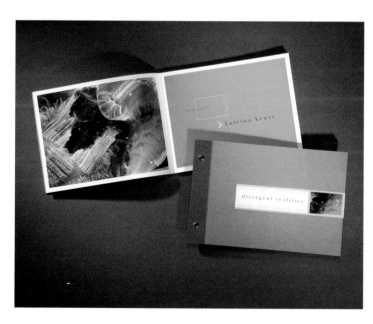

design firm
Belyea
Seattle, Washington
client
ColorGraphics

C - 14	C - 67	C - 38	C - 1
M - 44	M - 40	M - 0	M - 58
Y - 43	Y - 31	Y - 5	Y - 73
K - 2	K - 31	K - 0	K - 0

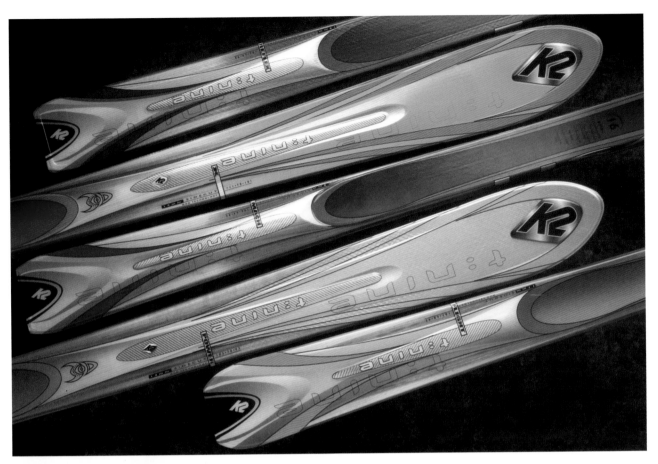

C - 60	C - 3	C - 80
M - 53	M - 93	M - 57
Y - 45	Y - 77	Y - 5
K - 44	K - 7	K - 5

design firm
Hornall Anderson Design Works
Seattle, Washington

ALPHA
High-Shrink Solutions

C - 0	C - 0
M - 75	M - 0
Y - 75	Y - 0
K - 0	K - 100

design firm
Louis & Partners Design
Bath, Ohio
client
Alpha

C - 100 C - 33
M - 97 M - 19
Y - 2 Y - 18
K - 4 K - 14

design firm
Pearlfisher
London (England)

Dry Gin

SINCE 1933

STAR
Dry Gin

ESTABLISHED IN
1933

38%vol V&S VIN & SPRIT AB 700ml
SE 117 97 STOCKHOLM

C - 82
M - 26
Y - 80
K - 12

C - 77
M - 33
Y - 0
K - 0

C - 22
M - 40
Y - 82
K - 5

C - 30
M - 23
Y - 30
K - 0

C - 39
M - 87
Y - 87
K - 38

design firm
Louis & Partners Design
Bath, Ohio
client
Rohrich

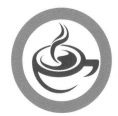

Cafe Bohéme
COFFEE HOUSE

C - 0
M - 24
Y - 100
K - 31

C - 72
M - 15
Y - 0
K - 56

design firm
Louis & Partners Design
Bath, Ohio
client
Café Bohéme

Kristen Eberhart Kottke

EBERHART INTERIORS

4385 Stone Canyon Drive
San Jose, California 95156

eberhartid@aol.com
p 408.229.0576 f 408.578.9958

EBERHART INTERIORS

4385 Stone Canyon Drive San Jose, California 95156 eberhartid@aol.com p 408.229.0576 f 408.578.9958

EBERHART INTERIORS

C - 86
M - 42
Y - 35
K - 26

C - 0
M - 0
Y - 0
K - 100

design firm
Becker Design
Milwaukee, Wisconsin
client
Eberhart Interiors

C - 100	C - 25	C - 27	C - 12	C - 0	C - 64	C - 5	C - 72	C - 0	C - 0
M - 68	M - 38	M - 100	M - 100	M - 0	M - 0	M - 60	M - 88	M - 19	M - 36
Y - 0	Y - 51	Y - 79	Y - 79	Y - 16	Y - 62	Y - 62	Y - 51	Y - 31	Y - 46
K - 25	K - 3	K - 24	K - 63	K - 54	K - 53	K - 15	K - 0	K - 5	K - 44

design firm
Bailey Design Group
Plymouth Meeting, Pennsylvania

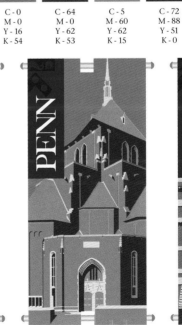

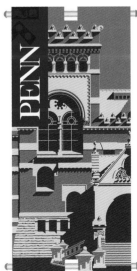

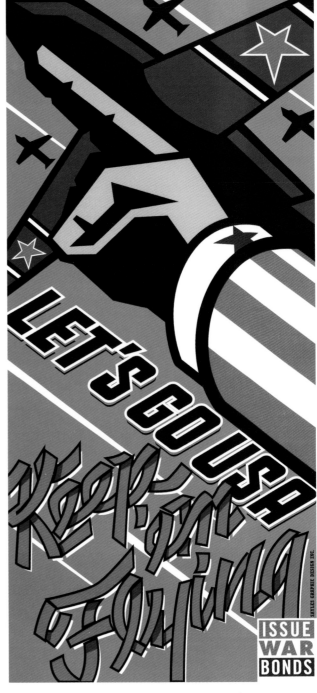

C - 61
M - 31
Y - 83
K - 54

C - 94
M - 81
Y - 25
K - 42

C - 4
M - 48
Y - 59
K - 1

C - 0
M - 89
Y - 93
K - 0

C - 84
M - 27
Y - 1
K - 1

design firm
Sayles Graphic Design
Des Moines, Iowa
client
"Art Fights Back"

C - 18
M - 49
Y - 79
K - 12

C - 0
M - 6
Y - 91
K - 36

C - 0
M - 0
Y - 0
K - 100

design firm
Klündt Hosmer Design
Spokane, Washington
client
MacKay Construction

design firm
Compass Design
Minneapolis, Minnesota

design firm
Sayles Graphic Design
Des Moines, Iowa
client
"Art Fights Back"

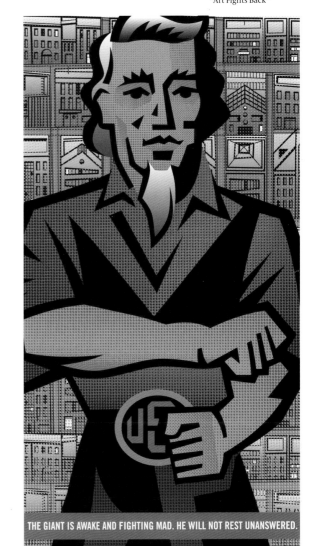

THE GIANT IS AWAKE AND FIGHTING MAD. HE WILL NOT REST UNANSWERED.

C - 26	C - 14	C - 20
M - 86	M - 78	M - 62
Y - 83	Y - 92	Y - 62
K - 27	K - 4	K - 10

C - 4	C - 99	C - 0	C - 0	C - 47
M - 48	M - 62	M - 50	M - 89	M - 35
Y - 59	Y - 2	Y - 90	Y - 93	Y - 33
K - 1	K - 1	K - 0	K - 0	K - 14

admission is free

dinner
activities
music
prizes
museums

shuttle service
is provided
from each
hospital campus

note:
parking is limited
at museum center

on track to success

march 7&8 2002
mercy health partners employee celebration
cincinnati museum center
6pm–midnight

look for your invitation in the mail

design firm
Five Visual Communication and Design
West Chester, Ohio

C - 72	C - 71	C - 22
M - 33	M - 99	M - 14
Y - 0	Y - 21	Y - 46
K - 1	K - 7	K - 2

Launch
Pad
PRODUCTIONS

design firm
Klündt Hosmer Design
Spokane, Washington
client
Launch Pad

C - 0	C - 0
M - 0	M - 25
Y - 0	Y - 90
K - 100	K - 0

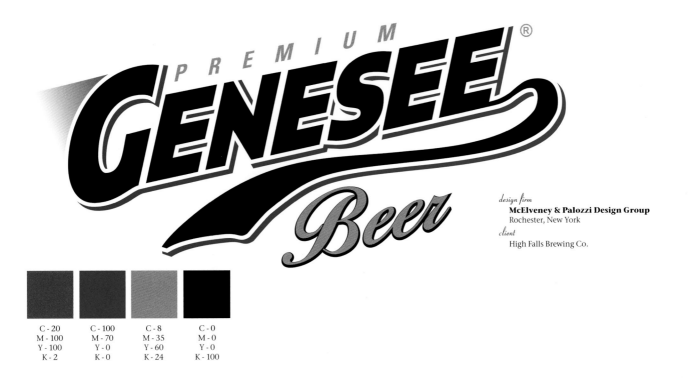

design firm
McElveney & Palozzi Design Group
Rochester, New York
client
High Falls Brewing Co.

C - 20	C - 100	C - 8	C - 0
M - 100	M - 70	M - 35	M - 0
Y - 100	Y - 0	Y - 60	Y - 0
K - 2	K - 0	K - 24	K - 100

design firm
Designation
New York, New York

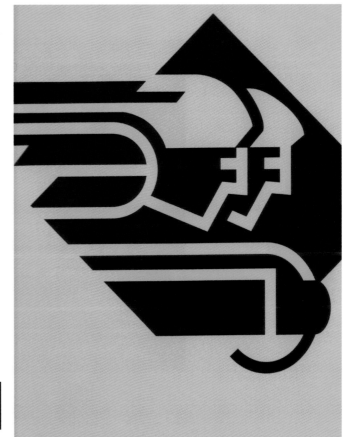

C - 1	C - 90
M - 41	M - 71
Y - 93	Y - 25
K - 0	K - 51

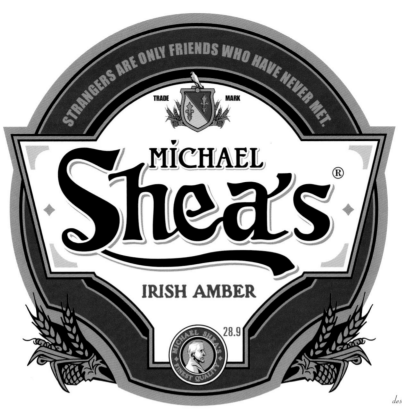

design firm
McElveney & Palozzi Design Group
Rochester, New York
client
High Falls Brewing Co.

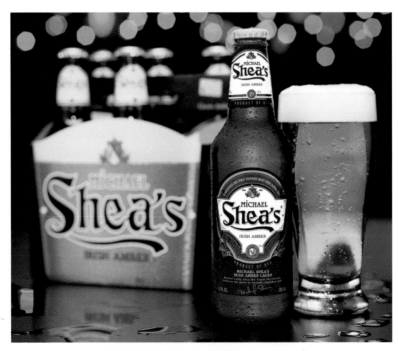

C - 79	C - 8	C - 0	C - 0
M - 0	M - 35	M - 0	M - 100
Y - 87	Y - 60	Y - 0	Y - 100
K - 56	K - 24	K - 100	K - 30

design firm
Armijo Design Office
Torrance, California
client
Lemax

C - 79
M - 23
Y - 89
K - 1

C - 4
M - 89
Y - 86
K - 4

C - 6
M - 11
Y - 64
K - 0

C - 24
M - 54
Y - 71
K - 0

C - 16
M - 88
Y - 67
K - 5

C - 24
M - 76
Y - 95
K - 18

C - 0
M - 50
Y - 85
K - 0

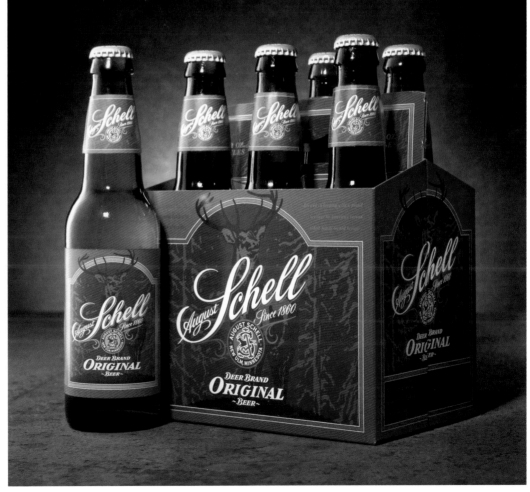

design firm
Compass Design
Minneapolis, Minnesota

RESIDENCIES IN
DENTISTRY AND
ORAL AND
MAXILLOFACIAL
SURGERY

CATHOLIC
MEDICAL
CENTERS

design firm
Designation
New York, New York

C - 62
M - 20
Y - 67
K - 20

C - 77
M - 39
Y - 0
K - 0

C - 1
M - 84
Y - 95
K - 0

C - 37
M - 2
Y - 1
K - 0

design firm
Brown & Partners
Las Vegas, Nevada
client
Fremont Street Experience

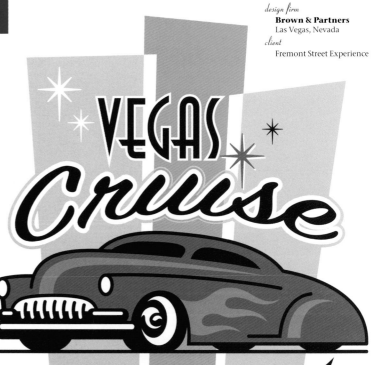

C - 3
M - 0
Y - 0
K - 22

C - 0
M - 75
Y - 100
K - 25

C - 100
M - 91
Y - 0
K - 44

320

FINEST HARDWOODS & HERBS
TRADITIONAL PURE SMOKED SALMON

C - 42
M - 45
Y - 78
K - 0

C - 69
M - 62
Y - 82
K - 28

C - 89
M - 80
Y - 77
K - 64

design firm
Mark Oliver Inc.
Solvang, California

client
Ocean Beauty Seafood

GREATWATERS™
BREWING COMPANY

C - 92
M - 50
Y - 50
K - 48

C - 46
M - 51
Y - 82
K - 3

C - 99
M - 98
Y - 96
K - 97

design firm
Compass Design
Minneapolis, Minnesota

client
Great Waters Brewing Co.

C - 2
M - 96
Y - 78
K - 35

C - 35
M - 12
Y - 19
K - 31

C - 100
M - 40
Y - 0
K - 55

C - 54
M - 44
Y - 24
K - 76

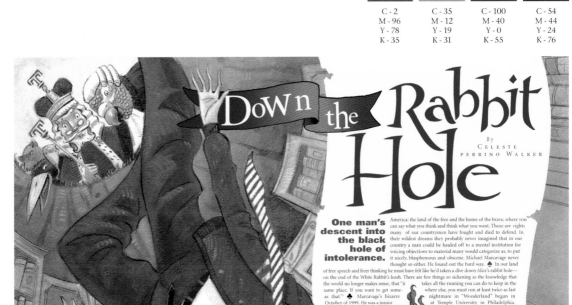

DoWn the Rabbit Hole

By
CELESTE
PERRINO WALKER

One man's descent into the black hole of intolerance.

America: the land of the free and the home of the brave, where you can say what you think and think what you want. Those are rights many of our countrymen have fought and died to defend. In their wildest dreams they probably never imagined that in our country a man could be hauled off to a mental institution for voicing objections to material many would categorize as, to put it nicely, blasphemous and obscene. Michael Marcavage never thought so either. He found out the hard way. ♣ In our land of free speech and freer thinking he must have felt like he'd taken a dive down Alice's rabbit hole—on the end of the White Rabbit's leash. There are few things so sickening as the knowledge that the world no longer makes sense, that "it same place. If you want to get some-as that." ♣ Marcavage's bizarre October of 1999. He was a junior Pennsylvania, when he versial play

takes all the running you can do to keep in the where else, you must run at least twice as fast nightmare in "Wonderland" began at Temple University in Philadelphia. learned that a production of the contro-*Corpus Christi* would be performed on campus. The play, written by Terrence McNally, features Jesus Christ as a homosexual who has sex with His disciples, is betrayed by His lover, Judas, and crucified for being "king of the queers". "It disturbed me that my school would be allowing this to be performed," said Marcavage. "I immediately went and voiced my opposition to the—*Continued on page 21*

Celeste perrino Walker writes from Rutland, Vermont.

ILLUSTRATION BY BRETT HELQUIST

design firm
Dever Designs
Laurel, Maryland

client
Liberty Magazine

C - 0
M - 13
Y - 87
K - 0

C - 8
M - 77
Y - 94
K - 0

C - 93
M - 67
Y - 92
K - 33

design firm
Compass Design
Minneapolis, Minnesota
client
Jake's Trading Company

design firm
Dotzler Creative Arts
Omaha, Nebraska

C - 98
M - 69
Y - 0
K - 3

C - 8
M - 98
Y - 92
K - 1

C - 0
M - 25
Y - 68
K - 23

design firm
Compass Design
Minneapolis, Minnesota

C - 0
M - 25
Y - 67
K - 0

C - 62
M - 51
Y - 49
K - 63

C - 13
M - 72
Y - 88
K - 3

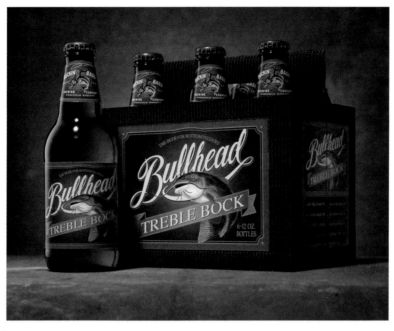

C - 34	C - 60	C - 13
M - 41	M - 53	M - 72
Y - 75	Y - 55	Y - 88
K - 25	K - 77	K - 3

design firm
Compass Design
Minneapolis, Minnesota

design firm
Stan Gellman Graphic Design
St. Louis, Missouri
client
University of Illinois Foundation

C - 100	C - 27	C - 24
M - 86	M - 85	M - 31
Y - 29	Y - 97	Y - 66
K - 15	K - 25	K - 1

C - 2
M - 14
Y - 77
K - 0

C - 96
M - 78
Y - 3
K - 0

design firm
Corey McPherson Nash
Watertown, Massachusetts
client
Concert Productions

C - 2
M - 30
Y - 15
K - 1

C - 100
M - 100
Y - 20
K - 30

C - 20
M - 100
Y - 80
K - 0

C - 75
M - 10
Y - 0
K - 0

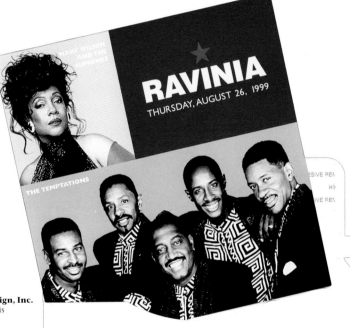

design firm
Connelly Design, Inc.
Chicago, Illinois
client
Arthur Anderson

(opposite) design firm
David Carter Design Assoc.
Dallas, Texas
client
Paris Casino Resort—Las Vegas

C - 0
M - 54
Y - 72
K - 0

C - 20
M - 58
Y - 3
K - 0

C - 45
M - 5
Y - 75
K - 0

C - 70
M - 19
Y - 20
K - 14

design firm
Louis & Partners Design
Bath, Ohio
client
San Francisco Oven

C - 43	C - 7	C - 41	C - 18
M - 38	M - 16	M - 50	M - 78
Y - 59	Y - 63	Y - 61	Y - 65
K - 5	K - 0	K - 11	K - 28

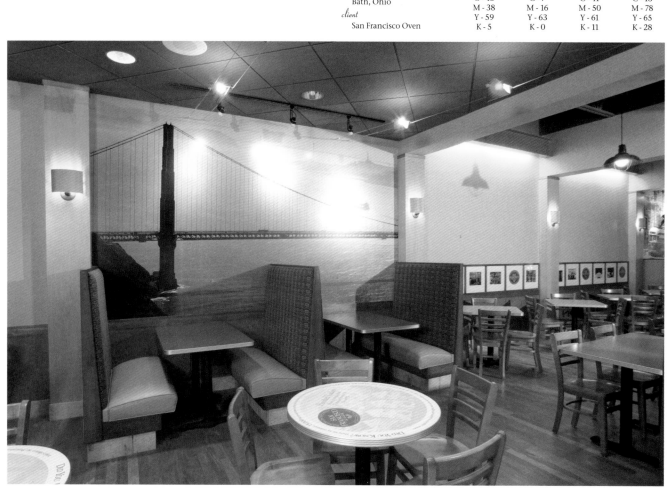

design firm
Klündt Hosmer Design
Spokane, Washington
client
Maryhill Winery

C - 30
M - 75
Y - 75
K - 15

C - 5	C - 3	C - 0
M - 92	M - 22	M - 0
Y - 80	Y - 57	Y - 0
K - 12	K - 0	K - 100

design firm
Slanting Rain Graphic Design
Logan, Utah

client
National Council on Education
for the Ceramic Arts

C - 27	C - 4	C - 51
M - 71	M - 6	M - 93
Y - 100	Y - 19	Y - 100
K - 17	K - 0	K - 61

design firm
Louis & Partners Design
Bath, Ohio

client
Belgium Iron Works

327

C - 95 C - 39
M - 79 M - 22
Y - 26 Y - 58
K - 14 K - 7

barra

design firm
Addison
San Francisco, California
client
Barra Corp.

C - 32 C - 25 C - 56
M - 1 M - 63 M - 25
Y - 46 Y - 56 Y - 16
K - 1 K - 23 K - 13

design firm
Belyea
Seattle, Washington
client
ColorGraphics

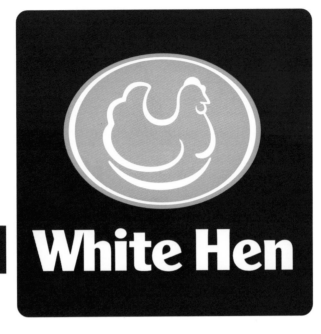

C - 5
M - 43
Y - 92
K - 0

C - 95
M - 79
Y - 36
K - 31

design firm
Addison
San Francisco, California
client
White Hen

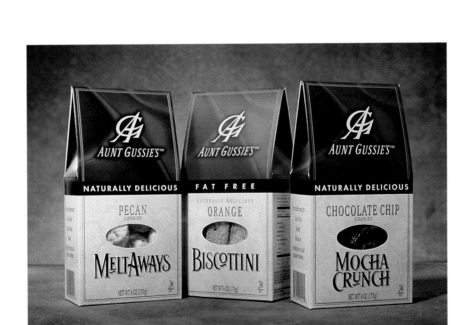

design firm
Compass Design
Minneapolis, Minnesota
client
Aunt Gussie's Cookies & Crackers

C - 80
M - 60
Y - 41
K - 14

C - 23
M - 70
Y - 67
K - 0

C - 65
M - 92
Y - 56
K - 17

329

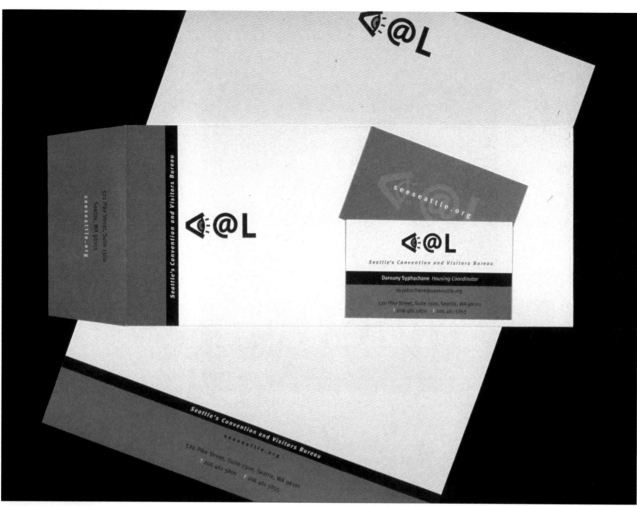

design firm
Hornall Anderson Design Works
Seattle, Washington

C - 47	C - 0
M - 47	M - 0
Y - 54	Y - 0
K - 25	K - 100

design firm
Brown & Partners
Las Vegas, Nevada
client
RS Development

Canterra

AT THE VISTAS

C - 69	C - 4	C - 69
M - 100	M - 1	M - 100
Y - 0	Y - 0	Y - 0
K - 23	K - 18	K - 65

design firm
LarsonLogosEtc
Rockford, Illinois
client
Rockford Area Lutheran Ministries

C - 99	C - 0	C - 100
M - 0	M - 24	M - 100
Y - 83	Y - 98	Y - 1
K - 47	K - 0	K - 0

design firm
Phinney/Bischoff Design House
Seattle, Washington
client
Preston Gates & Ellis LLP

GET REAL.

Preston|Gates|Ellis &
Rouvelas|Meeds LLP

C - 20	C - 0
M - 20	M - 0
Y - 40	Y - 0
K - 20	K - 100

(opposite) design firm
Cahan and Associates
San Francisco, California
client
Fine Arts Museum

C - 0	C - 60	C - 40	C - 0
M - 70	M - 0	M - 0	M - 40
Y - 60	Y - 20	Y - 30	Y -0
K - 30	K - 50	K - 20	K - 10

design firm
studioluscious
Columbus, Ohio
client
Inova Group

C - 60	C - 60
M - 50	M - 60
Y - 50	Y - 80
K - 0	K - 0

design firm
BET Weekend Magazine
Washington, D.C.
client
BET Publishing Group

C - 10	C - 15	C - 0
M - 100	M - 35	M - 10
Y - 70	Y - 55	Y - 20
K - 20	K - 10	K - 40

Fig. 6

ART OF THE AMERICAS

design firm
Wray Ward Laseter Advertising
Charlotte, North Carolina
client
SE Origami Festival

C - 27	C - 20
M - 96	M - 35
Y - 85	Y - 20
K - s9	K - 0

SOUTHEAST
ORIGAMI
PRODUCTIONS

Harvey Cohen
Executive Director

PO Box 2573
Charlotte, NC 28247
Direct 704.542.3991
Fax 704.544.9272

genuine

C - 90 C - 0
M - 10 M - 0
Y - 75 Y - 0
K - 5 K - 100

design firm
Design Objectives Pte Ltd
Singapore (Singapore)
client
The Fullerton Hotel, Singapore

C - 10 C - 0
M - 50 M - 0
Y - 60 Y - 0
K - 20 K - 100

design firm
Toolbox Studios, Inc.
San Antonio, Texas
client
Rhythm House Records

335

C - 12
M - 91
Y - 86
K - 2

C - 17
M - 12
Y - 97
K - 3

C - 26
M - 87
Y - 79
K - 21

2001
2002

The Contemporary Arts Center

Education Programs & Exhibitions

CINCINNATI
Ohio

The Contemporary Arts Center

design firm
**Five Visual
Communication and Design**
West Chester, Ohio

336

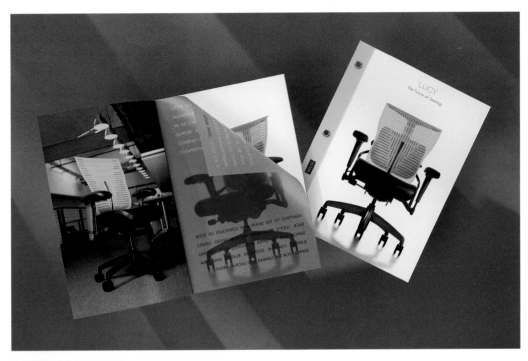

design firm
5D Studio
Malibu, California
client
Vecta

C - 19	C - 76	C - 27	C - 11
M - 20	M - 25	M - 85	M - 56
Y - 92	Y - 31	Y - 91	Y - 77
K - 0	K - 15	K - 33	K - 2

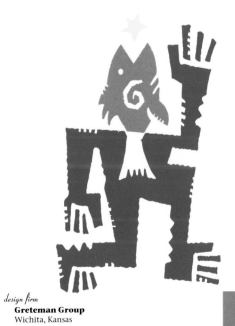

design firm
Greteman Group
Wichita, Kansas

C - 43	C - 0	C - 91
M - 0	M - 6	M - 60
Y - 15	Y - 43	Y - 0
K - 24	K - 0	K - 0

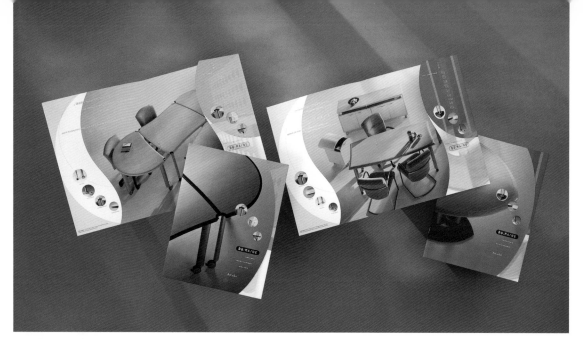

design firm
5D Studio
Malibu, California
client
Arcadia

C - 22
M - 62
Y - 85
K - 13

C - 15
M - 40
Y - 79
K - 0

C - 27
M - 87
Y - 85
K - 33

C - 82
M - 73
Y - 67
K - 55

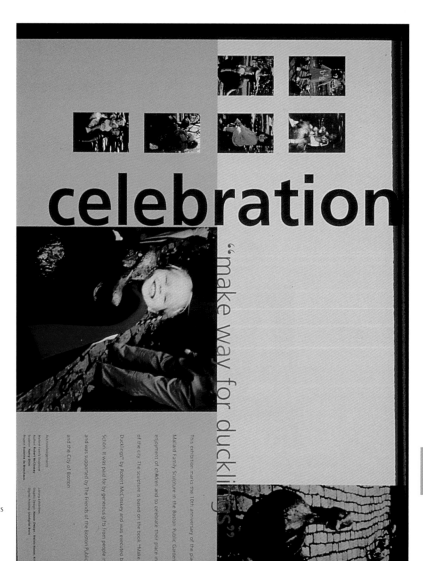

design firm
Nassar Design
Brookline, Massachusetts
client
Boston Public Library

C - 71
M - 87
Y - 9
K - 10

C - 57
M - 24
Y - 64
K - 0

C - 14
M - 45
Y - 91
K - 0

C - 15
M - 18
Y - 70
K - 0

C - 41
M - 88
Y - 95
K - 11

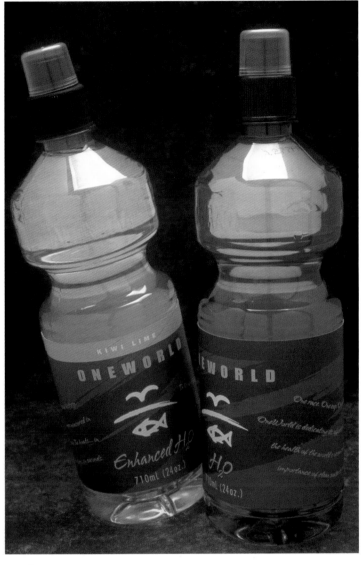

C - 2
M - 52
Y - 98
K - 15

C - 46
M - 42
Y - 34
K - 59

C - 16
M - 20
Y - 63
K - 13

C - 48
M - 33
Y - 20
K - 12

design firm
Compass Design
Minneapolis, Minnesota

design firm
Hornall Anderson Design Works
Seattle, Washington

C - 33
M - 36
Y - 38
K - 10

C - 0
M - 24
Y - 86
K - 0

C - 45
M - 37
Y - 82
K - 38

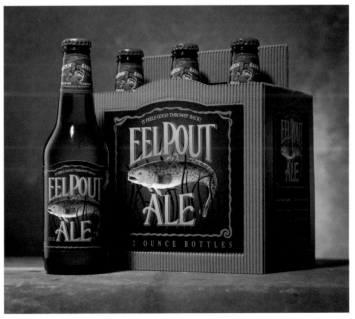

C - 100　　C - 78
M - 100　　M - 27
Y - 22　　　Y - 84
K - 16　　　K - 17

design firm
Designation
New York, New York

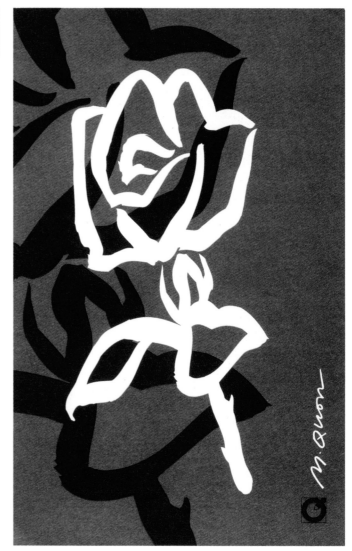

C - 100　　C - 98　　C - 84
M - 15　　　M - 82　　M - 44
Y - 28　　　Y - 51　　Y - 91
K - 7　　　　K - 48　　K - 31

design firm
Dever Designs
Laurel, Maryland
client
Melwood

dever designs

f⊙cus

C - 40　　C - 0　　C - 100　　C - 100　　C - 100
M - 17　　M - 17　　M - 5　　M - 74　　M - 70
Y - 98　　Y - 100　　Y - 20　　Y - 0　　Y - 0
K - 19　　K - 0　　K - 0　　K - 55　　K - 0

design firm
Dever Designs
Laurel, Maryland
client
Dever Designs

design firm
Tom Fowler, Inc.
Norwalk, Connecticut
client
Honeywell Consumer Products

C - 1　　C - 0　　C - 81　　C - 62
M - 97　　M - 1　　M - 1　　M - 18
Y - 100　　Y - 93　　Y - 73　　Y - 35
K - 19　　K - 12　　K - 42　　K - 11

C - 42	C - 5	C - 10	C - 31
M - 21	M - 41	M - 84	M - 64
Y - 64	Y - 74	Y - 63	Y - 56
K - 26	K - 4	K - 16	K - 35

design firm
**Hornall Anderson
Design Works**
Seattle, Washington

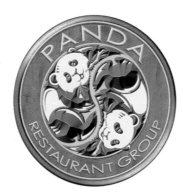

C - 59	C - 1	C - 36
M - 44	M - 22	M - 66
Y - 73	Y - 84	Y - 56
K - 3	K - 0	K - 3

design firm
Mike Salisbury L.L.C.
Venice, Caifornia
client
Panda Restaurant Group

342

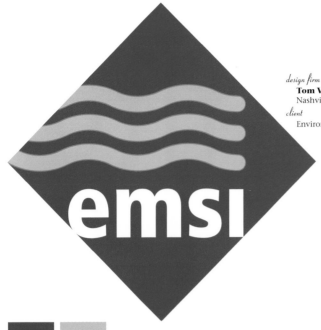

design firm
Tom Ventress Design
Nashville, Tennessee
client
Environmental Management Services Inc.

C - 100
M - 60
Y - 0
K - 0

C - 45
M - 0
Y - 16
K - 0

C - 100
M - 0
Y - 100
K - 0

design firm
LarsonLogosEtc
Rockford, Illinois
client
Village Bible Church

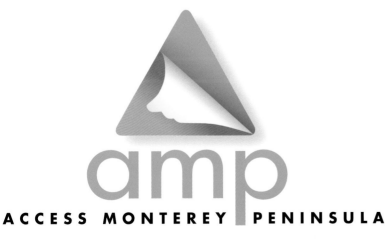

design firm
The Wecker Group
Monterey, California

C - 39
M - 0
Y - 100
K - 0

C - 50
M - 22
Y - 0
K - 0

ACCESS MONTEREY PENINSULA

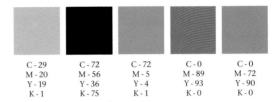

patriotic

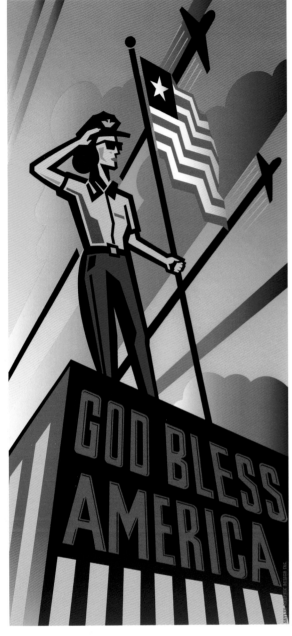

C - 29	C - 72	C - 72	C - 0	C - 0
M - 20	M - 56	M - 5	M - 89	M - 72
Y - 19	Y - 36	Y - 4	Y - 93	Y - 90
K - 1	K - 75	K - 1	K - 0	K - 0

design firm
Sayles Graphic Design
Des Moines, Iowa
client
"Art Fights Back"

C - 14	C - 90	C - 0
M - 100	M - 60	M - 0
Y - 100	Y - 0	Y - 0
K - 0	K - 0	K - 100

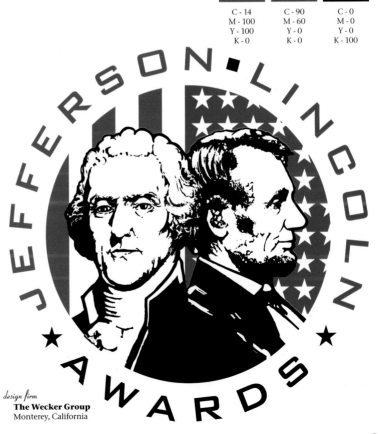

(opposite) design firm
Greteman Group
Wichita, Kansas

C - 16	C - 7	C - 95
M - 92	M - 6	M - 85
Y - 100	Y - 2	Y - 6
K - 5	K - 0	K - 2

design firm
The Wecker Group
Monterey, California

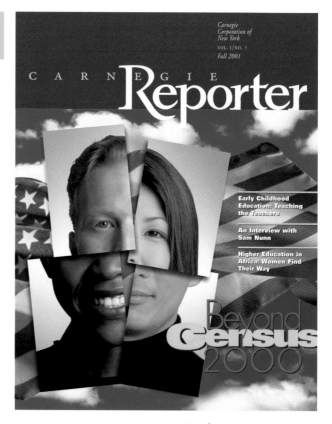

C - 100
M - 55
Y - 0
K - 0

C - 20
M - 100
Y - 70
K - 30

C - 0
M - 20
Y - 100
K - 0

*Carnegie
Corporation of
New York*

VOL. 1/NO. 3
Fall 2001

CARNEGIE
Reporter

**Early Childhood
Education: Teaching
the Teachers**

**An Interview with
Sam Nunn**

**Higher Education in
Africa: Women Find
Their Way**

Beyond
Census
2000

design firm
Dever Designs
Laurel, Maryland
client
Carnegie Corporation of New York

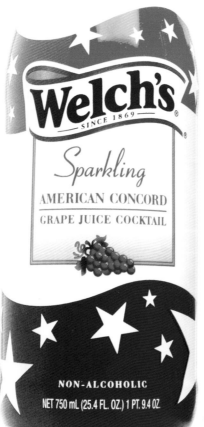

Welch's
SINCE 1869

Sparkling

AMERICAN CONCORD

GRAPE JUICE COCKTAIL

NON-ALCOHOLIC

NET 750 mL (25.4 FL. OZ.) 1 PT. 9.4 OZ.

C - 0
M - 100
Y - 100
K - 1

C - 100
M - 94
Y - 2
K - 2

design firm
Bailey Design Group Inc.
Plymouth Meeting, Pennsylvania

C - 73
M - 29
Y - 76
K - 13

C - 19
M - 8
Y - 8
K - 0

C - 4
M - 99
Y - 100
K - 1

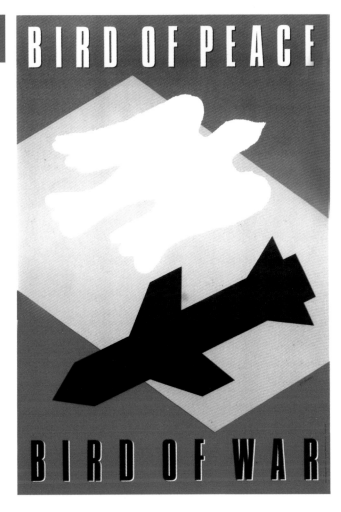

BIRD OF PEACE

BIRD OF WAR

design firm
Designation
New York, New York

C - 61
M - 28
Y - 11
K - 7

C - 24
M - 94
Y - 84
K - 16

design firm
Dever Designs
Laurel, Maryland

client
National Air and
Space Museum

The deterioration of the Apollo suits is somewhat surprising to people because they were built to survive the harshest conditions in space, and you'd expect them to survive anything.
—LISA A. YOUNG, CONSERVATOR

The spacesuit project team: from left, museum technician Samantha Gallagher, conservator Lisa Young, and museum specialist Amanda Young.

SPACESUITS AND ARTIFACTS

In March 2000 the National Air and Space Museum's Division of Space History began a special two-year project to save artifacts of the Apollo Space Program. Funded by the Save America's Treasures grant program in public-private partnership between the White House Millennium Council and the National Trust for Historic Preservation and Hamilton Sundstrand to United Technologies Company), museum specialist Amanda J. Young and conservator Lisa A. Young set out to accomplish four goals:
▪ To document the condition of the spacesuits and to stabilize them for long-term storage and display.
▪ To establish and maintain a Materials Advisory Group to research the issues inherent in the deterioration and preservation of the spacesuit collection.
▪ To design, test, and implement procedures for the long-term storage of the collection.
▪ To produce guidelines and standards for the storage, display, and preservation of spacesuits and make them available to other museums.

The project team established a priority list of suits for treatment, headed by the lunar suits, followed by the research and developmental suits, the flown mission suits, then training and non-flown suits. Work began with the lunar suits—including those custom-made for Neil A. Armstrong and Edwin E. "Buzz" Aldrin, Jr.'s historic Apollo 11 mission in July 1969, and that of Eugene A. Cernan

Amanda Young instructs student interns on how to write a condition report.

(Apollo 17), the "last man on the Moon," who, in 1972, explored the Moon in a lunar rover. They wrote condition reports for each suit, and over 260 components were examined and treated during this time. By targeting four areas of deterioration—the rubber components of suits and gloves, the PVC tubing, the interior and exterior zippers, and the anodized aluminum wrist and neck disconnects—the team established a baseline for each suit, which will make it easier to prioritize future conservation needs.

The suits were photographed in color to track visible changes over time. A colorimeter assessed color changes to the exterior fabrics of each suit, and they were evaluated with a CT scanner to record the relationships between interior layers of material. Having determined that flat storage was detrimental, the staff designed and constructed a suit mannequin from polyethylene foam, polyester batting, and white nylon hose to fit inside each suit. Additionally, staff designed and constructed storage trays, and purchased a storage racking system to enable air to flow freely around the suits.

All these measures will extend the life of the collection, but according to Amanda Young, "These are extremely fragile artifacts, and the best we can currently hope for is to prevent or slow down further deterioration."

The results of the team's successful project can be found in "The Preservation, Storage, and Display of Spacesuits," by Lisa A. Young and Amanda J. Young, published as Report Number 5 in the National Air and Space Museum's Collections Care series.

Neil Armstrong and Buzz Aldrin wore these spacesuits when they climbed down from their lunar module Eagle in July 1969 to become the first humans to walk on the Moon.

The spacesuit worn by astronaut Eugene Cernan, during the Apollo 10 mission, was treated as part of the Save America's Treasures project.

Director's Report

C - 92
M - 98
Y - 0
K - 3

C - 1
M - 98
Y - 64
K - 1

design firm
Supon Design Group
Washington, D.C.
client
Washington D.C. Convention and Tourism Corporation

C - 32
M - 40
Y - 84
K - 0

C - 86
M - 59
Y - 3
K - 0

design firm
Dotzler Creative Arts
Omaha, Nebraska

C - 0
M - 91
Y - 94
K - 30

C - 100
M - 60
Y - 0
K - 18

design firm
LarsonLogosEtc
Rockford, Illinois
client
St. Olaf College Viking Male Chorus

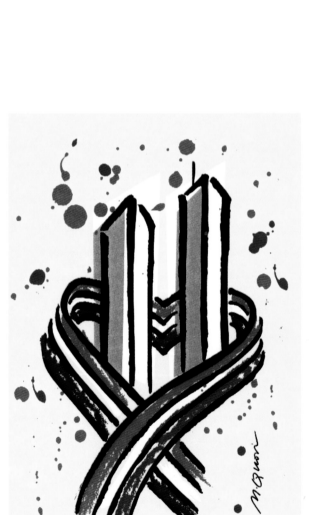

C - 22
M - 95
Y - 93
K - 1

C - 99
M - 80
Y - 11
K - 5

C - 45
M - 33
Y - 37
K - 1

design firm
Designation
New York, New York

design firm
Keiler & Company
Farmington, Connecticut
client
Connecticut Art Directors Club

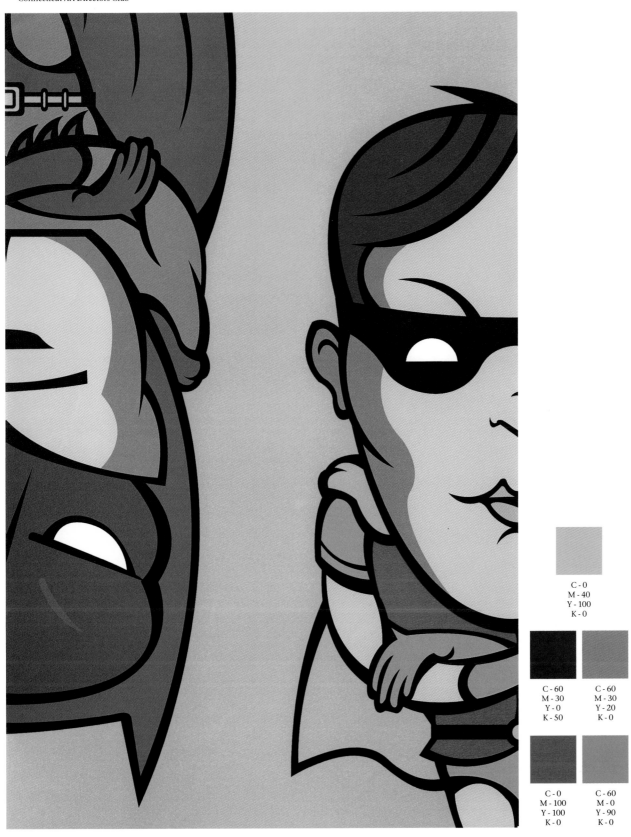

C - 0
M - 40
Y - 100
K - 0

C - 60
M - 30
Y - 0
K - 50

C - 60
M - 30
Y - 20
K - 0

C - 0
M - 100
Y - 100
K - 0

C - 60
M - 0
Y - 90
K - 0

design firm
5D Studio
Malibu, California
client
Vecta

C - 33	C - 0	C - 79	C - 46
M - 23	M - 13	M - 67	M - 20
Y - 18	Y - 97	Y - 55	Y - 61
K - 6	K - 0	K - 51	K - 4

C - 13	C - 0	C - 14	C - 61
M - 4	M - 60	M - 53	M - 38
Y - 53	Y - 76	Y - 14	Y - 8
K - 40	K - 25	K - 55	K - 50

design firm
Hornall Anderson Design Works
Seattle, Washington

congratulations

design firm
After Hours Creative
Phoenix, Arizona

C - 4 C - 9
M - 6 M - 13
Y - 17 Y - 38
K - 11 K - 26

design firm
Dever Designs
Laurel, Maryland
client
National Air and Space Museum

C - 60
M - 30
Y - 0
K - 15

C - 0
M - 20
Y - 100
K - 0

C - 0
M - 80
Y - 100
K - 0

COMMEMORATE, EDUCATE & *inspire*

Director's Report | 2002

 Smithsonian
National Air and Space Museum

KGBI is a ministry of Grace University
www.GraceUniversity.edu

Tom Sommerville
Director of Broadcasting
Grace University

831 Pine Street
Omaha, NE 68108-3629

402-449-2900
Fax: 402-449-2825

Tom@TheBridge.fm
www.TheBridge.fm

design firm
Dotzler Creative Arts
Omaha, Nebraska

C - 16
M - 33
Y - 94
K - 11

C - 99
M - 75
Y - 0
K - 10

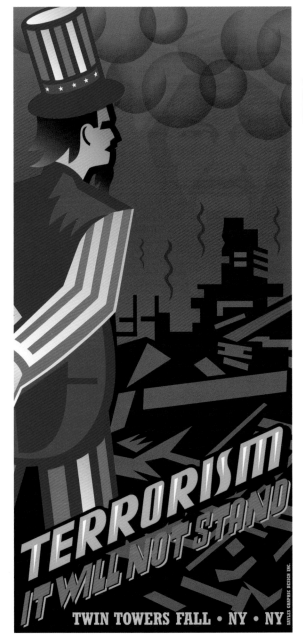

C - 100 M - 77 Y - 18 K - 15
C - 99 M - 62 Y - 2 K - 0
C - 25 M - 91 Y - 84 K - 21
C - 0 M - 89 Y - 93 K - 0
C - 57 M - 45 Y - 42 K - 35
C - 0 M - 50 Y - 90 K - 0

design firm
Sayles Graphic Design
Des Moines, Iowa
client
"Art Fights Back"

design firm
Sagmeister Inc.
New York, New York

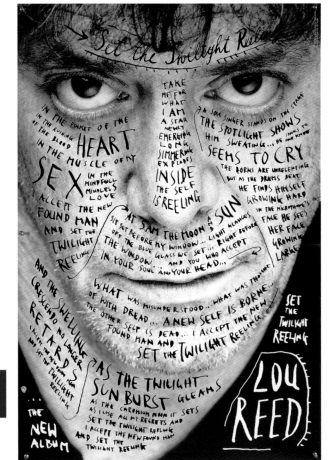

C - 50 M - 37 Y - 4 K - 0
C - 99 M - 81 Y - 52 K - 17

353

C - 0
M - 0
Y - 0
K - 100

design firm
Supon Design Group
Washington, D.C.
client
AdviceZone.com

C - 45	C - 69	C - 85	C - 63	C - 1
M - 33	M - 65	M - 76	M - 52	M - 62
Y - 0	Y - 15	Y - 35	Y - 51	Y - 68
K - 0	K - 4	K - 20	K - 100	K - 0

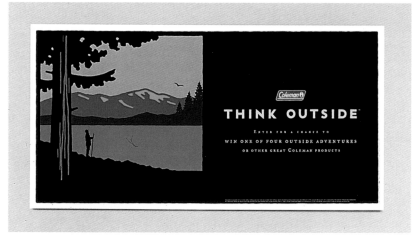

design firm
Clarion Marketing & Communications
Atlanta, Georgia
client
Coleman

C - 76	C - 0
M - 33	M - 0
Y - 7	Y - 0
K - 0	K - 100

design firm
Supon Design Group
Washington, D.C.
client
OnPoint Digital, Inc.

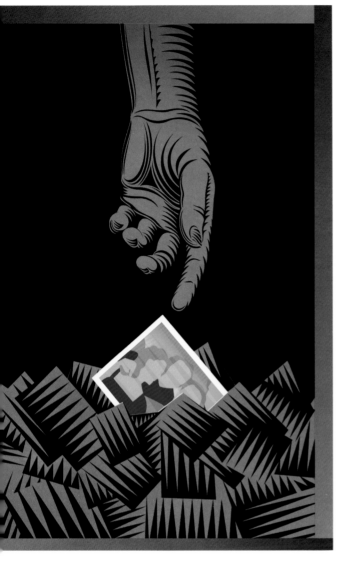

C - 0	C - 43	C - 99	C - 0	C - 0
M - 43	M - 43	M - 80	M - 0	M - 0
Y - 16	Y - 0	Y - 0	Y - 0	Y - 0
K - 0	K - 0	K - 0	K - 64	K - 100

design firm
Tom Fowler, Inc.
Norwalk, Connecticut
client
Connecticut Art Director's Club

design firm
Sam Smidt
Palo Alto, California
client
Healing Environments

C - 0
M - 0
Y - 0
K - 100

SEPTEMBER 2000 F1 S2 S3 M4 T5 W6 T7 F8 S9 S10 M11 T12 W13 T14 F15 S16 S17 M18 T19 W20 T21 F22 S23 S24 M25 T26 W27 T28 F29 S30

HORNBEAM ARBOUR, HAM HOUSE, ENGLAND, 1998

355

design firm
**Hornall Anderson
Design Works**
Seattle, Washington

C - 20
M - 30
Y - 47
K - 30

C - 5
M - 44
Y - 50
K - 3

C - 38
M - 34
Y - 30
K - 20

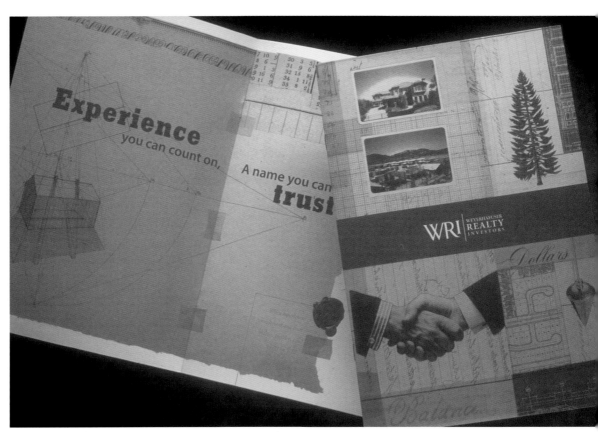

C - 0
M - 0
Y - 0
K - 100

C - 44
M - 35
Y - 23
K - 9

design firm
Becker Design
Milwaukee, Wisconsin
client
Food Affair

design firm
Becker Design
Milwaukee, Wisconsin
client
Winterpark Pub

C - 32
M - 83
Y - 76
K - 23

C - 93
M - 33
Y - 85
K - 23

C - 1
M - 8
Y - 27
K - 0

design firm
Belyea
Seattle, Washington
client
ColorGraphics

C - 32
M - 1
Y - 46
K - 1

C - 25
M - 63
Y - 56
K - 23

C - 56
M - 25
Y - 16
K - 13

GAINEY SUITES HOTEL

design firm
The Wecker Group
Monterey, California
client
Gainey Suites Hotel

C - 100	C - 3	C - 1	C - 75
M - 50	M - 1	M - 96	M - 0
Y - 50	Y - 91	Y - 89	Y - 37
K - 0	K - 0	K - 0	K - 0

design firm
Compass Design
Minneapolis, Minnesota
client
Jake's Trading Co.

C - 0	C - 4	C - 19	C - 16
M - 11	M - 65	M - 90	M - 27
Y - 64	Y - 98	Y - 84	Y - 33
K - 0	K - 0	K - 4	K - 0

C - 2
M - 90
Y - 91
K - 0

C - 0
M - 23
Y - 94
K - 0

C - 40
M - 5
Y - 0
K - 0

i left my heart

design firm
After Hours Creative
Phoenix, Arizona

design firm
Halleck
Palo Alto, California
client
St. Supery

C - 20	C - 10	C - 10
M - 30	M - 10	M - 10
Y - 50	Y - 50	Y - 30
K - 40	K - 0	K - 10

design firm
Dever Designs
Laurel, Maryland
client
Carnegie Corporation of New York

C - 0	C - 1	C - 19	C - 99	C - 100
M - 60	M - 1	M - 76	M - 75	M - 90
Y - 100	Y - 76	Y - 9	Y - 1	Y - 0
K - 0	K - 0	K - 17	K - 0	K - 35

design firm
Sign Kommunikation GmbH
Frankfurt (Germany)
client
Victor Sanovec/Barbasa Fuchs

C - 80
M - 40
Y - 60
K - 0

C - 10
M - 0
Y - 70
K - 0

C - 0
M - 0
Y - 0
K - 100

C - 0
M - 55
Y - 100
K - 30

C - 0
M - 0
Y - 0
K - 100

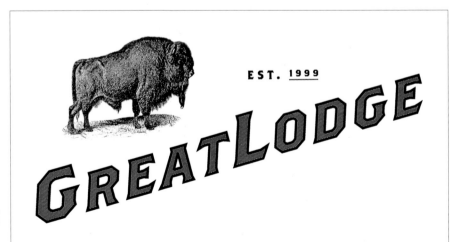

design firm
Cahan and Associates
San Francisco, California
client
Greatlodge.com

Coaptite is the most natural approach yet to the treatment of urinary incontinence. Where other materials are either short-lived or can produce acute reactions, Coaptite is a long-term solution compatible with the body's own chemistry.

The material is smooth, rounded, substantially spherical and 75 to 125 micron in size. Carefully controlled dispersion in the carrier gel facilitates easy injection. Coaptite particles readily flow through a very small 21 gauge needle, using standard 5 or 7 Fr cystoscopic injection catheters. In long-term performance, cells at the injection site grow directly on the surface of Coaptite particles, forming soft tissue identical to the surrounding area. Thus, Coaptite conforms to the body without reaction, isolation or migration.

The nature of Coaptite particles also offers other advantages:

> Skin testing is not required, allowing treatment to commence immediately.

> The small needle puncture minimizes loss of material at the injection site.

> Supplied in efficient 1cc syringes, Coaptite is cost-effective, requiring no special equipment such as injection guns or non-standard cystoscopes.

> Coaptite can be imaged using standard radiologic techniques. Treatment is optimized and the safety profile enhanced through verification that migration and absorption have not occurred.

COMPATIBLE WITH YOUR PRACTICE OF MEDICINE

Coaptite is not only compatible with the human body, it is also well-suited to the practice of medicine. From the design of the syringe to the formulation of the material, Coaptite has been developed to enhance your treatment of urinary incontinence. The syringe, unique to Coaptite, features wider flanges for better comfort and control. Even dispersion of Coaptite particles reduces mechanical effort and eliminates clumping. The product has a two-year shelf life with no special storage requirements. And Coaptite maintains familiarity, working with standard cystoscopic equipment.

The material advantages of Coaptite can assure patient comfort as well. Its biocompatibility alleviates concern about long-term effects, something which is still unknown with silicone or polymer materials. As an outpatient procedure, augmentation with Coaptite allows for a quick recovery. And it does not preclude subsequent surgery if necessary.

The clinical evidence to date suggests that utilizing Coaptite as the initial approach may be the only approach most patients will ever need.

design firm
Becker Design
Milwaukee, Wisconsin
client
BioForm

C - 15	C - 30
M - 5	M - 4
Y - 40	Y - 2
K - 0	K - 0

design firm
McElveney & Palozzi Design Group
Rochester, New York
client
Xelus

C - 87	C - 0	C - 75	C - 77	C - 4	C - 25
M - 54	M - 0	M - 16	M - 87	M - 10	M - 96
Y - 5	Y - 0	Y - 31	Y - 14	Y - 87	Y - 69
K - 1	K - 100	K - 2	K - 3	K - 0	K - 17

technological

C - 87	C - 0	C - 75	C - 27	C - 4
M - 54	M - 0	M - 16	M - 90	M - 10
Y - 5	Y - 0	Y - 31	Y - 0	Y - 87
K - 1	K - 100	K - 2	K - 0	K - 0

design firm
McElveney & Palozzi Design Group
Rochester, New York

client
Xelus

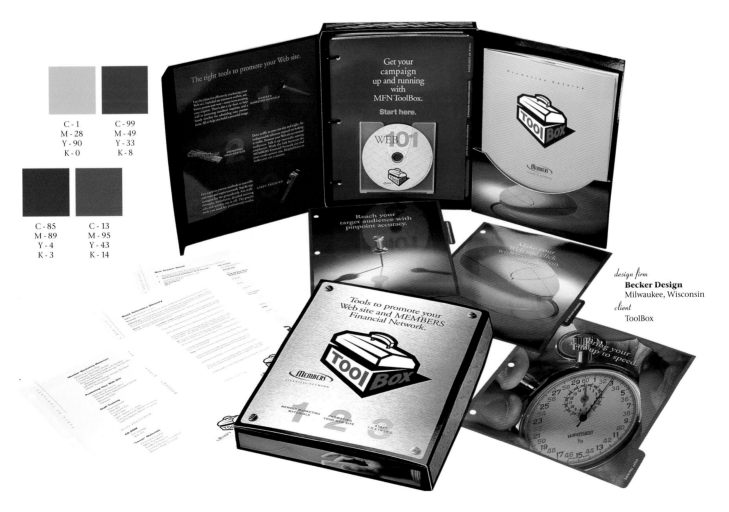

C - 1	C - 99
M - 28	M - 49
Y - 90	Y - 33
K - 0	K - 8

C - 85	C - 13
M - 89	M - 95
Y - 4	Y - 43
K - 3	K - 14

design firm
Becker Design
Milwaukee, Wisconsin

client
ToolBox

design firm
Bailey Design Group
Plymouth Meeting, Pennsylvania

C - 100	C - 75	C - 65	C - 0	C - 0	C - 0	C - 0
M - 68	M - 51	M - 35	M - 25	M - 35	M - 0	M - 100
Y - 0	Y - 0	Y - 0	Y - 100	Y - 100	Y - 50	Y - 100
K - 25	K - 0	K - 0	K - 0	K - 0	K - 2 0	K - 0

design firm
McElveney & Palozzi Design Group
Rochester, New York
client
Eastman Kodak Company

C - 100	C - 0	C - 32
M - 64	M - 18	M - 31
Y - 0	Y - 100	Y - 30
K - 0	K - 0	K - 0

design firm
McElveney & Palozzi Design Group
Rochester, New York
client
Badger Technologies

C - 0	C - 91	C - 0
M - 91	M - 43	M - 0
Y - 76	Y - 0	Y - 0
K - 6	K - 0	K - 100

design firm
Hornall Anderson Design Works
Seattle, Washington

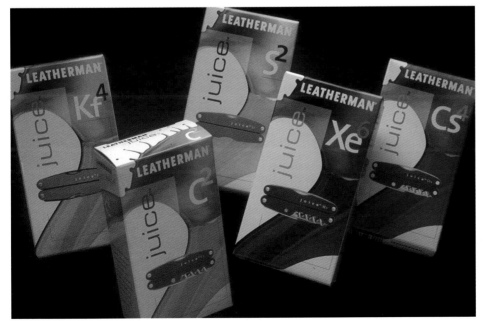

C - 29	C - 3	C - 66	C - 1
M - 12	M - 51	M - 49	M - 80
Y - 71	Y - 93	Y - 19	Y - 44
K - 56	K - 18	K - 38	K - 0

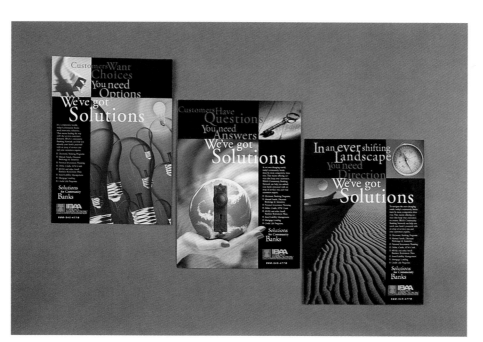

C - 86	C - 58	C - 7	C - 1
M - 68	M - 74	M - 74	M - 27
Y - 15	Y - 5	Y - 84	Y - 89
K - 15	K - 2	K - 9	K - 5

design firm
Dever Designs
Laurel, Maryland
client
Independent Bankers Association of America

INTERCONNECT
TECHNOLOGIES CORPORATION

design firm
Imtech Communications
Berkeley, California
client
Interconnect Technologies Corp.

C - 2	C - 0	C - 0
M - 65	M - 0	M - 0
Y - 91	Y - 0	Y - 0
K - 0	K - 39	K -100

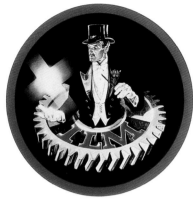

design firm
Mike Salisbury L.L.C.
Venice, California
client
Bernie Yuman

C - 88
M - 88
Y - 88
K - 78

C - 3
M - 98
Y - 98
K - 15

C - 68
M - 18
Y - 18
K - 0

C - 5
M - 0
Y - 73
K - 0

C - 5
M - 32
Y - 100
K - 0

C - 45
M - 33
Y - 86
K - 12

ONLINELEARNING
PUTTING THE WEB TO WORK FOR THE FED

TUESDAY, NOVEMBER 12 AND WEDNESDAY, NOVEMBER 13

Federal Reserve Bank of St. Louis

design firm
Stan Gellman Graphic Design
St. Louis, Missouri
client
Federal Reserve Bank of St. Louis

C - 77
M - 3
Y - 91
K - 0

C - 1
M - 96
Y - 89
K - 0

C - 94
M - 34
Y - 7
K - 1

C - 93
M - 94
Y - 2
K - 0

design firm
Lane + Lane
Los Angeles, California
client
OnlineLearning.net

OnlineLearning.net

your source for continuing education online

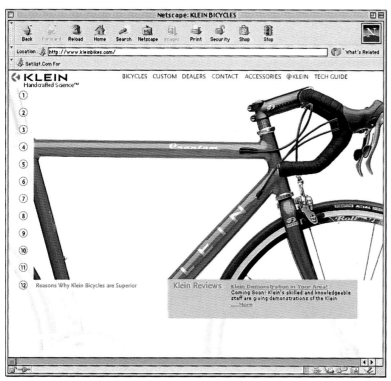

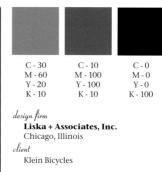

C - 30	C - 10	C - 0
M - 60	M - 100	M - 0
Y - 20	Y - 100	Y - 0
K - 10	K - 10	K - 100

design firm
Liska + Associates, Inc.
Chicago, Illinois
client
Klein Bicycles

design firm
Savage Design Group
Houston, Texas
client
Savage Design Group

C - 45	C - 0	C - 20	C - 0
M - 5	M - 0	M - 0	M - 0
Y - 20	Y - 0	Y - 10	Y - 0
K - 15	K - 0	K - 40	K - 100

annual report 1999

www.thisisnoble.com/

Search Netscape Security Stop

ompanies network noble news useful links

Noble group

Serving industry worldwide

Noble chemicals

Noble group limited

Noble group
annual report 1999
http://www.**thisisnoble**.com

design firm
Graphicat Limited
Hong Kong, China
client
Noble Group Limited

C - 34 C - 0
M - 29 M - 0
Y - 26 Y - 0
K - 5 K - 100

STRATEGIES 2000

ANNUAL REPORT | 1999

EL CAMINO RESOURCES INTERNATIONAL, INC.

(opposite) design firm
[i]e design
Studio City, California
client
El Camino Reserve

C - 5	C - 50	C - 0
M - 32	M - 67	M - 0
Y - 90	Y - 22	Y - 0
K - 0	K - 30	K - 100

Nineteen 99 Lightbridge Annual RePortal™

design firm
Tepperman/Ray Associates, Inc.
Andover, Massachusetts
client
Lightbridge, Inc.

C - 0	C - 15
M - 20	M - 97
Y - 90	Y - 97
K - 0	K - 0

design firm
Popular Mechanics
New York, New York
client
Popular Mechanics

C - 0	C - 0	C - 20
M - 100	M - 10	M - 10
Y - 100	Y - 80	Y - 10
K - 0	K - 10	K - 10

1: Gangbusters
2: Expect the Unexpected
3: Whateverman
4: Modern Day Devils
5: Get Up
6: Always the Same
7: Big Wheel
8: In the City
9: Right Out
10: One Day
11: True Color
12: In Time (Growing Come)

produced by Italric

RR 8726-2

design firm
Kb.D
Hillsdale, New Jersey
client
Dog Eat Dog/Roadrunner Records

C - 100 C - 0
M - 50 M - 0
Y - 10 Y - 0
K - 10 K - 100

THERE'S
MORE TO
VISOR™
THAN MEETS
THE EYE

design firm
Mortensen Design
Mountain View, California
client
Handspring, Inc.

C - 0 C - 90 C - 100 C - 0
M - 40 M - 60 M - 20 M - 0
Y - 80 Y - 20 Y - 70 Y - 0
K - 10 K - 10 K - 20 K - 100

372

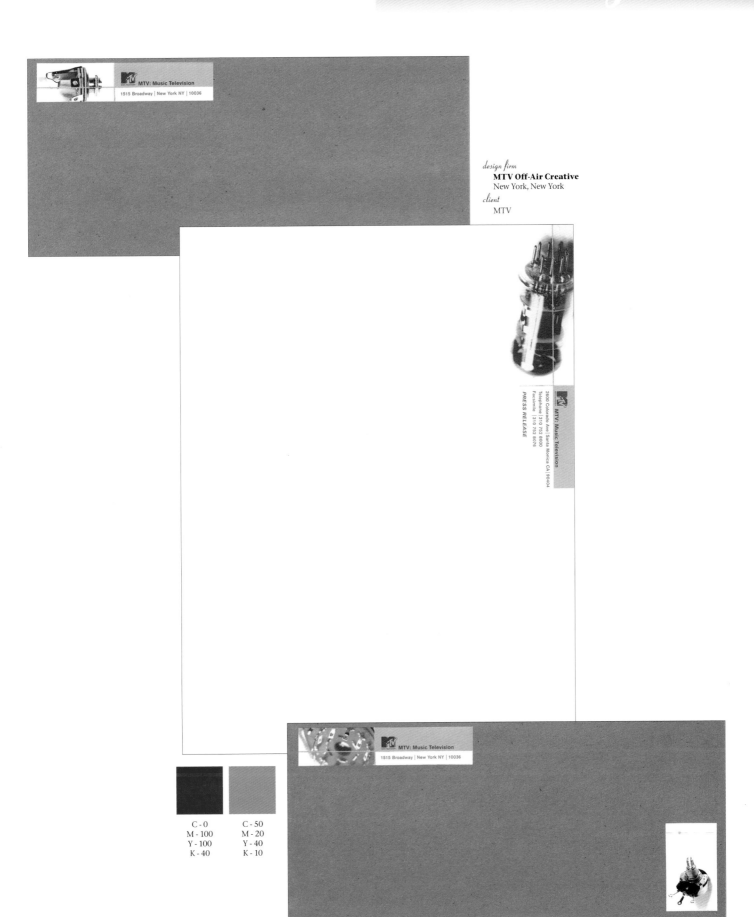

design firm
MTV Off-Air Creative
New York, New York
client
MTV

MTV: Music Television
1515 Broadway | New York NY | 10036

2600 Colorado Ave | Santa Monica CA 90404
Telephone | 310 752 8000
Facsimile | 310 752 8076
PRESS RELEASE
MTV: Music Television

MTV: Music Television
1515 Broadway | New York NY | 10036

C - 0
M - 100
Y - 100
K - 40

C - 50
M - 20
Y - 40
K - 10

EPOS | endless possibilities productions inc.

1639 sixteenth street | santa monica | california 90404 | 310.581.2418 studio | www.epos-grd.com

C - 30
M - 20
Y - 80
K - 5

C - 55
M - 100
Y - 15
K - 30

C - 0
M - 65
Y - 80
K - 0

C - 100
M - 5
Y - 5
K - 0

EPOS
endless possibilities productions, inc.

plant manager
joni eckley

epos=humanity×technology

1639 Sixteenth Street
Santa Monica, CA 90404
310.581.2418 tel
310.581.2422 fax
e-mail: joni@epos-grd.com
www.epos-grd.com

e=htn

EPOS
endless possibilities productions, inc.

senior art director
clifford singontiko

epos=humanity×technology

1639 Sixteenth Street
Santa Monica, CA 90404
310.581.2418 tel
310.581.2422 fax
e-mail: cliff@epos-grd.com
www.epos-grd.com

e=htn

EPOS
endless possibilities productions, inc.

ceo/creative director
gabrielle raumberger

epos=humanity×technology

1639 Sixteenth Street
Santa Monica, CA 90404
310.581.2418 tel
310.581.2422 fax
e-mail: gabrielle@epos-grd.com
www.epos-grd.com

e=htn

EPOS | endless possibilities productions inc.
1639 sixteenth street | santa monica | california 90404

design firm
EPOS, Inc.
Santa Monica, California
client
EPOS, Inc.

design firm
Agnew Moyer Smith, Inc.
Pittsburgh, Pennyslvania
client
The National Aviary

C - 57
M - 3
Y - 1
K - 0

C - 42
M - 2
Y - 75
K - 1

design firm
Funk/Levis & Associates
Eugene, Oregon
client
Eugene Parks & Open Spaces

E U G E N E
Parks and Open Space

C - 98
M - 10
Y - 62
K - 0

C - 98
M - 75
Y - 0
K - 14

design firm
designRoom Creative
Cleveland, Ohio
client
Euclid Hospital

C - 56
M - 29
Y - 76
K - 0

C - 33
M - 15
Y - 45
K - 0

You're invited!

friendly

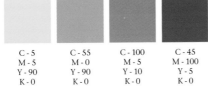

design firm
David Lemley Design
Seattle, Washington
client
jacknabbit.com

C - 5	C - 55	C - 100	C - 45
M - 5	M - 0	M - 5	M - 100
Y - 90	Y - 90	Y - 10	Y - 5
K - 0	K - 0	K - 0	K - 0

jacknabbit.com

22605 SE 56th Street
Suite 250
Issaquah, Washington
98029

phone 425/ 557-8955
toll free 877-NABTIME
fax 425/ 557-8576

Appointime, Inc.

C - 49	C - 25
M - 29	M - 2
Y - 1	Y - 53
K - 0	K - 0

Protecting
your interests,
building
your investment.

2001 ANNUAL REPORT

design firm
Lawrence & Ponder Ideaworks
Newport Beach, California

client
Starbucks Coffee

design firm
Boller Coates & Neu
Chicago, Illinois

client
Hon Industries Inc.

Some of us can't live
without coffee.

None of us can live
without blood.

Blood Bank
of San Bernardino
and Riverside Counties

C - 14	C - 22	C - 92
M - 1	M - 7	M - 82
Y - 1	Y - 1	Y - 1
K - 0	K - 0	K - 10

When it comes to high bandwidth, low cost
and superior customer service,
listen to the experts:

Our customers.

cogent
COMMUNICATIONS

Optical Internet

C - 86	C - 52
M - 58	M - 33
Y - 0	Y - 22
K - 0	K - 0

design firm
Don Schaaf & Friends, Inc.
Washington, D.C.
client
Cogent

friendly

design firm
Bernhardt Fudyma Design Group
New York, New York
client
Antigenics

Antigenics Annual Report 2001

Challenging convention
to redefine medicine

C - 35	C - 36
M - 0	M - 26
Y - 13	Y - 25
K - 0	K - 0

379

C - 70
M - 24
Y - 86
K - 25

C - 11
M - 98
Y - 86
K - 39

you'll like our
true
colors

Summit Press

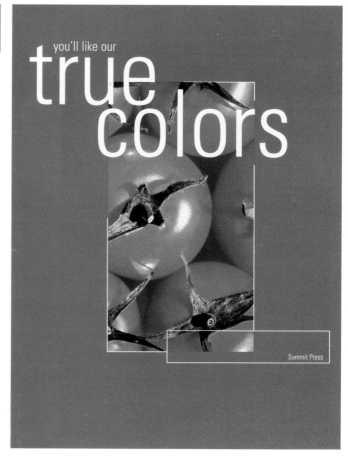

design firm
Hull Creative Group
Boston, Massachusetts
client
Summit Press

C - 77
M - 66
Y - 26
K - 20

C - 0
M - 98
Y - 85
K - 4

C - 38
M - 79
Y - 84
K - 17

design firm
Kircher, Inc.
Washington, D.C.
client
International Association of
Amusement Parks and Attractions

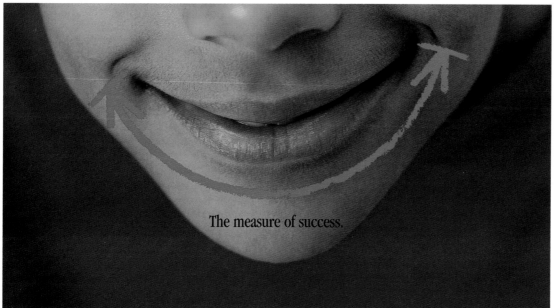

The measure of success.

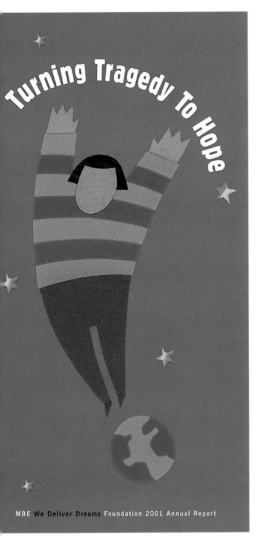

C - 84
M - 36
Y - 92
K - 11

C - 74
M - 28
Y - 2
K - 0

C - 69
M - 67
Y - 0
K - 0

C - 2
M - 77
Y - 95
K - 0

design firm
viadesign
San Diego, California
client
Mail Boxes Etc. Foundation

design firm
Rottman Creative Group, LLC
La Plata, Maryland
client
Rottman Creative Group, LLC

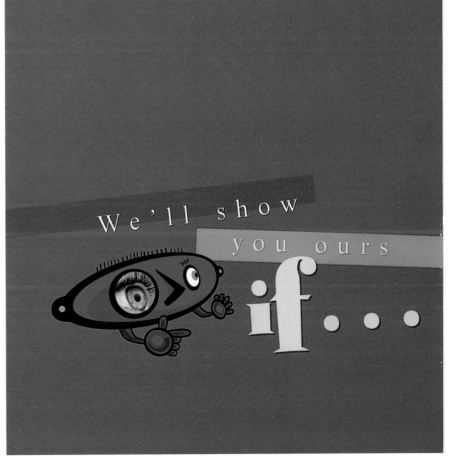

C - 93
M - 43
Y - 13
K - 4

C - 33
M - 86
Y - 23
K - 17

C - 0
M - 16
Y - 99
K - 0

C - 0
M - 71
Y - 83
K - 0

JAMES PETTUS
16 TIMBERLINE DRIVE FARMINGTON, CT 06032 USA
860.677.7116 jpet33@aol.com

PATRICIA M. PETTUS
16 TIMBERLINE DRIVE FARMINGTON, CT 06032 USA
860.677.7116 patiopika@aol.com

C - 0	C - 98
M - 37	M - 95
Y - 48	Y - 95
K - 0	K - 90

design firm
Pettus Design
Farmington, Connecticut
client
James and Patricia Pettus

unitus

C - 0	C - 23
M - 0	M - 0
Y - 0	Y - 51
K - 100	K - 11

design firm
Belyea
Seattle, Washington
client
ColorGraphics

Dare
family services

C - 33	C - 48
M - 85	M - 85
Y - 37	Y - 99
K - 55	K - 8

design firm
Hull Creative Group
Boston, Massachusetts
client
Dare Family Services

382

C - 0	C - 0
M - 55	M - 0
Y - 100	Y - 0
K - 15	K - 100

design firm
Klündt Hosmer Design
Spokane, Washington

C - 0	C - 44	C - 60	C - 100	C - 3
M - 7	M - 7	M - 19	M - 71	M - 53
Y - 93	Y - 73	Y - 0	Y - 10	Y - 98
K - 0	K - 2	K - 0	K - 13	K - 0

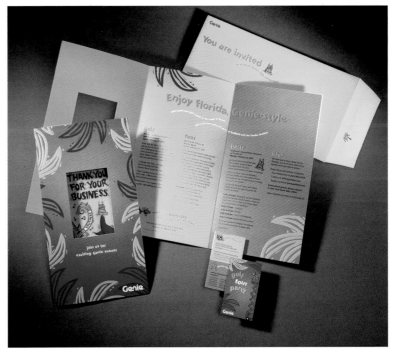

design firm
Belyea
Seattle, Washington
client
Genie Industries

Index

CREATIVE FIRMS

Symbols

[i]e design, Los Angeles 71, 370
3D Studio 7, 52, 123, 245, 282, 307, 337, 338, 350

A

Ad Formula Design Studio 212
Addison 51, 126, 127, 139, 211, 226, 227, 248, 249, 304, 328, 329
Advantage Ltd. 73
After Hours Creative 62, 76, 97, 109, 112, 113, 136, 214, 215, 236, 269, 270, 304, 351, 359
AGC—Mktg. Comm. Dept. 295
Agnew Moyer Smith Inc. 143, 376
All Media Projects Limited (AMP 260
Allen Bell Solutions Inc. 116
Amber Design Associates 106
American Airlines Publishing 238
AMP 67
Armijo Design Office 319

B

B-Man Design 295
Bacardi USA 88
Baer Design Group 158, 178
Bailey Design Group Inc. 21, 22, 23, 36, 49, 55, 74, 124, 125, 161, 179, 261, 300, 313, 346, 364
Bald & Beautiful 147
Ball Advertising & Design 107
Barbour Design Inc. 17
BBK Studio 262
Be.Design 171
Becker Design 28, 40, 56, 79, 86, 104, 118, 119, 132, 145, 186, 215, 220, 223, 237, 266, 302, 305, 313, 356, 357, 362
Belyea 50, 127, 226, 228, 251, 277, 286, 288, 309, 328, 357, 382, 383
Bernhardt Fudyma Design Group 379
Berni Marketing & Design 247
Besser Design Group 77, 81
BET Weekend Magazine 332
Boller Coates & Neu 207, 378
Bouvier Kelly 100
Bradley Brown Design Group 98
Brian J. Ganton & Associates 14
Bridge Creative Inc. 71
Bronz/Esposito Inc. 192
Brown & Partners 320, 330
Bruce Yelaska Design 78
Buck & Pulleyn 44
Burrows 156

C

Cahan and Associates 279, 333, 361
Campbell-Ewald Advertising 46
Cassata & Associates 34
Champ Cohen Design 27
Checkman Design 27
Cisco Systems 254
Clarion Marketing & Communications 354
Colgate–Palmolive In-House Design 207
Compass Design 29, 34, 35, 36, 88, 89, 90, 92, 102, 103, 105, 116, 117, 133, 144, 145, 148, 182, 191, 210, 237, 240, 259, 273, 274, 275, 285, 287, 315, 319, 321, 322, 323, 329, 339, 358
Conflux Design 66
Connelly Design, Inc. 325
Conover 295
Corey McPherson Nash 130, 325
Cornerstone 172, 174, 181, 189
Creative, Ink. 12

D

David Carter Design Assoc. 300, 324
David Lemley Design 377
Davidoff Associates Inc. 70
Dean Design/Marketing Group 294
Dentz & Cristina 55
Desbrow 253
Design Forum 182
Design Guys 138
Design Objectives Pte Ltd 13, 129, 151, 335
Design Room 82
Designation 157, 213, 231, 248, 275, 286, 301, 317, 320, 340, 347, 348
designRoom Creative 96
Dever Designs 18, 19, 34, 114, 126, 132, 148, 149, 159, 211, 276, 321, 340, 341, 346, 347, 352, 361, 366
DGWB 43
Di Donato Associates 265
Disney Online 80
Disneyland Creative Print Services 69
Don Schaaf & Friends, Inc. 7
Dotzler Creative Arts 46, 74, 146, 278, 307, 323, 348, 352

E

EPOS, Inc. 375
Erbe Design 296

F

Finished Art, Inc. 185
Five Visual Communication and Design 272, 316, 336
Fixgo Advertising (M) Sdn Bhd 177
Forward Branding & Identity 157, 189, 270
Full Steam Marketing & Design 143
Funk/Levis & Associates 45, 129, 288, 377
Fusion/Design Communications 66

G

Gammon Ragonesi Associates 174, 175, 184
Gauger & Silva 255
Gauger + Santz 9, 181, 254
Gibson Creative 25
Goldforest 100
Grafik 131
Graphical Limited 369
Graphiculture 176
Greenfield/Belser Ltd. 81, 124, 271
Greteman Group 45, 53, 65, 77, 78, 79, 99, 144, 201, 202, 204, 205, 213, 216, 221, 225, 245, 273, 283, 337, 344

H

Halleck 297, 360
Hardball Sports 17
Haugaard Creative Group 175
Heye 65, 72
Heye + Partner GmbH 219
Hornall Anderson Design Works 30, 31, 32, 33, 42, 52, 84, 86, 87, 100, 117, 122, 123, 140, 152, 166, 169, 187, 204, 205, 221, 222, 223, 234, 242, 281, 282, 283, 284, 310, 330, 339, 342, 350, 356, 365
Hughes Design 83
Hull Creative Group 380, 382

I

Im-aj Communications & Design, Inc. 299
Imtech Communications 230, 366
Inc Design 120
Interbrand 180, 236
Interbrand Hulefeld 37, 69, 72, 111
Interrobang Design Collaborative 301

J

JGA, Inc. 14
Jiva Creative 125, 247
John Kneapler Design 150
Julia Tam Design 239

K

Kb.D 372
Keiler & Company 162, 349
Kircher, Inc. 380
Klündt Hosmer Design 23, 29, 33, 53, 63, 97, 109, 110, 113, 135, 152, 155, 163, 167, 169, 190, 196, 203, 223, 240, 246, 253, 258, 269, 284, 314, 316, 326, 383

Kontrapunkt 47
kor group 193, 264

L

Lane + Lane 367
LarsonLogosEtc 229, 255, 276, 331, 343, 349
Launch Creative Marketing 80
Lawrence & Ponder Ideaworks 49, 378
Lemley Design Company 154, 155
Leslie Evans Design Associates 293
Lesniewicz Associates 243
Levine & Associates 146
Lewis Moberly 22
LIFT Creative 170, 171
Liska + Associates, Inc. 217, 368
Louis & Partners Design 28, 52, 59, 96, 134, 164, 165, 198, 281, 308, 311, 312, 326, 327
Lynn Cyr Design 128

M

MackeySzar 188
Mark Oliver, Inc. 47, 206, 321
Marketing Design Group 10
Marshall Fenn Communications 68
McCann-Erickson 136
McClain Finlon Advertising 48
McElveney & Palozzi Design Group 19, 37, 47, 75, 76, 79, 96, 101, 102, 126, 159, 179, 184, 238, 250, 261, 278, 288, 305, 306, 308, 309, 317, 318, 362, 363, 364, 365
merish design 231
Michael Osborne Design 38, 56, 58, 77, 85, 94, 105, 139, 198, 256, 267, 279, 280, 298
Mike Salisbury L.L.C. 20, 116, 193, 195, 197, 211, 216, 257, 277, 287, 309, 342, 367
Mobium Creative Group 54
Mortensen Design 372
MTV Off-Air Creative 373

N

Nassar Design 15, 338
Natalie Kitamura Design 293

O

Oakley Design Studios 83
Ortega Design Studio 26, 93

P

Paradowski Graphic Design 16
Pat Taylor Inc. 105, 229
Pearlfisher 31, 33, 84, 166, 167, 168, 235, 303, 311
Pensaré Design Group, Ltd. 68
Performance Graphics of Lake Norman 73
Pettus Design 382
Phinney/Bischoff Design House 16, 331
Pinkhaus 54, 216
Popular Mechanics 371
Praxis Diseñadores, S.C. 18, 114, 115, 178, 191, 210, 286
ProWolfe Partners 48

R

Redgrafix Design & Illustration Studi 46
Resco Print Graphics 209
Ron Bartels Design 160
Rottman Creative Group, LLC 67, 381
Rule29 9, 20

S

s2design Group 35
Sagmeister Inc. 75, 101, 121, 140, 208, 210, 213, 225, 274, 279, 280, 298
Sam Smidt 355
Savage Design Group 368
Saybrook Advertising 11
Sayles Graphic Design 21, 38, 51, 87, 94, 133, 134, 135, 153, 160, 187, 192, 199, 200, 201, 202, 267, 314, 315, 345, 353
SevenTwenty Group 11
Shields Design 91
Sign Kommunikation GmbH 361
Simple Green Design 257
Slanting Rain Graphic Design 327
Stan Gellman Graphic Design 61, 119, 120, 239, 259, 306, 323, 367
Stan Gellman Graphic Design Inc. 241
Sterrett Dymond Stewart Advertising 71
Straightline Int'l. 130
Studio Archetype 161
studioluscious 332
Suka & Friends Design, Inc. 353
Sunspots Creative, Inc. 82
Supon Design Group 159, 196, 276, 291, 348, 354
Szylinski Associates Inc./Protocol 206, 212

T

Tangram Strategic Design 7, 8, 30, 111, 129, 151, 180, 257, 268, 289
Taylor & Ives Incorporated 208
Tepperman/Bay Associates, Inc. 371
The Humane Society of the United Stat 250
The Lemonides Design Group, Inc. 183
The Riordon Design Group Inc 25, 41, 42, 57, 58, 199, 245, 258
The Sloan Group 209
The Wecker Group 7, 39, 61, 85, 90, 95, 96, 104, 105, 110, 120, 121, 122, 129, 153, 190, 220, 229, 234, 235, 242, 278, 299, 343, 345, 358
The Wyant Simboli Group, Inc. 246
The Zimmerman Agency 141
Thompson Design Group 170, 172, 173
Tiffany + Company 163
Tom Fowler, Inc. 43, 64, 92, 99, 136, 147, 168, 203, 214, 225, 243, 271, 292, 341, 355
Tom Ventress Design 64, 99, 146, 197, 343
Toolbox Studios, Inc. 44, 158, 335
Trinchero Family Vineyards 12, 13

U

U.S. Bancorp Asset Management 10
über, inc 230
Ukulele Design Consultants Pte Ltd 300
United Retail Group 218

V

Vanderbilt University Publication & D 188
viadesign 15, 381
Visual Asylum 233

W

Wallace Church, Inc. 64, 183
Wray Ward Laseter Advertising 334

Z

ZGraphics, Ltd. 130
Zunda Design Group 177

CLIENTS

Symbols

[i]e design, Los Angeles 71
3D Studio 7, 52, 123, 245, 282, 307, 337, 338, 350
20th Century Fox 216

A

AAA 249
Abbott Animal Health 70
Academy of Achievement 19
Ad Formula Design Studio 212
Adjobs 67
AdviceZone.com 354
Ahold USA—Tops Division 179
AirTouch 227
Alegro Internacional 191, 286
Alex Marshall Studios 293
Alliant Energy 127

Alpha 311
American Academy of Physician Assistants 34
American Way Magazine 238
AmericanStyle Magazine 276
Andrews Federal Credit Union 67
Antigenics 379
Appropriate Temporaries, Inc. 158
Arby's 147
Arcadia 123, 338
"Art Fights Back" 21, 38, 51, 87, 94, 133, 134, 135, 153, 160, 187, 192, 199, 200, 201, 202, 267, 314, 315, 345, 353
Arthur Anderson 325
Arvida 300
ASAP Software Express 130
Ashland 120
Atkins Nutritionals 181
August Schell Brewing Co. 103, 105
Aunt Gussie's Cookies & Crackers 329
Avery Dennison 126

B

B.M.I. 209
Bacardi USA, Inc. 216
Badger Technologies 365
Barra Corp. 328
Bausch & Lomb 101, 189, 305
Bayer Corporation 206
Bayer—Pursell, LLC 212
Beer Nuts 174
Belgium Iron Works 327
Bellissimo 183
Belyea 228
Bermuda Tourism 73
Bernie Yuman 367
BET Publishing Group 332
Beta Systems 79, 86
Bethel Constructiort 120
BioForm 186, 362
Blue Fin Cafe & Billiards 104
Blue Note Records 257
Bonsee Software 309
Borsani Comunicazione 7, 8
Boston Public Library 338
bp Trinidad and Tobago LLC (bpTT) 260
Brand Management 69
Breuninger 65, 72
Brooklyn Bottling 35
Brown Jordan 245
Buckin' Bass Brewing Co. 103

C

C.A. 212
Cadbury Beverages 170
Café Bohème 312
Campfire USA 277
Campion Walker 296
Canadian Opera Company 199
Canandaigua Wine Co. 261
Canyon Road 85
Carnegie Corporation of New York 346, 361
Casa della Cultura 289
Casino Rama 68
Charles Button Company 196
Chateau Valeria 110
Ciao Bella Gelato Co., Inc. 183
Ciclón 226
Cisco Systems 254
CNS 188
Cogent 379
Coleman 354
Colgate-Palmolive Company 192, 207
ColorGraphics 50, 127, 251, 286, 309, 328, 357, 382
Community Foundation for Monterey County 242
Computer Repair Express 39
Concert Productions 323
ConocoPhillips 207
Connecticut Art Directors Club 349
Connecticut Art Director's Club 355
Connecticut Grand Opera & Orchestra 64, 203, 214
Corus Entertainment 58
Covance 51
Crystal Clear 118
CUNA Mutual Group 104

D

Danone de México 115
Dare Family Services 382
Data Comm Plus 128
Davide Cenci 30
Deer Creek Golf Club at Meadow Ranch 295
Definitive Sound 258
Del Monte Aviation 229
Dever Designs 114, 126, 341
Dick Corporation 14
Discovery School 269
DiviDivi 287
Dog Eat Dog/Roadrunner Records 372
Domino's Pizza 227
Dragonfly 25
Dunkin' Donuts 182

E

Early Childhood Research Institute on Inclusion 188
Eastman Kodak Company 79, 159, 278, 364
Eat N' Park 164
Eaton Sales 11
Eberhart Interiors 313
eguana.com 82
El Camino Reserve 370
Embarcadero Systems Corp. 125
Empire Forster 47
English Hotbreads (Sel) Sdn Bhd 177
Environmental Management Services Inc. 343
EPOS, Inc. 375
Essential Skin Inc. 116
Euclid Hospital 376
Eugene Parks & Open Spaces 377
Everafter 291
Express Theatre 63

F

Famous Eddie's 59
Federal Reserve Bank of St. Louis 259, 367
FedEx 127
Fina Flickman S.A. 22
Fine Arts Museum 279, 333
FMC Technologies 119, 239
Food Affair 356
Foppiano Vineyards 26
Ford Motor Company 156
Foster Farms 173
Frost Specialty Risk 196

G

Gainey Suites Hotel 358
Genie Industries 383
Georgia Organics 295
Girard College 193, 264
Global Crossing 308
Gloria Dei Lutheran Church 255
GO Wireless 270
GoBookMax 97
Good Printing 266
Goodmark Foods 172, 181
Gotcha 211
Graphic Source 56, 220, 302

Great Waters Brewing Co. 321
Greater Greensboro Chrysler Classic 100
Greatlodge.com 361
Green Jespersen 122
Greenfield/Belser Ltd. 81
Guidance Financial Group 249
Gunn Automotive 44, 158
Gymboree 77, 139, 267

H

Hammer Golf 95
Handspring, Inc. 372
Healing Environments 355
Hedstrom Corporation 80
Herman Miller 262
Heron Hill Winery 250, 288
High Falls Brewing Co. 98, 102, 238, 317, 318
HKR Limited (Hong Kong) 151
Hon Industries Inc. 378
Honeywell Consumer Products 43, 99, 136, 341
HR Value Group 119, 145
Huntsinger Farms 294

I

IFM Infomaster 129
iHorses 288
Im-aj Communications & Design, Inc. 299
Independent Bankers Association of America 366
Independent Perinatal Associates of Cincinnati 111
Indiana Basketball Hall of Fame 11
Inova Group 332
Intelsat 91
Interconnect Technologies Corp. 366
International Association of Amusement Parks 380
Itronix 196

J

Jack Toolbox Company 102
jacknabbit.com 377
Jacob's Java 169
Jake's Trading Co. 358
Jake's Trading Company 322
James and Patricia Pettus 382
James Madison Council 18
Janet Gillespie Law Office 25
Janie and Jack 256, 298
Jarmuz 28
JCC MetroWest 12
JGA, Inc. 14
Jim Beam Brands Company 265
Johanna Foods 174
Johnson & Johnson 27
Julie Scholz, CCHT 247

K

K/P Corporation 226
Kemps Marigold 148, 287
Klein Bicycles 368
KMPC Sporting News 46
KMY Instruments 230
Kodak 64
Kroger Company 37, 69

L

LaBarge Inc. 120
Laboratorios Promeco 114
LakeCity Community Church 223
LaserCosmedics 253
Launch Pad 316
Lawrence & Ponder Ideaworks 49
Leap 225
Lemax 319
LFP 116
Liberty Magazine 159, 211, 321
Lightbridge, Inc. 371
LimeAide Refreshing Delivery 73
Linesoft 23
Living with Elephants Foundation 292
Local Initiatives Support Group 271
London by Design 332
Louise Wegmann 15

M

M 276
MacKay Construction 314
Magic International 10
Magnanni 96
Mail Boxes Etc. Foundation 381
maltwhiskey.com 91
Maryhill Winery 29, 167, 326
MCC 44
McDonald's Promotion GmbH 219
McElveney & Palozzi Design Group 75, 76
MDO 150
Meijer 178
Melwood 340
Merv Griffin 193, 277
Meta•Logic Software Developer 160
Michael Osborne Design 279
Michigan Opera Theatre 66
Microsoft 30, 136
Ministry for European Integration, Croatia 47
Montana Eyes 277
Monterey Sports Center 61
Moodwax Candle Co. 301
Morgan Winery 234
Mott's U.S.A. 83
MTV 373
Mutual UFO Network Museum 48
Myrick Photographic 105

N

National Air and Space Museum 347, 352
National Cherry Blossom Festival 68
National Council on Education for the Ceramic 327
Natrol 255
Neovation 54
Nestlé Ice Cream Company 184
Nestlé Purina Pet Care Division 170
Nestlé USA 175
Nestlé USA, Inc - Beverage 172, 173
Newton Learning Corp. 129
NexPress 157
Ng Nam Bee Marketing Pte Ltd 300
Noble Corporation 369
Northern Va. Comm. College 229
Northstar Capital Investment Corp. 253

O

Ocean Beauty Seafood 321
Oldham 107
OnlineLearning.net 367
OnPoint Digital, Inc. 354
Organic Milling, Co. 206

P

Pacific's Edge 235
Paco Rabanne 55
Palis Gen. Contracting 105
PAML 120
Panda Restaurant Group 342
Panoz 141
Paradowski Graphic Design 16
Paris Casino Resort—Las Vegas 324
Parlor 215
PC Assistance, Inc. 126
Peter Pepper Products 52
Pfizer 271
Pinckney Photography 61
Pittsburgh Dance Council 143
Playtex Products, Inc. 92, 147
Polycom 15
Polygram Record Group 20
Popular Mechanics 371

Power Play Billiards 82
PPL Corporation 207
Prénatal 111, 151, 257, 268
Preston Gates & Ellis LLP 331
Procter & Gamble 72, 236
Procter & Gamble Argentina 115

Q

Quaker Oats 175
Quarterlight Productions 197

R

Redgrafix Design & Illustration Studio 46
RediHelp 223
REI 154, 155
Reily Foods 198
Resco Print Graphics 209
Rhythm House Records 335
Ridgewood Power 130
Riveredge Resort 19
Rivermark 9, 254
Riverside Symphony 231
Robert L. Cooper, M.D. 109, 110
Robert Scott—David Brooks 293
Rock Valley College Starlight Theatre 66
Rockford Area Lutheran Ministries 223
Rohrich 312
Rottman Creative Group, LLC 381
RS Development 330
Rule29 9, 20

S

S3 308
Saarman Construction 74
Sage Metering, Inc. 90
San Francisco Museum of Modern Art 38, 56, 77, 94, 105, 198
San Francisco Oven 164, 165, 281, 326
Santa Barbara Ad Federation 47
Santher 189
Savage Design Group 368
Sbarro International 177
Scheid Vineyards 85
Schramberg Champagne Winery 26
SD Malkin 295
SE Origami Festival 334
Sean Kernan Photo/Keiler & Allied Printing 162
Simi Winery 93
Sirach Capital Management 16
Six Sigma Canada 17
Sky Bank 243
Sligo Seventh-Day Adventist Church 132
SmithKline Beecham 151
Society of American Florists 149
Sokol Blosser Winery 83
Sony 45
Souper Salad 28
South Coast Plaza 43
Spokane Industrial 258
Spokane Public Schools 284
Spokane Regional Health District 246
St. Olaf College Viking Male Chorus 349
St. Supery 360
Starbucks Coffee 378
Steinway Musical Instruments, Inc. 246
Sterret Dymond Stewart Advertising 71
Stoked Media 143
Straits Advisors Pte Ltd 13
Stu Small 71
Studio Archetype 161
Suburban 237
Sue Weishaar, D.D.S. 113
Summit Press 380
Sun Orchard Brand 37
Synergy Business Environments 50

T

Target 176
TD Waterhouse 247
Telect 155
The Coca-Cola Company 185
The ESPY Awards 17
The Front Porch Magazine 148
The Fullerton Hotel, Singapore 335
The Good Guys 211
The Humane Society of the United States 250
The James Beard Foundation 150
The Jewish Home & Hospital Lifecare System 261
The Kellog Foundation 146
The National Aviary 355
The Pepsi Bottling Group, Inc. 70
The Walt Disney Company 80
Thomas Arledge 131
Tiffany + Company 163
Tom Fowler 168
ToolBox 305, 362
Total Quality Apparel Inc. 257
Traveleze.com 248
Tribecca 130
Trinchero Family Estates 12, 13
Tripos 48
Trusted Choice 248
Tuohy 7

U

Ulman Paper Bag Company 159
Unilever Home & Personal Care USA 225, 243
United Distillers & Vintners 297
United Industrial Corporation 208
United Overseas Bank 129
Universal Pictures Amblin 197
University of Illinois Foundation 241
UNYCoR 306
Urgi 218
Utopia Marketing 230

V

Valle Redondo 18, 178
Vecta 307, 337, 350
Victor Sanovec/Barbasa Fuchs 361
Village Bible Church 343
Visual Asylum 233
Vue Lodge 288

W

Walker Foods 149
Walker Zanger 282
Washington D.C. Convention and Tourism Corporation 348
Washington Federal 253
Washington Park Christian Church 229
Webprint 33, 53
Wegmans Food Markets 184
Weil Gotshal + Manges 124
Welch 171
Wells Fargo 139
White Hen 329
Whitworth 190
Williams-Sonoma, Inc. 171
Windstar Cruises 77, 81
Winterpark Pub 357
Wm Wrigley Jr. Company 34
Wolfsonian Institute 54
Women's Professional Football League 117, 133, 210
WorldWide Packets 63

X

Xelus 309, 362, 363

Y

Yosemite Wild Bear Project 280

Z

Zoom Messenger 40
Zoomstock Stock Photography 217